Robert —

This book reminded me
of all the wonderful Times
we've shared.

Thanks for the memories!

All my love

Joe

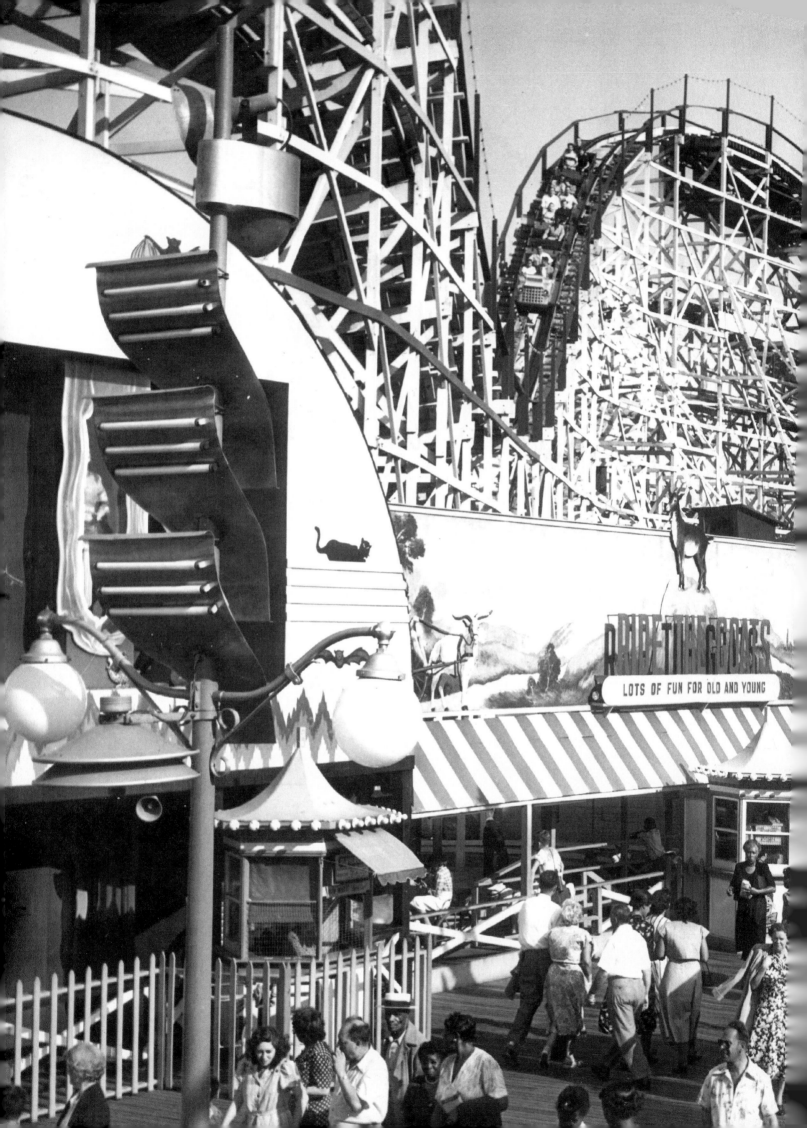

Old Rockaway, New York

IN EARLY PHOTOGRAPHS

❧

Vincent Seyfried
and
William Asadorian

❧

DOVER PUBLICATIONS, INC.
MINEOLA, NEW YORK

Dedicated to the memory of
Hayward Cirker

Copyright

Copyright © 2000 by Dover Publications, Inc.

All rights reserved under Pan American and International Copyright Conventions.

Published in Canada by General Publishing Company, Ltd., 30 Lesmill Road, Don Mills, Toronto, Ontario.

Bibliographical Note

Old Rockaway, New York, in Early Photographs is a new work, first published by Dover Publications, Inc., in 2000.

Library of Congress Cataloging-in-Publication Data

Seyfried, Vincent F.
 Old Rockaway, New York, in early photographs / Vincent Seyfried and William Asadorian.
 p. cm.
 Includes index.
 ISBN 0-486-40668-7 (pbk.)
 1. Rockaway (New York, N.Y.)—History—Pictorial works. 2. New York (N.Y.)—History—Pictorial works. 1. Asadorian, William. II. Title.
F129.R8 S49 2000
974.7'1—dc21

 00-022417

Book Design by Carol Belanger Grafton

Manufactured in the United States of America
Dover Publications, Inc., 31 East 2nd Street, Mineola, N.Y. 11501

Preface

More than eighty years have elapsed since the publication of Alfred H. Bellot's *History of the Rockaways* in 1917. Despite all the changes during the intervening years, no other book on this important section of New York City has been published. Rockaway today is essentially a year-round residential and business community of over 100,000 people, much more ethnically diverse than ever before and closely linked to the mainland city by subway, highways, bridges, and tunnels. The resort Rockaway of popular imagination and hundreds of picture postcards lasted about 100 years, from 1850 to 1950. This volume, both pictures and text, is designed to recapture the spirit and scene of this lively seaside vacation spot, with resort hotels, a beautiful sandy beach, and hundreds of amusement places of all types. The early Rockaway attracted thousands, eventually millions of visitors each year.

Rockaway entertained the public in a fashion similar to that of its ongoing rival, Brooklyn's Coney Island. Rockaway was more remote from the city but occupied a much larger area, so it developed in a different way than did the more famous Coney. In addition to the rides and other amusements, Rockaway also had space for many hotels, inns, rooming-houses, bungalows, and tent colonies in which entire families could vacation for a week or two or even the whole season. People returned year after year to Edgemere, Arverne, Rockaway Beach, and other communities. And, surprising to outsiders, the Rockaway peninsula included affluent residential sections such as Neponsit, Belle Harbor, and Bayswater that remained remote from summer visitors. Perhaps because of the area's geographical unity, well-defined boundaries, and relative separation from the rest of New York City, the year-round population created one of the most cohesive urban communities in the United States. Those who have lived in Rockaway for any length of time continue to maintain a strong sense of identification with the place, one that seems never to wane.

The historical material in this book is based on extensive research in the files of the *Brooklyn Eagle, Hempstead Inquirer,* and other newspapers, especially the splendid local weekly, *The Wave,* which is still being published more than 100 years after its founding. Of particular value have been the clipping resources of the Queens Borough Public Library, Long Island Division. Special thanks go to Charles Young, manager of the division (now retired). For the illustrations the authors are indebted to the photographic files and postcard collection of this fine library as well as material made available by Charles Huttenen, Robert Stonehill, Dean Georges, and Emil Lucev. We are especially grateful to Mr. Lucev, a lifelong resident of the Rockaways and its current historian, whose firsthand knowledge of the area is unrivaled. The information he has so graciously provided has been invaluable. We also wish to thank Dr. Lawrence Kaplan for his generous assistance with the preparation of this book and Mr. Hayward Cirker, president of Dover Publications, for his encouragement and help. We hope that *Old Rockaway, New York, in Early Photographs* does justice to his special affection for the people and traditions of the Rockaways.

Vincent F. Seyfried
William Asadorian

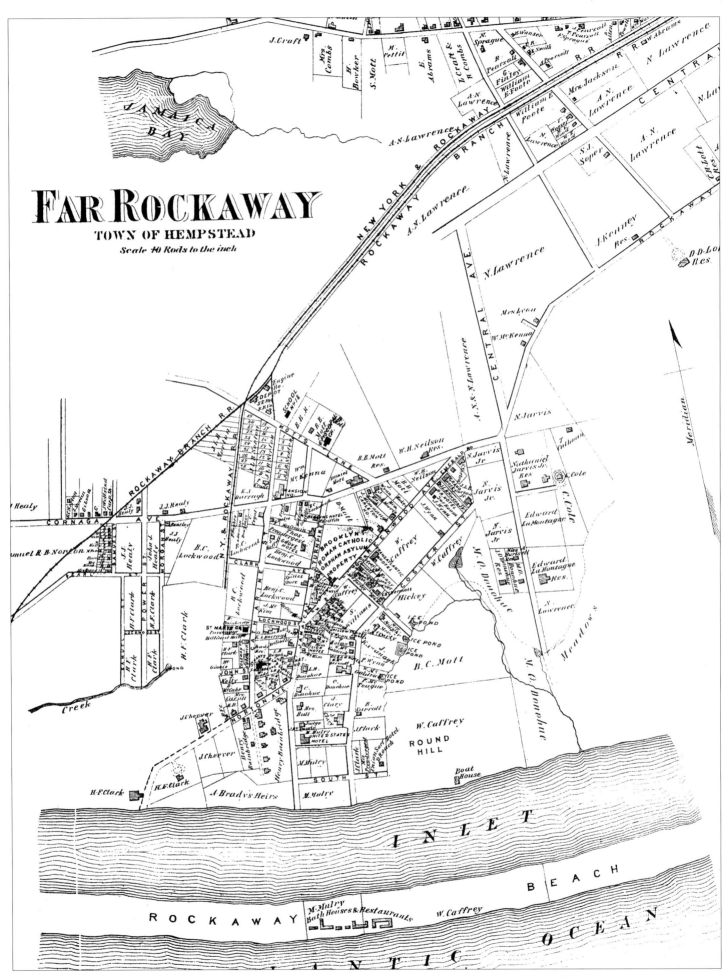

One of the earliest maps of Far Rockaway, from *Beer's Atlas of Long Island* (1873).

Introduction

AN HISTORICAL OVERVIEW

The Rockaways comprise the western end of the long barrier beach on the south shore of Long Island, New York. The eighty-mile strand extends all the way from Southampton, in Suffolk County, on the east to Breezy Point, in Queens County, on the west. For thousands of years powerful storms have roared in from the ocean and cut channels through the barrier at various points. Still, the beach today constitutes an essentially continuous strip that protects the Long Island mainland from tides and storms. The Rockaway peninsula is part of this land formation, beginning at what is now Hewlett and Woodmere and steadily narrowing through Cedarhurst and Hewlett to Far Rockaway. From here a sandy strip barely a quarter-mile wide continues about nine miles before ending at Rockaway Inlet.

Primeval Rockaway was an area of sandy hillocks, swampy tracts, and cedar trees. Its dimensions were continually altered by nature, its outlines regularly reshaped by hurricanes and the constant littoral drift that has pushed the tip ever westward with deposits of sand. Long ago, Native Americans settled in and around what is now Far Rockaway, where woodland, fresh water, and meadowland supported a pastoral way of life. These first settlers were Canarsees, a Mohican tribe that was part of the great Mohawk nation. The modern name for the peninsula has been attributed to many sources, but most likely it derives from the Indian word *Rechquarkie*, spelled in various ways and connoting "the sand place." The Europeans came early in the seventeenth century. By 1642 the Dutch had begun farming the Long Island plain, and two years later the town of Hempstead was settled by English colonists moving down from New England. Over the next decades a sprinkling of these settlers arrived at the head of the Rockaway peninsula.

In 1684 Phillip Welles surveyed Rockaway neck on behalf of a potential purchaser, Capt. John Palmer. Because of Welles's inexact demarcation and failure to indicate his baseline with visible markers in the shifting sands, property boundaries were often the subject of disputes. Litigation continued through the years, most recently in 1908. In any case Palmer signed a treaty with the local Indians in October 1685 to purchase all of Rockaway Neck and beach from the Welles baseline to the peninsula's western tip, then located at present-day Wavecrest. The price was 31 pounds, 2 pence. The governor of New York, Thomas Dongan, who was a friend of Palmer's, approved the deed, which is still held at the state capital, Albany.

Palmer proved to be a short-term investor, selling Rockaway to Richard Cornell (also spelled Cornwell and Cornhill), an ironmaster from Flushing, in 1687. He moved his family to Rockaway in 1690 and built a large frame house on what is now B.20th Street. Evidence exists that he kept slaves to farm his land. Over the years he added to his property, and several other families settled in the area, causing the town of Hempstead to apportion more lands in 1723. Titles and boundaries became confused during the eighteenth century, and in 1809 the Cornell family brought a partition suit to court. As a result, the land was split into a western division with sixteen plots and an eastern division with fifteen plots. Again, however, a firm baseline was not fixed, and surveyors disagreed over how this could be done to satisfy all sides. Nevertheless, the Cornells held on to Division 1, and John L. Norton purchased Division 2. Both Norton and the Cornells later sold expanses of land to people who became important in the real estate development of the Rockaway peninsula: Garret Eldert, James Remsen, Michael Holland, Louis Hammel, and Remington Vernam.

At first, what building there was proceeded gener-

ally from east to west. The first commercial hotel on the peninsula, the renowned Marine Pavilion, opened in 1833. Other establishments followed. By the 1860s Far Rockaway was not only a thriving summer resort but was also on its way to becoming a desirable residential suburb of New York City. Between 1855 and 1860 the Seaside, Hammels, and Holland sections saw the construction of hotels, bathhouses, and other recreational enterprises. In these early days the Jamaica Bay side of Rockaway was the focus of commercial activity, chiefly because the steamboats from the city landed there. Not until the late 1880s and early '90s did the oceanfront come into its own; that area has remained the primary tourist destination ever since.

The coming of the South Side Railroad in 1872 opened the area to still more tourists, and when the cross-bay railroad bridge opened in 1880, daily summer patronage at the beach reached heights never thought possible. Thus began what has been termed Rockaway's "golden age," an accolade that has also been used to describe other times using different criteria. Bathhouses capable of renting 10,000 bathing suits a day were built, along with restaurants, food stands, and fun palaces. The latter consisted of carousels, scenic railways (soon to become roller coasters), other rides, shooting galleries, saloons, dancehalls, games of chance, exhibition halls, shows, and whatever else might attract the public's money. Seaside, where the steamboats landed at the foot of what is now B.103rd Street, was the early amusement center, with activity spreading east to Hammels (B.85th Street). The peninsula's only east-west thoroughfare, Rockaway Beach Boulevard, was also its main street. By 1885 it ran from the western "frontier" to the heart of Far Rockaway, but its width of fifty to sixty feet left little room for the traffic that soon came.

Politically, all of Rockaway remained an unincorporated district of Hempstead town. Taxes went to Hempstead, and police protection and other municipal services were administered from a town hall that was some miles distant. A groundswell for home rule brought about the incorporation of the villages of Far Rockaway (1888), Arverne-by-the-Sea (1895), and Rockaway Beach (1897). The big change came in 1898, with the consolidation of New York City. The Rockaway villages were detached from Hempstead and Nassau County to become part Queens County, one of the five boroughs of the newly established City of New York. At first the residents of Rockaway were little affected by the new affiliation, but as the twentieth century unfolded, the changes would be profound.

A minor urbanization was the numbering of most Rockaway streets in 1916. Signs with names like Jarvis Lane and Hudson Avenue were tossed aside as all the north-south streets on the peninsula were given numbers, starting with Beach lst Street on the Nassau County border and ending at that time with Beach 149th Street in western Neponsit. As additional streets were built to the west, the numbering system was extended to B.222nd Street. (In the text and captions in this book, we have generally cited streets by their numbers even when referring to events before 1916, consistently abbreviating Beach to B., as in B.103rd Street.) East-west streets either kept their original names or were retitled at the request of local leaders. Some of the railroad (today, subway) stations retained their names, such as Straiton Avenue and Gaston Avenue, even though no thoroughfares actually carry those names.

With the dawn of the new century more and more people became attracted to Rockaway as a place to stay for more than just a day. To accommodate vacationists on a limited budget entrepreneurs established tent cities on or near the beach. The first appeared in 1901, near B.108th Street, and others soon followed. These open-air colonies were quite large, each accommodating 1600 to 2000 people. Costs were relatively low: Rental of a tent for the summer season ran about $300. Families tended to return each year for the cool ocean breezes as well as the informality of tent life.

At the same time as tent colonies were sprouting at the beach, the year-round community at Rockaway was increasing in size. This development came despite some drawbacks, including the long commute to jobs on the "mainland" and the dangers posed to property by storms. No less destructive, and in a way more dangerous, were the fires that have ravaged the community from the beginning and up to the present day. Many of the buildings in the area were of flimsy construction, almost entirely of wood, baked by intense sunlight and squeezed together on the narrow peninsula. A small blaze, fanned by the ocean wind, always had the potential to escalate into a major conflagration. Large fires swept through Seaside in 1892, wiping out a large section of the amusement area from ocean to bay, and Arverne in 1922, destroying eighty-two houses, fifty-three bungalows, and ten hotels. Countless hotels and other buildings have been destroyed by smaller fires.

These and other problems were offset by the generally healthful climate, the relative proximity to Manhattan, the beautiful beach, and the amenities that gradually came because of affiliation with New York

City. The boardwalk, begun by private enterprise in Rockaway Park in 1889, continued to expand. Over time the city rebuilt parts of this structure on concrete foundations until, by 1926, a stretch of oceanfront walkway stretched from B.9th Street to B.126th Street, about six miles, just shy of being the longest boardwalk in the world, a title claimed by Atlantic City, New Jersey.

For years many of Rockaway's business people had craved a bridge and causeway across Jamaica Bay that would give automobiles straight-line access to the peninsula. Few motorists chose to take the long, circuitous drive east through Queens to Nassau County, then south and back west to the Rockaway beaches. Private interests had begun construction on a direct route in 1901, but high costs together with opposition from the then-politically powerful Long Island Railroad forced abandonment of the project. But as more voters bought Model Ts and other automobiles, the city leaders' interest in the cross-bay project revived. After many legal and engineering difficulties, Cross Bay Boulevard was extended from Howard Beach in Queens to B.94th-95th Streets in Rockaway Beach. Many small islands were joined for the roadbed, with drawbridges at Broad Channel and North Channel. The 100-foot-wide thoroughfare opened to traffic on October 31, 1925. It cost $6,935,970, expensive for the time, but it is generally regarded as one of the most important public works projects in the history of Rockaway. To provide for the increased traffic on the peninsula, the edge of Jamaica Bay was filled in, and Beach Channel Drive was built, eventually extending from B.35th Street in Edgemere to B.169th Street in Riis Park.

Another long-desired improvement to Rockaway's transportation did not come to fruition until the early 1940s. Efforts to eliminate the many dangerous grade crossings on the Long Island Railroad had begun in 1916. Delay after delay occurred as the city, the railroad, and civic leaders argued over the apportionment of costs to improve the four-mile-long stretch of track. Finally, in July 1939 an understanding was reached among the interested parties that a two-track concrete-and-steel viaduct would be built with a roadway beneath. Work began in 1940 and continued for two years, resulting in the elimination of forty grade crossings at a cost of $11,650,000. The safety of railroad passengers and of drivers crossing the tracks was vastly improved, but the roadway beneath the elevated roadbed turned out to be a major hazard. The pillars holding up the structure proved to be a labyrinth for the automobiles zig-zagging along the street.

Another problem with the railroad finally came to a head in 1950. For years fires had plagued the wooden trestle that carried the railroad over Jamaica Bay from the mainland to Rockaway. A fire on May 7, 1950, damaged the timbers so extensively that the Long Island Railroad, then in bankruptcy, refused to pay for the necessary repairs. The LIRR ran trains to Rockaway through Valley Stream, but on November 2, 1955, the trains ceased running down the peninsula. The city finally paid $8.5 million for the cross-bay line in 1953, rebuilt the trestle in steel and concrete, and connected it to the Fulton Street line of the IND subway. Service began in time for the 1956 summer season.

Another important event related to the 1898 consolidation was the transfer of a large tract of open land west of Neponsit from New York State to the New York City Department of Parks. Not much happened at first, since it was difficult to get to the area except by boat. Initially named Seaside Park, then Telewana Park, the large, ocean-to-bay tract got its present name, Riis Park, in 1914, in honor of Jacob Riis, who died that year. Riis was a Danish-American journalist who had brought to public attention the horrors of New York City slum life in the 1890s. The purpose of the Board of Aldermen in establishing Riis Park may have been to give the masses of city residents free access to an unspoiled beach, but this did not happen immediately. During World War I the U.S. Navy established a small airfield in the northwest corner of the tract. It was from this insignificant and, even today, neglected spot that the historic first flight over the Atlantic Ocean took off in 1919. Naval aviators in three NC-4 seaplanes attempted the crossing, stopping first at Newfoundland. Three weeks later, after many mishaps and failures but without any loss of life, one of the planes made a triumphant entrance to the harbor at Lisbon, Portugal—the first to fly all the way across the Atlantic, eight years before Charles Lindbergh made his historic solo flight from New York to Paris.

The U.S. military also took over about 300 acres west of Riis Park during World War I to install big coastal artillery weapons to defend against any attack from the sea. The guns were eventually removed, but Fort Tilden, as it was called, remained under control of the federal government. After a brief recall to active duty in World War II, the fort was "mothballed" until 1974, when most of the acreage was turned over to the Department of the Interior as part of the new Gateway National Park.

Meanwhile, Riis Park did not become a true haven

for beachgoers until the 1930s, when Parks Commissioner Robert Moses built bathhouses along with many other amenities and, most important, the Marine Parkway Bridge across Jamaica Bay. This opened the western part of the Rockaways to the millions of people who lived in Brooklyn. Only a few diehard fishermen and beachcombers criticized Moses and his builders for coming in with their heavy machinery to make Riis Park a true city park. This was not the case with the commissioner's other activities on the Rockaway Peninsula. In 1935 there was major opposition to his decision to destroy acres of buildings just behind the boardwalk from B.73rd to B.108th Street in order to build a major new road, the Shorefront Parkway. Construction went forward, destroying some of the better-known rides in Seaside—the Tornado, the Thriller, and Nunley's Carousel—along with dozens of rooming houses, hotels, bathhouses, and other buildings. Locals scoffed at what they called "the road to nowhere," unaware that the parkway was but one link in a road Moses wanted to build from Rockaway through Atlantic Beach, Jones Beach, and Fire Island, ending in the Hamptons. This grand design was never fulfilled, but the Shorefront Parkway is still there, a six-lane highway that separates Rockaway's residents and tourists from the beach.

Like many parts of the United States, Rockaway experienced enormous change after World War II. First was the great migration to the suburbs. Nassau County, just to the east of New York City, saw its population double between 1950 and 1960. Many of the city's working people were moving out of the old densely populated districts marked by railroad flats and airless walk-ups that were especially uncomfortable in the summer heat. Developments like Levittown, together with low-interest mortgages available under the GI Bill of Rights, made it possible for millions to own their own homes complete with a small garden. For others, air conditioning made the city less uncomfortable in the summer. In addition, the vacation needs and desires of New Yorkers were no longer fulfilled by the simple pleasures available in Rockaway. With the increasing availability of relatively inexpensive air travel, the postwar tourists had access to distant destinations. For many, Rockaway was no longer the place to go for recreation.

At the same time the year-round resident population was increasing. High-rise, city-style apartment houses replaced many of the old rooming-houses and bungalows. Nursing homes and other public health facilities predominated in oceanfront sections of Far Rockaway. And some of the old buildings were converted into overcrowded tenement-type dwellings or single-room-occupancy housing. Especially in eastern Rockaway, vacant lots, often strewn with rubbish, replaced buildings that burned down or were declared unfit for occupancy. Most of the structures in Arverne and Edgemere, between the subway viaduct and the boardwalk, were bulldozed into the sand during the turbulent 1960s.

At the dawn of the twenty-first century civic leaders have proclaimed the coming of a new Rockaway, a place where people can live in safety and comfort in close proximity to the wide Atlantic. As they were a century ago, construction crews are building homes, developers are formulating grand plans, and politicians are proclaiming that the future looks brighter than ever. Whatever happens on the peninsula, the Rockaway experience continues to be cherished in the affections of those who experienced its unique offering.

Contents

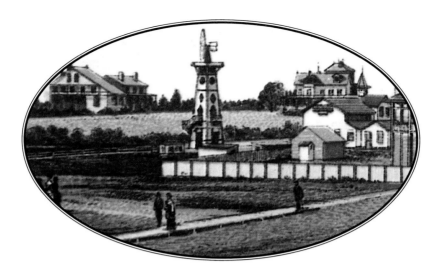

Far Rockaway

Far Rockaway is the oldest part of the peninsula and has traditionally been the most built-up area—in many ways the peninsula's focal point. Geographically, it occupies the point where the narrowing southern coast of Nassau County tapers to a barrier beach. This connection gave the early Native Americans easy access to the meadows, sand dunes, and cedar clumps of the unspoiled landscape, as well as to abundant seafood at the ocean's edge. Although the Native Americans had mostly moved away by the 18th century, traces of their presence occasionally crop up, mainly in the form of burial grounds that construction crews have stumbled upon while working on streets or putting down foundations for new buildings.

Although the Dutch were the first Europeans to colonize Long Island, it was the English—many of whom were moving down from New England—to survey the mostly barren area by the sea. Among the early settlers were people bearing names that are still familiar today from the street signs in Far Rockaway—Mott, Norton, Smith, and Hicks. The first formal settlement by an Englishman in the Rockaway area was that of Richard Cornell, who around 1690 built his farmhouse on the west side of what is today B.19th Street, midway between Seagirt and Plainview Avenues. An oil painting of the house by his granddaughter has survived. The Cornell heirs continued to farm their extensive acres until 1833, when the old homestead was torn down.

In 1832 an outbreak of cholera in New York City provided the spur for the first large influx of people to Far Rockaway. The panic generated by the plague caused hundreds of families to seek a safe haven in this isolated community by the sea. John Leake Norton, well connected politically through his marriage to a sister of Governor George Clinton, had already set up his homestead two years earlier. With his entrepreneurial abilities, he persuaded a group of New York businessmen to form the Rockaway Association. This group grew to include a former governor, John Alsop King, and an ex-mayor of New York City, Philip Hone. (Hone remains well known today for his extensive diaries, which give an insider's account of life in old New York.) The Rockaway Association purchased the Cornell holdings and began construction on a large hotel on the oceanfront, to be known as the Marine Pavilion.

The elite of New York society soon made the pavilion one of their favorite summer places. Among the names on the hotel's register were Astor, Schermerhorn, Morris, Gillette, Langdon, and King. Hone's diary gives his account of lavish dinners, grand balls, trotting matches, clambakes, and other upper-class events. In the 1840s General Winfield Scott, hero of the Mexican War, came for a visit, and at other times writers Henry Wadsworth Longfellow and Washington Irving and the painter John Trumbull were in residence at the Marine Pavilion.

Sea bathing, considered a novelty by most Americans, was, according to legend, first introduced to high society by two Far Rockaway men, Benjamin C. Lockwood and the aforementioned John Norton. They provided wooden bathhouses on wheels in which bathers changed their garments and were

pulled into the surf by horses. After getting into four or five feet of water, the horses were unhooked and taken ashore, while the little house in the ocean stayed in place until the bather chose to be hauled back to the beach. This arrangement was especially favored for women, whose presumed Victorian modesty required such seclusion while bathing in public areas.

When the summer of 1835 turned out to be cold and stormy at Rockaway, New York society folk looked for pleasure elsewhere. Within a year the nervous management of the Marine sold out. This tendency for property to change hands frequently has been a characteristic of Rockaway, as investors learned how changing weather conditions could determine profit or loss. A succession of managements ran the hotel through the 1840s and '50s, still attracting a group of affluent guests. The end came in June 1864, when a fire destroyed the wooden hotel. Indeed, fire periodically revisited the Rockaways over the years, laying waste to hundreds of buildings. The Marine Pavilion, like many of its descendants, was not rebuilt, but its importance to Rockaway lingered for decades. For it was the Marine that first brought nationwide publicity to the area. The success of this early hostelry encouraged other investors and developers to come to the seaside resort that was so close to the premier American city. From this time forward, well into the 20th century, Rockaway was known as one of the nation's great coastal resorts.

Even as the Marine Pavilion catered to the rich, other more modest establishments began to appear on the Rockaway peninsula. As early as 1833, along B.19th and B.20th Streets could be found John Kavanagh's modest New York Hotel, James Caffrey's Transatlantic Hotel (1843), and Roche's Surf Hotel (1848). The latter continued, in one form or another, for the next hundred-odd years. Caffrey also opened a shop on B.20th Street in 1843, initiating a trend that led to the street eventually being named Central Avenue — in the hub of an urbanized Far Rockaway. The oldest map of Far Rockaway that exists, printed by M. Dibbs in 1853, locates the early buildings and property holdings. There were twenty-four houses and inns then, but only five main thoroughfares — Cornaga Avenue, Greenport Road, New Haven Avenue, Plainview Avenue, and Seagirt Avenue. North of the tiny village the map depicts a large forest, and to the east a broad tract of meadow and bogland.

The first of the many great mansions to be built in Far Rockaway was the beachfront residence of Horace F. Clark, a judge from Manhattan. Clark was Commodore Vanderbilt's son-in-law and a future U.S.

congressman (1859-61). His house was built on a hillock facing the ocean and was surrounded by a broad lawn with colorful flowerbeds. It survived well into the 1890s. Otherwise, most of the construction in Far Rockaway in the mid-19th century was commercial, especially hotels. The Walling map of 1859 showed remarkable growth, including the earliest religious structure, St. Mary Help of Christians, built in 1851. New streets included Mott and Augustana Avenues. It was around this time that the village was first called Far Rockaway, to distinguish it from Near (soon to be called East) Rockaway, and that building began to pick up in Rockaway Beach, to the west. Much of the latter area's business came from day excursionists, who came by steamboat from the city. The South Side Railroad came to Rockaway in July 1869. The line extended from Valley Stream to Far Rockaway, where a terminal was built on land donated by Benjamin B. Mott. The Long Island Railroad built its own branch from Hillside, just east of Jamaica, to Cedarhurst and beyond, opening service to Rockaway on May 14, 1872. The Long Island management wanted to extend their line to the water's edge, but Judge Clark used his considerable influence to keep the tourists away from his stately summer home. Instead, the tracks were laid closer to the Jamaica Bay side of the peninsula, terminating at Benjamin C. Lockwood's picnic grove at Brookhaven Avenue and B.21 and B.22 Streets. After 1876 both railroads used the Mott Avenue station.

The coming of the trains finally put an end to the arduous journey from Jamaica in a four-horse stagecoach jolting along the ten miles of unpaved Rockaway Turnpike, a road that was subject to flooding at high tide. Now the trip from Long Island City (after a short ferry ride across the East River) took about an hour. Its relative speed (about five minutes longer than today's time) served to put an end to the isolation of Far Rockaway, and the subsequent real estate boom and increase in summer visitors permanently altered the rural character of the village.

Wave Crest, a development in the western section of Far Rockaway, was built on land assembled in 1878 from the now-defunct Marine Pavilion as well as part of Judge Clark's private estate. No less than eighty acres were set aside for expensive homes, the construction of which began in 1880. Set in a residential park with lodges, a gated entrance, and a rustic fence, the community offered plots of a quarter-acre and more. Soon two dozen houses had been built to reflect the wealth and status of the residents. A fine turf lawn covered the bluffs and slopes of the original terrain,

watered by thirty-feet-deep wells. All the streets curved irregularly, creating a pleasant rural ambiance as well as discouraging through traffic. A single fine hotel in the development had a short life, burning down in February 1889.

The next district to be developed in Far Rockaway was Bayswater. Facing Jamaica Bay—more specifically, basins named for Norton and Mott—it was the creation of William Trist Bailey, who purchased the half-upland, half-swamp tract from the Cornell family in 1878. Bailey first laid out Mott and Bayswater Avenues as the main thoroughfares and then added side streets gradually as new owners bought homes. Not quite as ritzy as Wave Crest, Bayswater was nonetheless home to many fine mansions on the bayfront, in addition to a hotel of brick construction, somewhat of a rarity in the area. To enhance the status of his development, Bailey founded the Bayswater Yacht Club in 1889 and soon began sponsoring regattas. In 1891 additional land just south of Bayswater was acquired from Richard Mott in order to erect a clubhouse; members, now numbering 100, were asked to subscribe a total of $5,000. This was one of the heydays of aristocratic pretensions, including the mounting of the first hunt with hounds in Bayswater.

The success of real estate investments in Far Rockaway led developers to build in other parts of the community. Ocean Crest, the creation of the Norton family, was built slightly west of Wave Crest, on the site of a large timber tract facing the bay. Beginning in the early 1880s modest summer homes were built along newly laid-out streets. The section remained only lightly settled until well after 1900, however, as was the case with two new developments in the eastern part of Far Rockaway, Cedar Lawn and Cedar Hill. Samuel Althause, Jr., started the former in 1888-89, and Cassius Reed and Ed Stokes developed the latter around the same time.

Construction of all types in Far Rockaway continued apace until around 1910, when most of the desirable land within easy reach of public transportation had been built up. This period also saw the appearance of one public convenience after another, contributing to the community's quality of life. As early as 1886 the Far Rockaway Village Railroad began operating horse cars during summers from the Mott Avenue terminal to the beach at the foot of B.19th Street. In 1898 an electric trolley line began running between the terminal and Rockaway Park. The year before, in June 1897, a trolley line along Rockaway Turnpike from Jamaica had opened, with regular service to a terminal at Mott and Redfern Avenues.

Despite its increasingly residential character, Far Rockaway had many seafront enterprises catering to the summer visitor. The largest of these resorts was Ostend Beach, at B.13th-14th Streets. Built in 1908 and named for the famous resort in Belgium, it held a hotel, a casino, and a multitude of bathhouses. The big hotel was destroyed by fire in 1941, but the bathhouses continued in operation for a short time afterward, as did their main competitor, Roche's.

Other turn-of-the-century improvements revealed the growth of a year-round community. In July 1890 Rockaway got its first bank, as the Far Rockaway Bank opened at the corner of B.20th Street and Cornaga Avenue. The First National Bank came to town eighteen years later. There had been an old-fashioned one-room school in Rockaway as far back as 1861, but not until the 1890s did educational facilities begin a period of rapid growth. A high school began operating with twenty students in 1897 on the site of what later became P.S. 39. The present-day Far Rockaway High School, located in Wavecrest and built in 1929, provided a sound education as well as being a unifying force for the entire peninsula. The U.S. Post Office finally authorized free home delivery of mail in Rockaway on August 5, 1901. Four letter carriers were on the permanent staff, with an extra deliverer added for summers. Telephone service came the same year, when the Leek Building opened at Cornaga Avenue and B.20th Street; at the time there were 120 Bell subscribers in the village. Nearby, a public library was erected at the corner of B.20th Street and Mott Avenue in 1904, donated by Andrew Carnegie. The library is still on the same site, in a new building.

The Long Island Railroad electrified its Rockaway line in 1905, first for trains coming to the peninsula, then for local service as well. Tourists made their summertime jaunts in increasing numbers, but many year-round residents came as well. The year 1914 saw a record total of 429 houses built in Far Rockaway, mostly on plots of modest size. World War I put a hold on most development, but construction resumed its active pace in the 1920s. The focus had shifted to multiple dwellings, however, as city-style apartment buildings came into favor. The first large house of this kind was the five-story Crossways, with fifty-five apartments at the corner of Mott Avenue and Greenpoint Road. Within a year four other buildings opened: the Gold Central, the Morris, the Roanoke, and the Ocean Country. More and more of the stately mansions disappeared as the village became increasingly urbanized.

By the 1930s, when the population was about 15,000, there were twenty-five apartment houses as well as some 370 stores in Far Rockaway. Central Avenue continued its growth as the town hub, with most residents shopping there regularly. Just after the war, in 1919, the Strand Theatre had opened on the Avenue with a progam that offered both silent films and vaudeville. The theatre was on the main New York City circuit, and Al Jolson and other famous performers of the day played the house.

Starting as early as the 1870s local newspapers began to be published in Rockaway. The first two, *Rockaway News* and *Rockaway Rambler,* lasted only a short time. The *Rockaway Rattler,* soon renamed the *Rockaway Journal,* lasted almost twenty years, part of that time owned by the developer Remington Vernam. The name was picked up for a subsequent newspaper, which continued publishing until the 1990s. The *Argus* was in circulation from 1914 until 1942, the year before the *Rockaway News* ceased publication. The most durable local newspaper, *The Wave,* is still in print over 100 years after its founding in 1893. It has established itself as a Rockaway institution.

The years after World War II were not kind to large parts of Far Rockaway. Although the famous board-walk was extended eleven blocks east from B.20th Street, the day-trippers and vacationists turned their attention to farther shores. Business migrated else-where as well. The sites of Ostend Beach and Roche's, derelict for many years, were converted to a green oasis by the sea, O'Donoghue's Park. The rest of Far Rockaway's beachfront area is characterized by high-rise apartment complexes and nursing homes. In Bayswater and some other developments, well-maintained homes still line the suburban-type streets. Nearby, the center of town has become an urban hodgepodge of abandoned buildings, closeout stores, vacant lots, and an occasional new or renovated building that holds out some hope for the future.

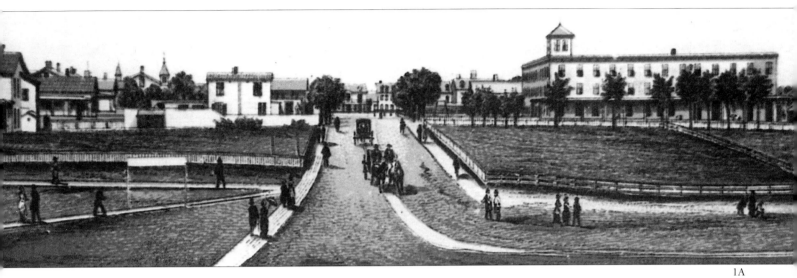

1A

～ **1A & B.** Earliest known street views of Far Rockway, from an Albertype album of 1880. Looking east *(1A)* from Seagirt Avenue (B.19th Street), sizable boarding houses and hotels like the United States Hotel (at right) have already begun to fill the open land. Looking inland *(1B)* toward Wave Crest, strollers gained access to the shore by way of the small bridge from B.20th Street. *(Queens Borough Public Library)*

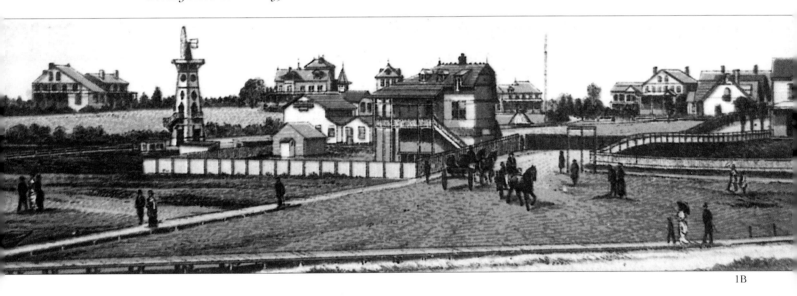

1B

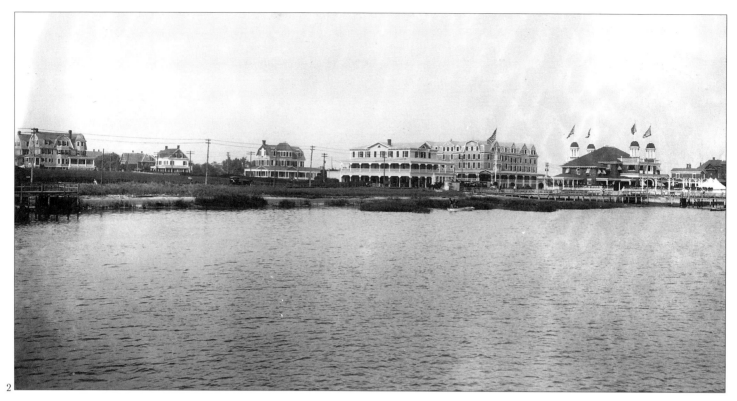

2

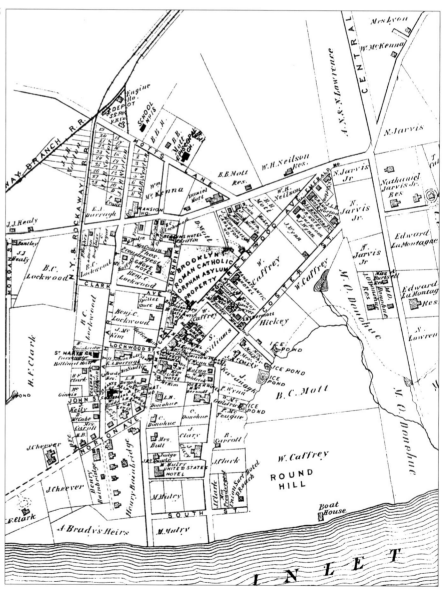

3

❧ **2.** Several large hotels dominated the bayfront at B.19th Street in 1904. At the right, with its four flags flying, is the Kuloff Hotel. Behind the Kuloff is the Tack-a-pou-sha House, and to the left, close to the water, is the Dolphin Road House. The Tack-a-pou-sha was named for the Indian chief who signed his mark to the 1685 deed that ceded the Rockaway peninsula to the English. *(Detroit Publishing Co.)*

❧ **3.** Detail from one of the earliest maps of Far Rockaway, from *Beer's Atlas of Long Island* (1873). The full map is reproduced on page vi.

❧ **4.** Walking over the narrow inlet to Hog Island in 1904. The trolley car in the background ran from the railroad station along B.19th Street all the way to the footbridge. At left is the M. H. Beers mansion and the Ocean View Hotel. The United States Hotel is behind the bowling alleys. *(Library of Congress)*

❧ **5.** Family picnic on the beach at Rockaway early in the 20th century. Three of the ladies are in proper bathing attire, the fourth is keeping cool in white lace under the umbrella. The boy is permitted slightly more exposure to the sun. *(Queens Borough Public Library)*

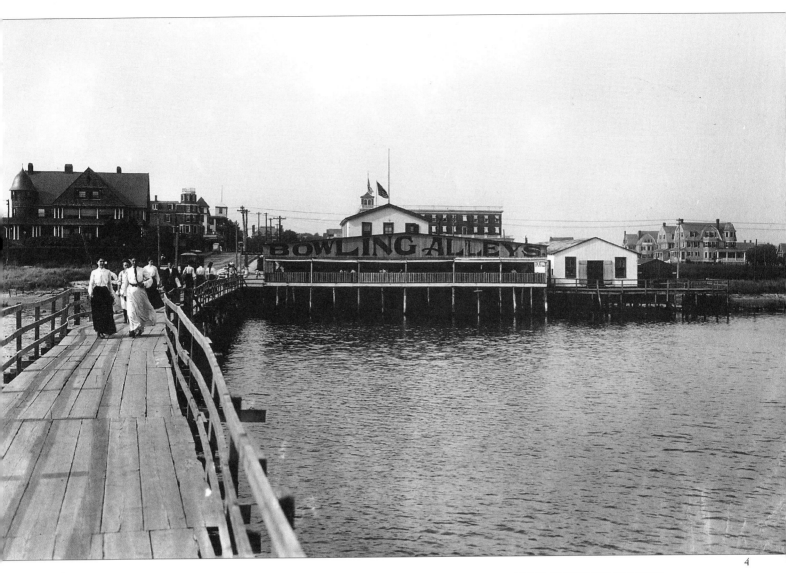

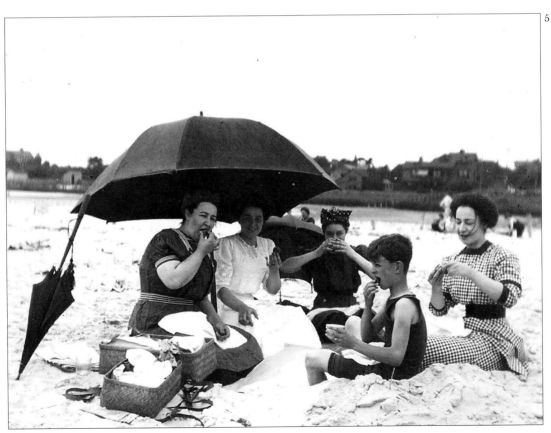

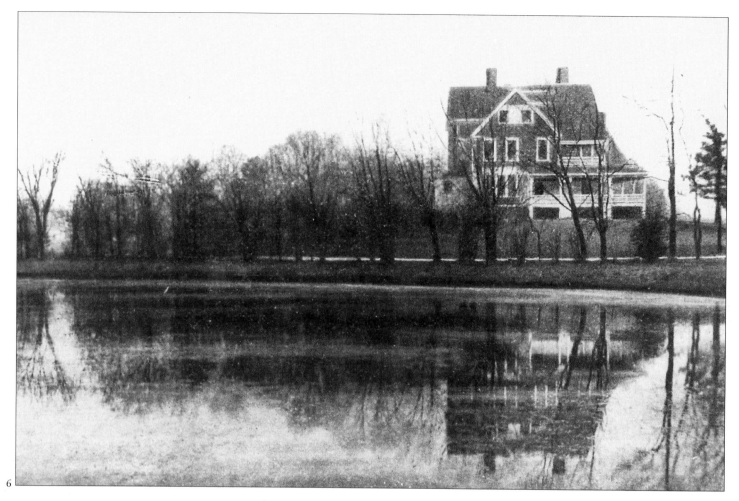

6

6. In many areas of Long Island lakes and ponds were formed in depressions scoured out of the outwash plain that forms so much of the local topography. Wave Crest Lake, near the ocean, made an attractive setting for the houses on its shores until it was filled in by developers.

7. The Richard Cornell family cemetery was opened in 1693 and was last used in 1820, with twenty-nine graves known. The property was neglected for many years but is now a New York City landmark and is being restored. On the south side of Greenport Avenue, opposite Everdale Avenue, the old burial ground measures 70 by 75 feet. (*Photo by Stanley Cogan*)

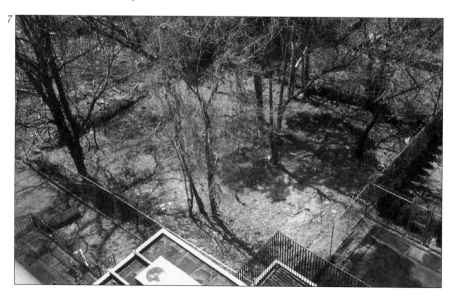

7

8. The famous Marine Pavilion was the first major resort hotel in Rockaway. Built in 1833, the three-story Greek Revival building was on the west side of B.20th Street, south of Plainview Avenue, and had a 250-foot-long oceanfront piazza. With two wings, the Marine had 160 rooms. New York society made the resort one of the most fashionable in the U. S., and prominent men such as Henry Wadsworth Longfellow, Washington Irving, and Gen. Winfield Scott (hero of the Mexican War) were among the Marine Pavilion's guests. In 1854 the hotel's front was extended to 450 feet; ten years later the wooden building was destroyed by fire. (*Thompson*)

9. The only building to survive the Marine Pavilion fire was the hotel kitchen. After it became a private residence, the owner added Victorian gingerbread to the exterior, along with a peaked roof with ornate dormers. The original board and batten construction of the building, on the west side of B.20th Street 200 feet north of South Street, survived on the first floor. (*Armbruster*)

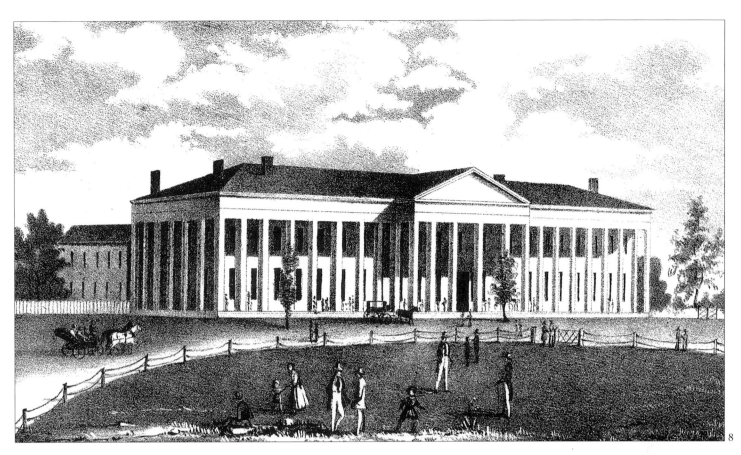

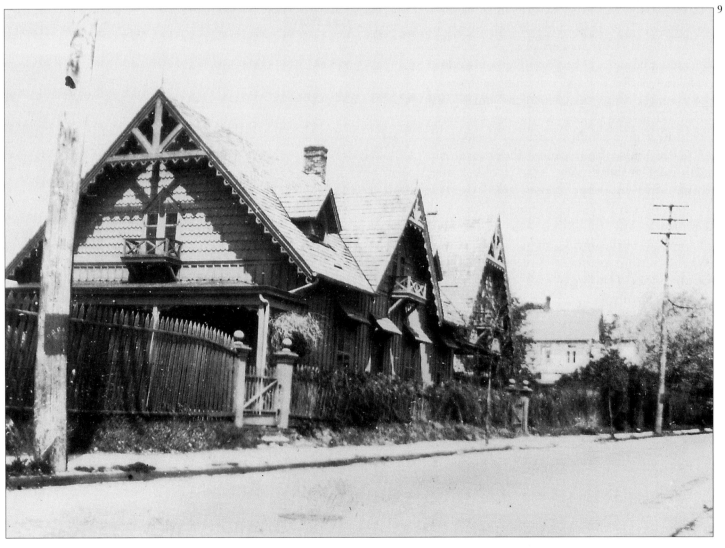

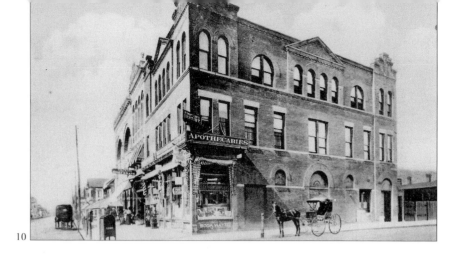

10

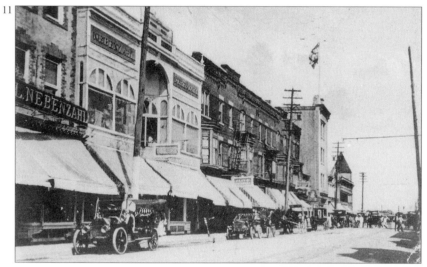

11

10-13. Central Avenue, probably the oldest street in the Rockaways, has also been the busiest ever since the Marine Pavilion became a fashionable watering place. Originally called Catharine Street, after an early resident, the street was renamed Central Avenue in July 1889, then B.20th Street in 1916, following the numerical system devised by city planners. The boardinghouses and small hotels that lined its sidewalks in the mid-19th century soon gave way to stores and other businesses. Many of the old buildings are still standing today. Three of these postcard views date from around the turn of the century. The fourth view *(13),* looking west from Mott Avenue, shows that Central Avenue was still the main shopping street of Far Rockaway in 1940. Two well-known chainstores of the day, Cushman's Bakery and Whelan Drugs, anchored corners on the busy intersection. *(Postcards from the Vincent F. Seyfried Collection)*

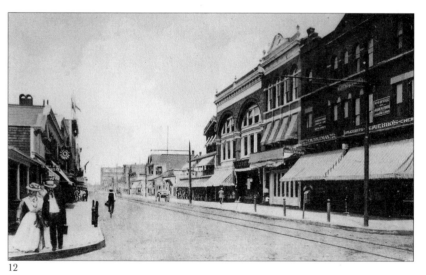

12

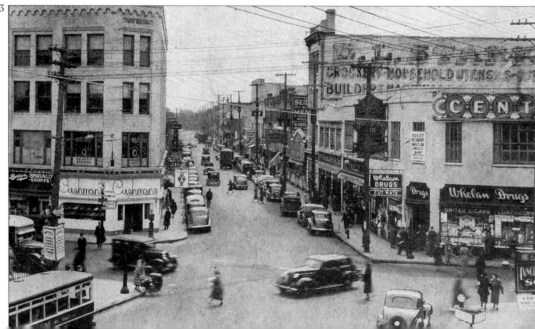

13

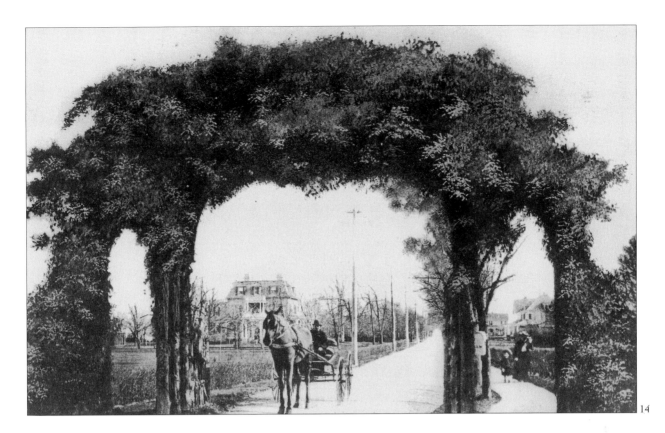

14

14. The famous arch over Jarvis Lane (B.9th Street), created by training cedar trees into an overhead arbor. *(Postcard from the Vincent F. Seyfried Collection)*

15. The oldest known photograph of Far Rockaway. Engine #17 of the South Side Railroad of Long Island looks like something out of a Hollywood Western as it sits in the Far Rockaway station. The signs announce "Southern R.R. ticket office for Brooklyn and New York" and "Western Union Telegraph Office." *(Ron Ziel)*

15

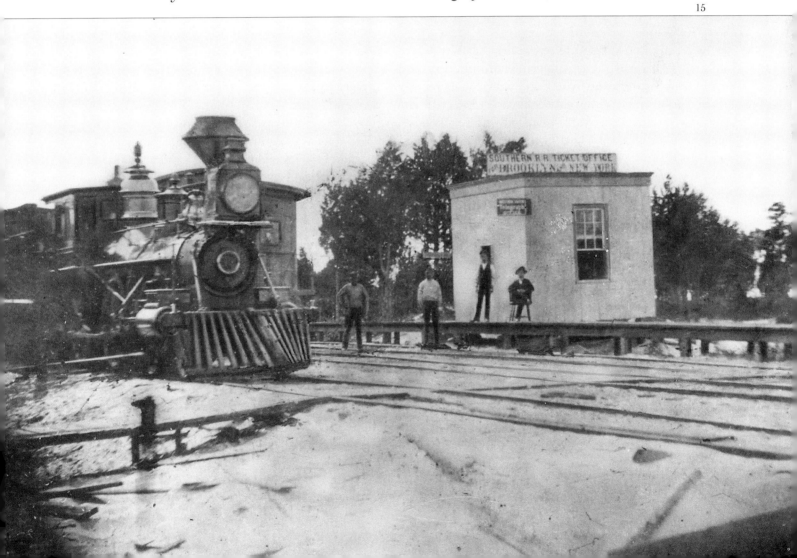

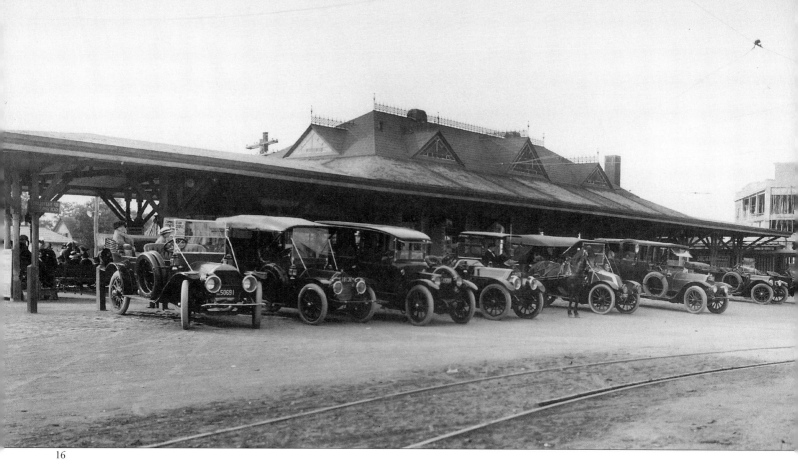

16

16. On this Decoration (Memorial) Day weekend in 1914, the Far Rockaway station of the Long Island Railroad attracted a stunning collection of vehicles, including a horse-and-carriage (center). The sign barely visible at the left directs travelers to the "trolley car for Rockaway Beach," seen at the right side of the photo. *(Presbrey Photo)*

17. Only known picture of the original Bayswater Hotel, which was on a large plot of land at Mott and Westbourne Avenues and Waterloo Place. The hotel was built in 1880 by William Trist Bailey, developer of the Bayswater community, but failed to attract enough guests to make a profit. The structure was finally torn down in 1907 and replaced by the smaller Elstone Park Hotel. *(Queens Borough Public Library)*

18. Wave Crest was an exclusive community estab-lished for wealthy New Yorkers in the 19th century. The first houses were built in 1880 on land from the former Clark Estate and the Marine Pavilion. The serpentine roads west of B.20th Street and south of New Haven Avenue still reflect the ample estates of the original own-ers. *(Postcard from the Vincent F. Seyfried Collection)*

19. Far Rockaway was home to some of the most interesting domestic architecture on Long Island. The 1770 farmhouse at the corner of Mott Avenue and Eggert Place was the oldest building on the Rockaway peninsula until its demolition sometime after 1923, when this photograph was taken. Built by John Mott, it was known as the Aunt Sally Mott Homestead for many years before its occupancy by a Mrs. Seaman. Note, at the left side of the photo, how successive generations enlarged the house. *(Armbruster)*

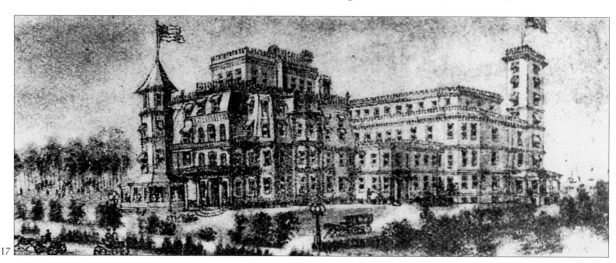

17

18

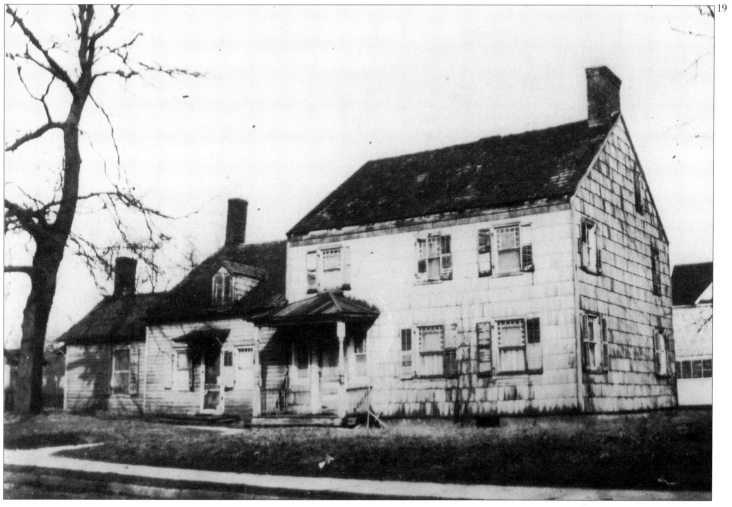
19

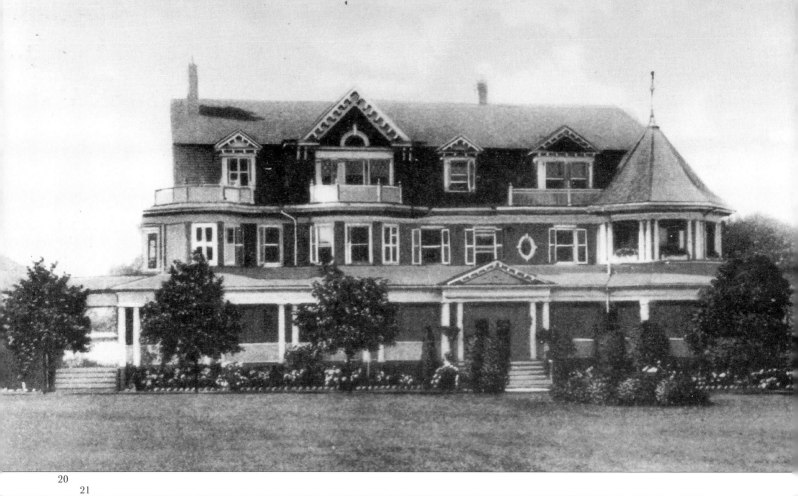

20

21

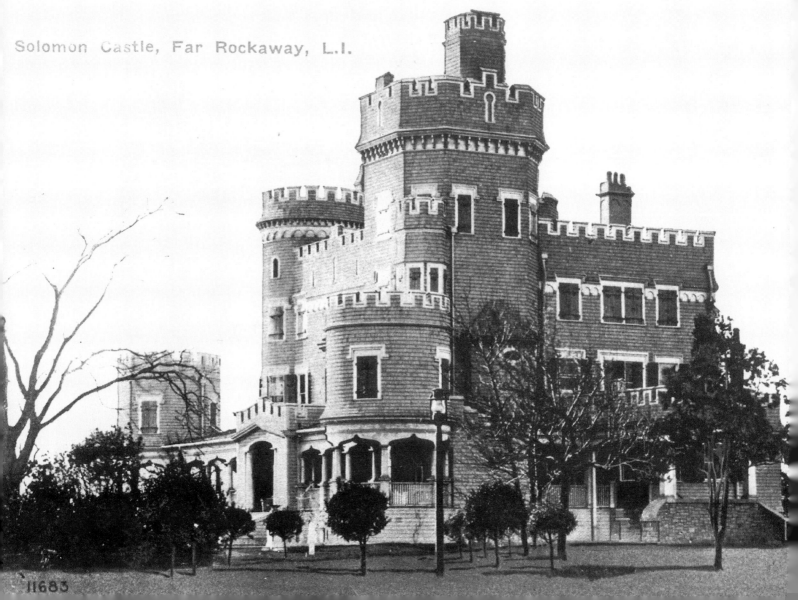

Solomon Castle, Far Rockaway, L.I.

11683

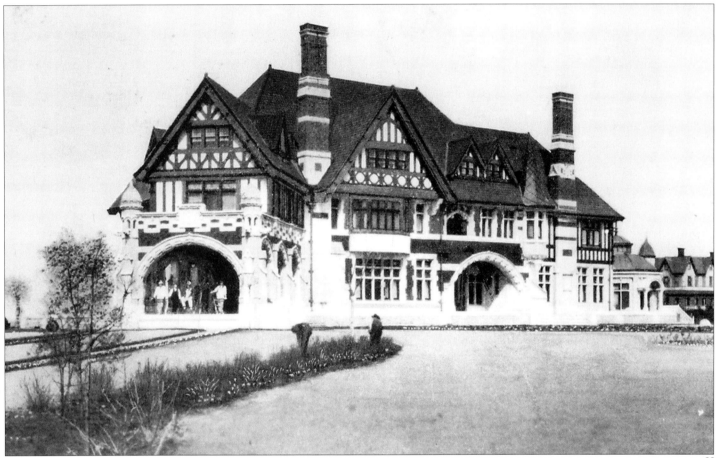

∾ **20.** The Mott House would have fit into one corner of "Broad Lawn," one of the fine summer "cottages" built in Bayswater and Wave Crest around the turn of the century. The many windows and turrets and the open porches offered cross ventilation and cool sea breezes in those days before air conditioning.

∾ **21.** Facing Jamaica Bay, between Bessemund and Gansevoort Avenues, was a wooden castle built for Louis H. Solomon, prominent chemist and inventor. The site was owned by John Cornaga in the 18th century, when it was the largest of the Indian shell banks. With its twin towers and eccentric roof embellished with crenellations, merlons, and embrasures, the Solomon redoubt was a tourist attraction in its own right. The wooden structure burned to the ground in 1921. *(Postcard from the Vincent F. Seyfried Collection)*

∾ **22.** A marble and granite mansion worthy of Newport was built on Breezy Point, overlooking Jamaica Bay, in 1908 for New York banker Louis A. Heinsheimer. To build his dream home he tore down an impressive mansion on the site that had been owned by Brooklyn hotel owner Louis Bossert. Heinsheimer's interiors were all finished in heavy woodwork and carvings. After most of New York society had followed the winds of fashion away from Rockaway, the big house was taken over by the Maimonides Institute for Exceptional Children. The building burned down in the 1980s, leaving only the conservatory (seen at the extreme right) still standing. On October 30, 1991, the site was dedicated as Bayswater Point State Park, with the conservatory serving as the park rangers' headquarters. *(Postcard from the Vincent F. Seyfried Collection)*

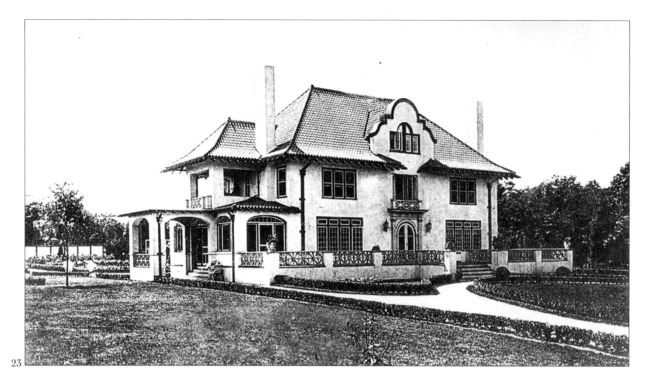

23

23. As late as the 1920s handsome summer homes set in parklike settings were still being built in Far Rockaway. Typical of these summer houses, which often had tile roofs, is the Aaron Levy residence, at the corner of Healey (formerly Bayview) Avenue and B.28th Street. *(Postcard from the Vincent F. Seyfried Collection)*

24. Another of the many striking residences in Far Rockaway was the Japanese Cottage on Jarvis Lane (B.9th Street), seen in this postcard view. Little bells were hung on each side of the upturned roof corners and even the chimney. The porch railing and other architectural features continued the Asian motif. *(Postcard from the Vincent F. Seyfried Collection)*

24

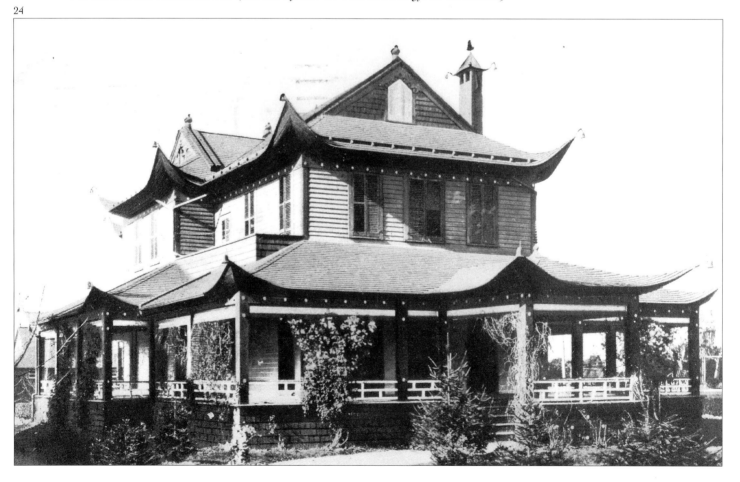

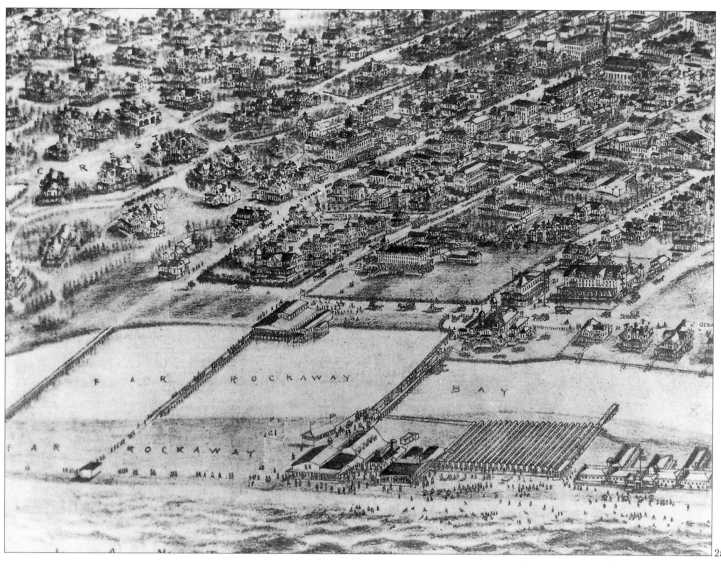

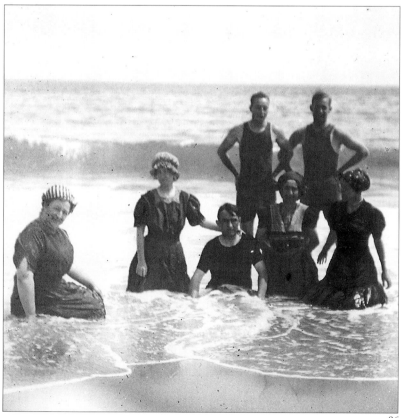

25. What came to be called Hog Island was a good-sized sandbar that rose above the sea off Rockaway in the winter of 1858. It was washed over in April 1870, then recovered enough by 1875 to encourage renewed building of bathhouses and even restaurants and pavilions, as seen in this historic print. (The bridges over "Far Rockaway Bay" are at present-day B.17th, B.19th, and B.20th Streets.) Most of the buildings were washed away in the storms of 1886 and 1889, as the island rose and fell with the elements for many years. By 1905 the sandbar was closer to the shore and seemed to be on a firmer footing, so the builders got busy again. The mini-resort lasted until the tides washed it away in the 1920s. Not even a shoal remains today. (*Queens Borough Public Library*)

26. Family bathing on Hog Island around the turn of the century. The ladies' bathing attire closely resembled dresses, and kerchiefs and bonnets kept their hair in place. The men's suits were skirted to avoid any tell-tale outlines. (*Queens Borough Public Library*)

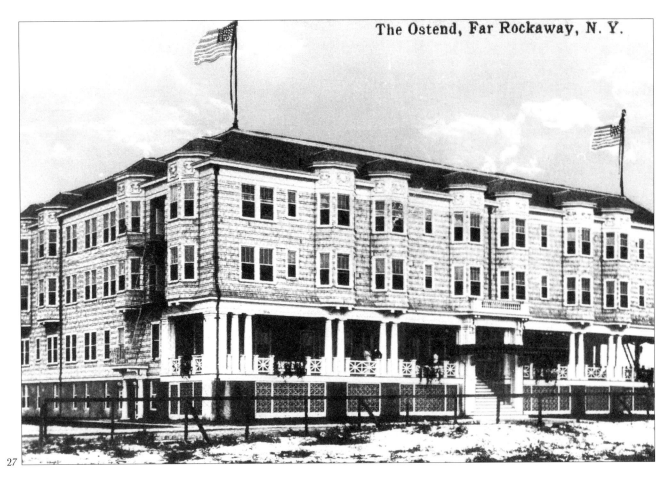

27

27. The Ostend Hotel and Casino was built on part of the old Caffrey estate at the foot of B.14th Street, beginning in 1908. By the 1920s, with 2,000 wooden bathhouses it was the largest bathing pavilion in Far Rockaway. The Ostend was destroyed by fire on April 8, 1941. *(Postcard from the Vincent F. Seyfried Collection)*

28. It was the custom before World War I for people to put on their holiday finery, including shoes and stockings, for an outing to the beach—even on days when the wind was not blowing the flags straight out, as in this photo. Kaiser's Restaurant, specializing in multicourse shore dinners, was a concession in the Ostend complex. *(Postcard from the Vincent F. Seyfried Collection)*

28

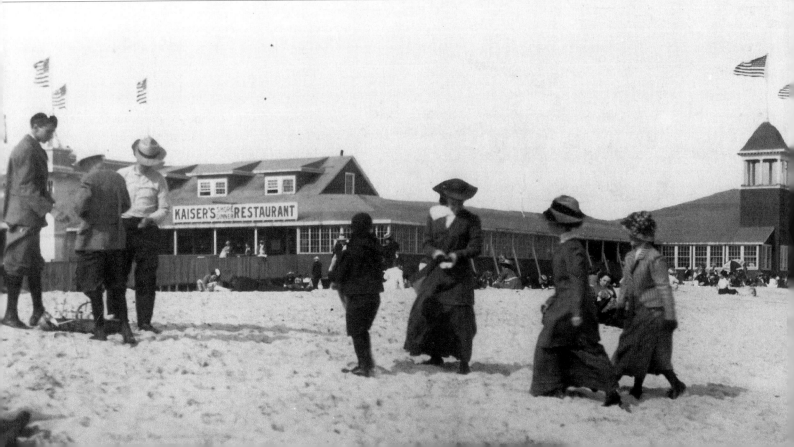

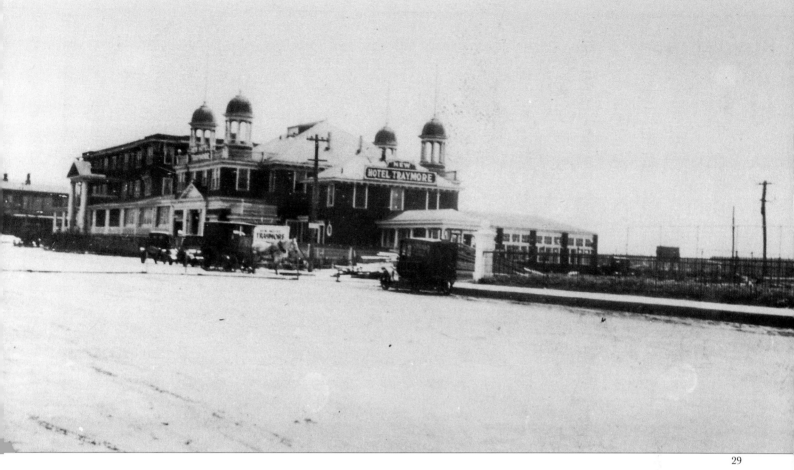

29

🌊 **29.** An important hotel not far from the Ostend was the Kuloff, built at B.17th Street by James Caffrey about 1898. The two-and-one-half-story building with four cupolas was a beachfront landmark for many years. In 1919 the hotel was renamed Chateau-Thierry in honor of the World War I battle, but the signs were changed to Traymore in the 1920s. The hotel was eventually demolished. *(Postcard from the Vincent F. Seyfried Collection)*

🌊 **30.** A rare back-door photograph of the kitchen staff at the Kuloff and Tack-a-pou-sha hotels around 1905. Then, as now, most of the work in the back of the house was done by recent immigrants. *(Queens Borough Public Library)*

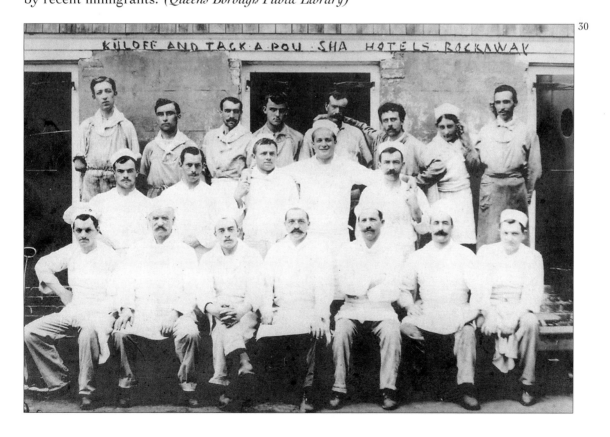

30

FAR ROCKAWAY 🌊 19

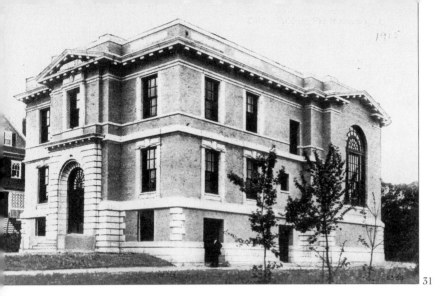

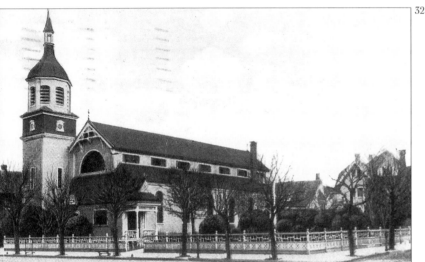

STAR OF THE SEA LYCEUM, FAR ROCKAWAY, L. I.

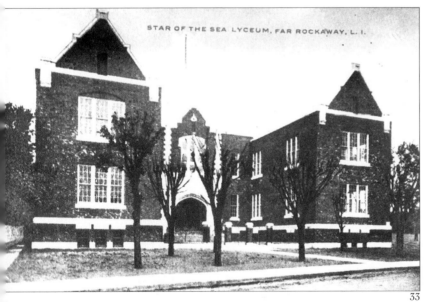

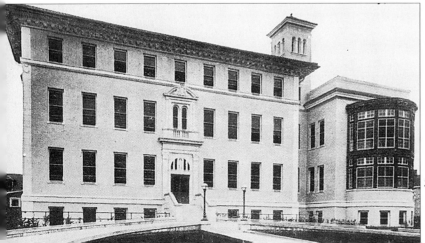

〜 **31.** One of the Atlantic cables made landfall in the Rockaways. To process telegrams to and from Europe, in 1912 the Mackay-Bennett Cable Company built a large, impressive station on B.17th Street just in front of the old Cornell Cemetery. The cable business fell off in the 1930s, and the building was converted for use as a yeshiva. In 1985, as the Jewish population of Far Rockaway declined, the building was torn down. The land, still vacant, is slated to become a parklike access to the landmark burying ground. *(Robert Stonehill)*

〜 **32.** The Roman Catholic Church of St. Mary Star of the Sea began as a mission and moved into a small wooden church in 1851. Thirty-four years later, on August 16, 1885, this impressive building, seating over 600, was dedicated. The church buildings, on a large plot at B.20th Street and New Haven Avenue, included a parish house and rectory. The complex was destroyed by fire on August 16, 1974. (C.H.)

〜 **33.** As the year-round population of Far Rockaway increased, a parochial school for St. Mary's parish was opened in the Lyceum, a brick and terra-cotta-trimmed building that was opened in 1909. In addition to the school the Lyceum was home to a public auditorium seating 900. *(Postcard from the Vincent F. Seyfried Collection)*

〜 **34.** The Catholic Church was also active in providing health care for the Far Rockaway community. St. Joseph's Hospital was opened around 1901 in a cottage on B.20th Street. The large hospital shown here was opened December 15, 1912, next to the old building. The hospital was virtually two units, one for men and the other for women, and had large solariums where patients, especially those suffering from tuberculosis, could take advantage of the fresh sea air. *(Postcard from the Vincent F. Seyfried Collection)*

> **35A & B.** One of the noted Protestant churches in the Rockaways was the First Presbyterian Church *(35A)*, organized in January 1888. (The old building, much altered, still stands at Central and Neilson Avenues.) The railroad tycoon and philanthropist Russell Sage was a summer worshipper there, and after his death Mrs. Sage decided to build a community church in his memory. She engaged the noted firm of Cram, Goodhue & Ferguson, architects who later designed St. Thomas Episcopal and other churches in Manhattan, to build the Sage Memorial Church. The site was a large plot on Central Avenue between B.12th Street and Sage Place. The most striking features of the Gothic Revival church are twelve stained glass windows, especially the large window at the south end of the nave *(35B)*. Designed by Louis Comfort Tiffany in a purely American style, at 25 by 21 feet "The Tree of Life" is the largest Tiffany landscape in existence. Sage Memorial Church was placed on the National Register of Historic Places in 1986.

35A
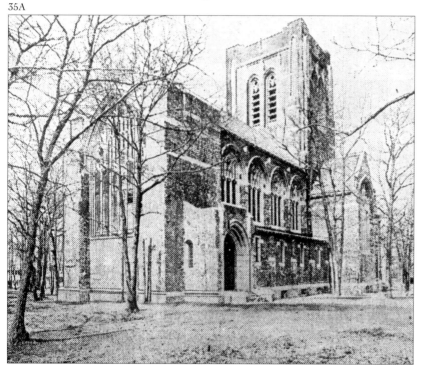

35B
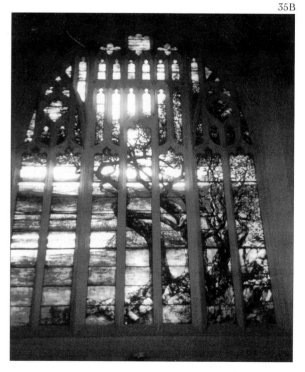

36
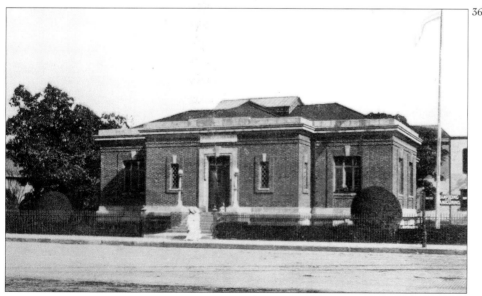

> **36.** Rockaway also benefited from the philanthropy of another multimillionaire, Andrew Carnegie. Of the five public libraries he built and equipped in Queens County, one was in Far Rockaway. The brick structure was built in 1904 on land donated by Benjamin Mott at the corner of B.20th Street and Mott Avenue. A federally funded addition to the library was opened in 1936. A new library building now occupies the site.

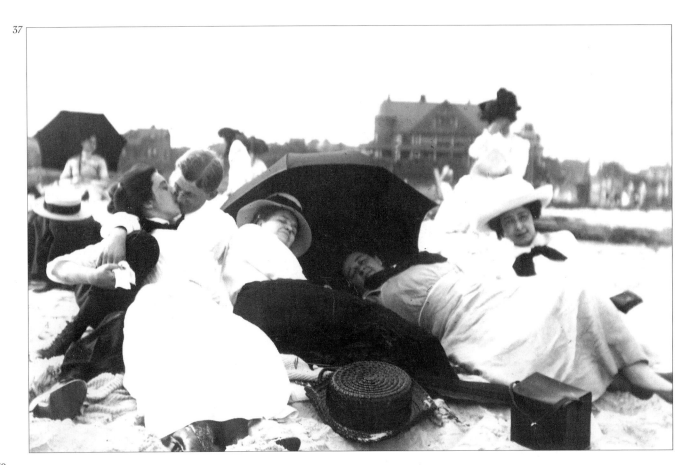

37

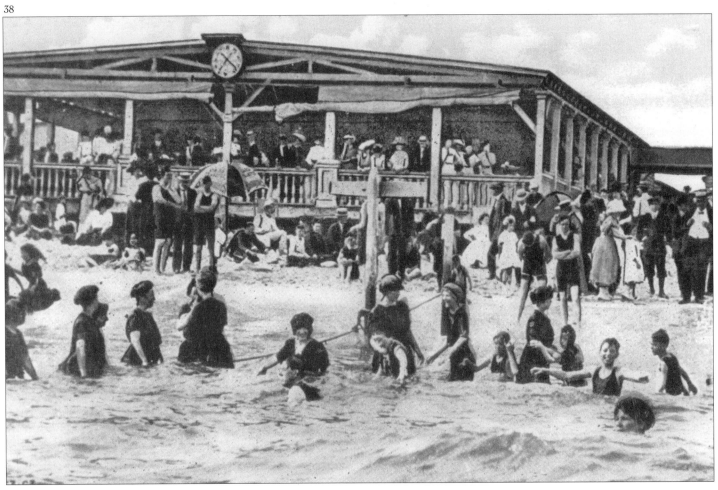

38

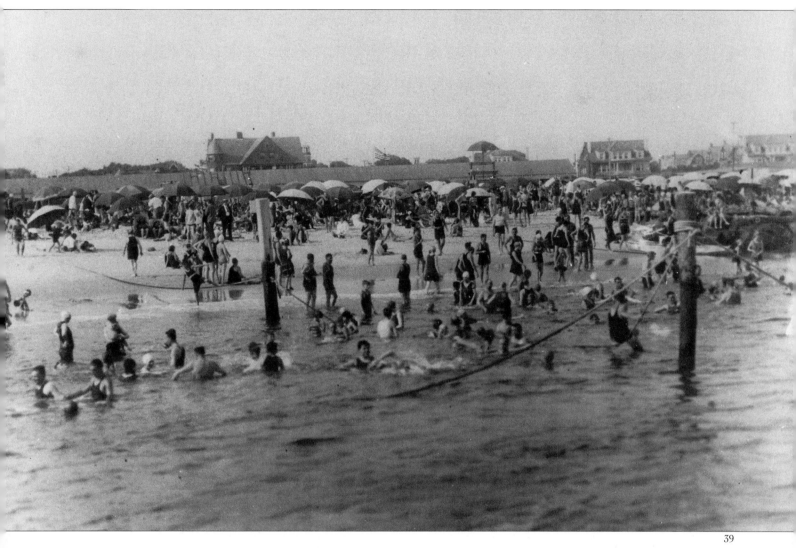

↝ **37.** Rare informal view of a beach party around 1908. Bathing in the surf was not on the agenda as these city-dwellers enjoyed the day on Hog Island, opposite B.19th Street. In the background is the M. H. Beers mansion, subsequently known as the Wheeler Cottage. *(Queens Borough Public Library)*

↝ **38.** Roche's Pavilion, as seen in this 1915 photo, was built close to the waterline. The establishment was at the foot of B.19th Street and drew many of its patrons from the trolley cars that ran from the railroad station directly into the back end of the pavilion. The building held refreshment bars and souvenir stands in addition to one of the largest bathhouses in Far Rockaway. In the days when few Americans could swim, clinging to the ropes was a safe way to cool off in the ocean waters. *(Postcard from the Vincent F. Seyfried Collection)*

↝ **39.** World War I and its aftermath brought great changes to American life. This photo of Roche's Beach, taken around 1925, shows how the more informal style of the 1920s influenced the bathing attire and customs of New Yorkers. Bare legs, bare heads, and even a few male bare backs are in evidence. The waterside pavilion has been washed away, leaving a much wider strand for sunbathing and other beach activities. Even a lifeguard tower can be observed above the sea of beach umbrellas. *(Postcard from the Vincent F. Seyfried Collection)*

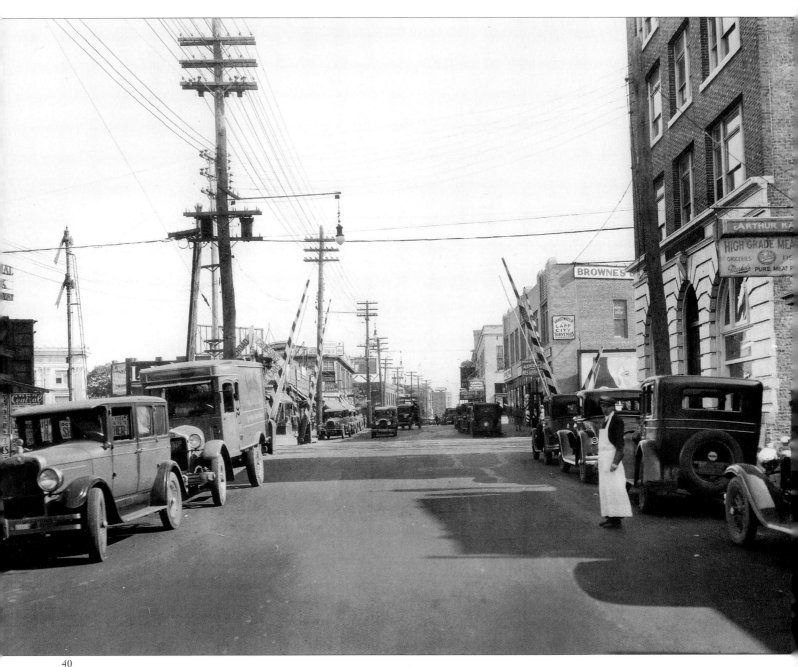

40

∿ **40.** The beach was less than ten blocks away from the intersection of Mott Avenue with the Long Island Railroad crossing. This photo was taken on October 7, 1930, and shows the year-round business district of Far Rockaway still active even though most vacationers have gone back home. Soon the stock market's 1929 Crash would begin to have its depressing effects on Rockaway and throughout the U.S. *(Queens Borough Public Library)*

∿ **41.** Not far from the railroad station was the famed Strand Theatre, on the east side of Central Avenue south of Cornaga Avenue, shown here during its grand opening in 1919. Silent films and vaudeville were the featured attractions. Far Rockaway was on the prime Keith Albee circuit, especially in the summer, and star performers such as Al Jolson and Sophie Tucker appeared on the Strand's stage. *(Emil Lucev)*

∿ **42.** Far Rockaway High School was opened in 1929 on B.25th Street, Wavecrest, in 1929. By that time the year-round population of the Rockaways had grown large enough to support a large, centralized institution. Far Rockaway was an outstanding city high school, the only one in the Rockaways until 1971. Among its graduates is the American genius Richard Feynman, a Nobel laureate in physics.

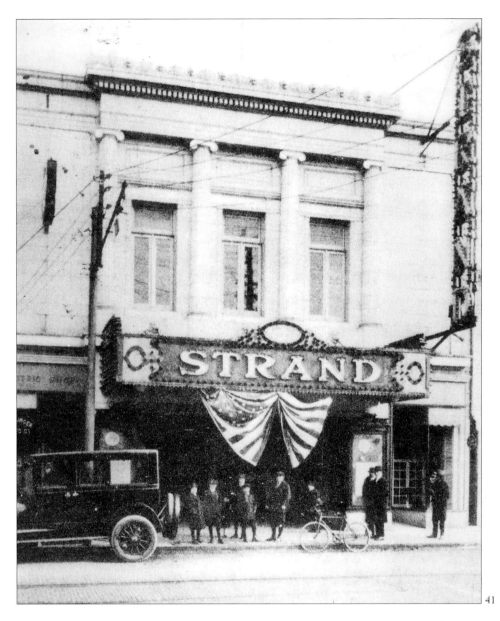

41

42

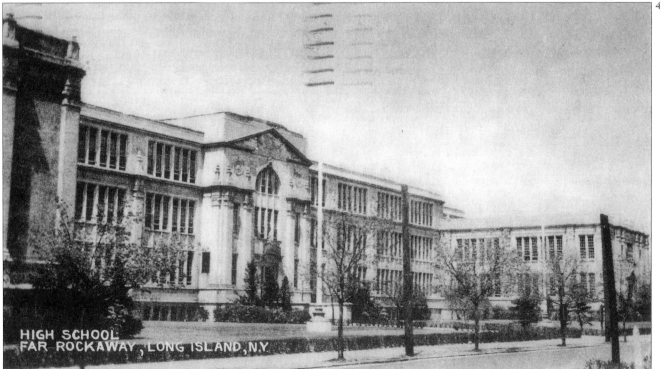

HIGH SCHOOL
FAR ROCKAWAY, LONG ISLAND, N.Y.

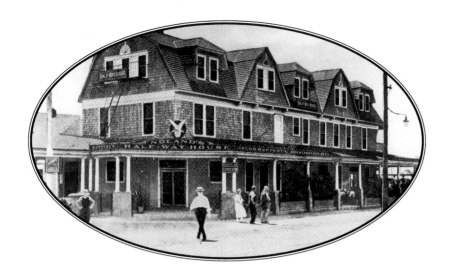

Edgemere

In 1890 Edgemere did not exist. The area immediately west of what is today B.32nd Street consisted of sand and sparse vegetation, with an artificial waterway called Norton's Creek running down the middle, connecting Jamaica Bay with the ocean. This canal went through a neck of land that had been known as Hog Island before its disappearance under the shifting tides. The existence of this once-thriving resort has been virtually forgotten.

In 1892 the heirs of Samuel L. B. Norton, who held title to all the land in the general vicinity, sold out to a syndicate that included Frederick J. Lancaster of Hempstead and investors connected with the Arverne Hotel. The area had become suitable for development with the opening in 1886 of Rockaway Beach Boulevard, which provided through access up and down the peninsula. The syndicate had fanciful ideas of turning the area into a development called New Venice, complete with canals and gondoliers. This was not the only such scheme in Rockaway. The Vernam family had planned a similar project for Arverne, modeled on the canals in Amsterdam, Holland. Neither of these grandiose plans came to fruition. The Edgemere scheme ended in disaster for some investors when the contractor absconded with a considerable sum of money in 1893. Undaunted, the next year Frederick Lancaster set up the Lancaster Sea Beach Improvement Company for the purpose of building a substantial seaside colony along conventional lines. The name he chose for the development, Edgemere, came to be the permanent one, though many residents derided its pretensions of aristocracy.

As part of his development Lancaster built a large, luxurious beachfront hotel, the Edgemere, which opened in 1895 with accommodations for about 500 guests. Mother Nature failed to cooperate in the venture, however, and the violent storm that struck the coast in 1896 inundated the structure with tons of sand and washed away the outlying bathhouses and the oceanfront boardwalk. The turbulent waters burrowed under the hotel and widened Norton's Creek, threatening to undermine all the buildings in the neighborhood. Fortunately for the investors, the federal government was persuaded to repair the damage to the beach by building two stout bulkheads on either side of the creek and filling the space between them with sand pumped from the sea. The creek was effectively closed, making it possible to rebuild the hotel and continue with development of the land. Further impetus to construction came in 1895, when the Edgemere station of the Long Island Railroad was opened.

The rebuilt Edgemere Hotel was the major summer attraction in the community, along with a few smaller establishments such as the Edgemere Crest Inn, the Holmeshurst Inn, and the Half-Way House. There were fewer hostelries in Edgemere compared with the rest of Rockaway. In fact, there seems to have been a tendency to downplay Edgemere as a summer resort and to promote it as a year-round residential community. In August 1912 some 290 building lots were sold at auction, and the next year 140 were sold, all in the area between B.32nd and B.38th Streets. These lots were restricted to the construction of detached private

homes costing at least $2,500. The owners of the Edgemere Crest Inn owners also liquidated their holdings, including sixty houses and 407 lots.

After World War I many of the other hotels were either disposed of or sold outright, including the great Lancaster establishment and the more modest Shelbourne and Palace. Just before the war most of the tent colonies that had sprung up in the western section of Edgmere, from B.35th Street to the Arverne boundary, had gone out of business. About this time developers filled in land on the bayside to Conch Basin and Norton Basin and laid out streets between B.41st and B.51st Streets. In this area they built small frame houses for year-round use. The 1920s saw the construction of summer bungalows in the area, mostly on the ocean side of the railroad tracks.

Edgemere saw little structural change during the 1930s, but the year-round population grew steadily in number. Old-time residents, summer and winter, still reminisce about the matchless knishes they bought at Jerry's and the silent films that continued to be shown by a boardwalk theater until the late 1940s.

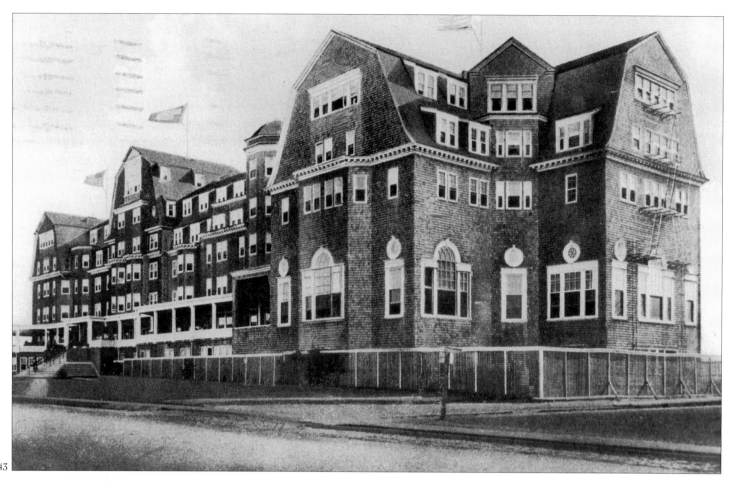

43

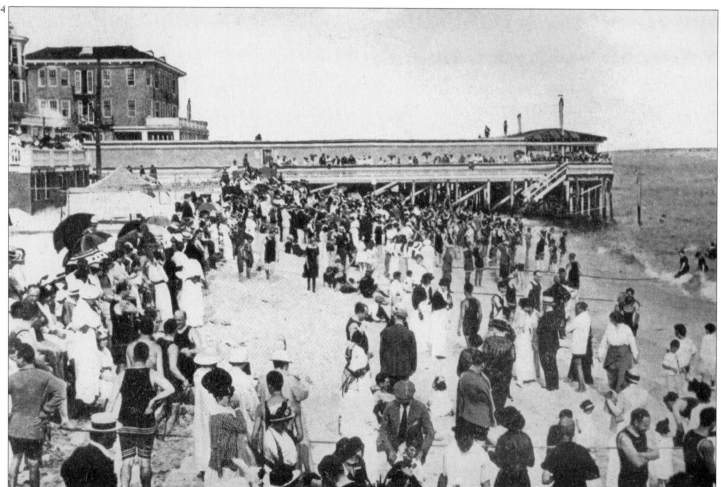

44

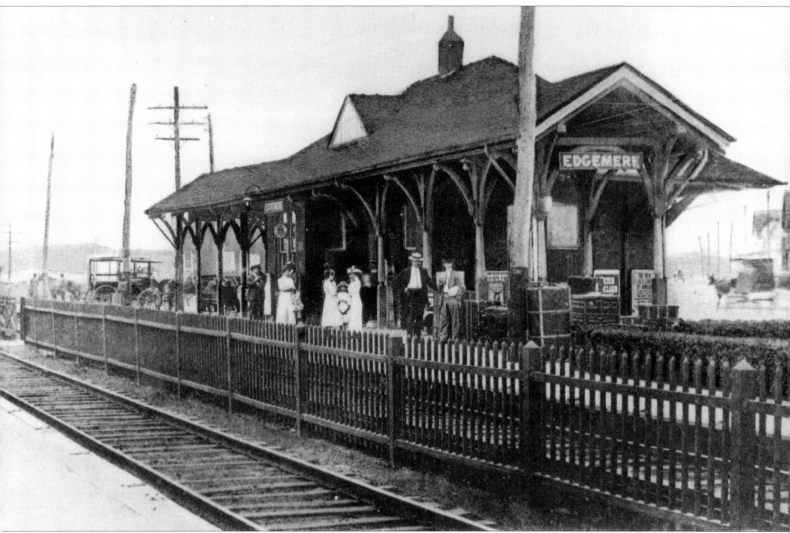

43. The Edgemere Hotel opened in 1895 on the ocean between B.35th and B.36th Streets. This prominent landmark had 182 rooms, sixty with private bath, and electric elevators. In 1906 the hotel changed its name to the Edgemere Club. From 1919 a series of different new owners operated the aging hotel, which was finally demolished in 1935.

44. As Edgemere became more and more popular with New Yorkers, the beach became quite crowded, especially on weekends and holidays. Day-trippers from the city could change into beach attire at one of the many bathhouses in the area. Piers were popular attractions, even if they were washed away by storms every few years.

45. A 1914 view of the railroad stop at Edgemere, between B.35th and B.36th Streets. The station was built around 1895 and was used by both electric trains and trolley cars. The treelike pillars supporting the canopy closely resemble those of the still-existing East Hampton station. *(Robert Stonehill)*

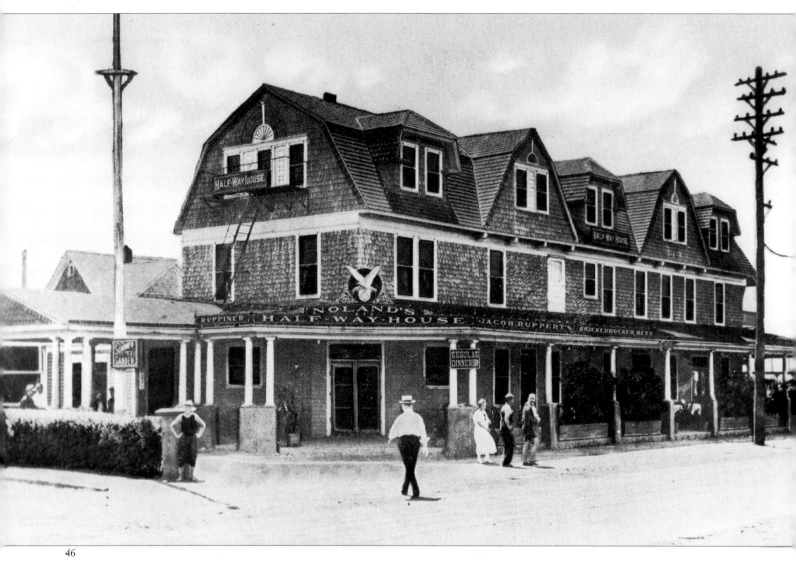

46

✑ **46.** Noland's Half-Way House was built in 1886 at the western end of Edgemere, on Rockaway Beach Boulevard and B.44th Street. Originally it was a good stopping place in the sand dunes between Far Rockaway and Rockaway Beach. Unlike most hostelries on the Rockaway peninsula, the Half-Way House was open all year. Its Summer Garden was a popular meeting-place in season. The Ocean Electric trolley cars stopped at the door, and the Long Island Railroad later established a small station there (Frank Avenue). *(Vincent F. Seyfriend Collection)*

✑ **47, 48.** The Hotel Lorraine *(47)* was built in 1908 on the east side of B.32nd Street at Spray View Avenue, a short block from the oceanfront. An early advertisement promised a telephone in every room, a restaurant with orchestra, and lawn tennis and golf. The hotel was still serving its middle-class clientele when this photo was taken, in 1935. The long verandah, seen in this 1925 view *(48)*, was a breezy, relaxing haven from the summer sun. *(Robert Stonehill)*

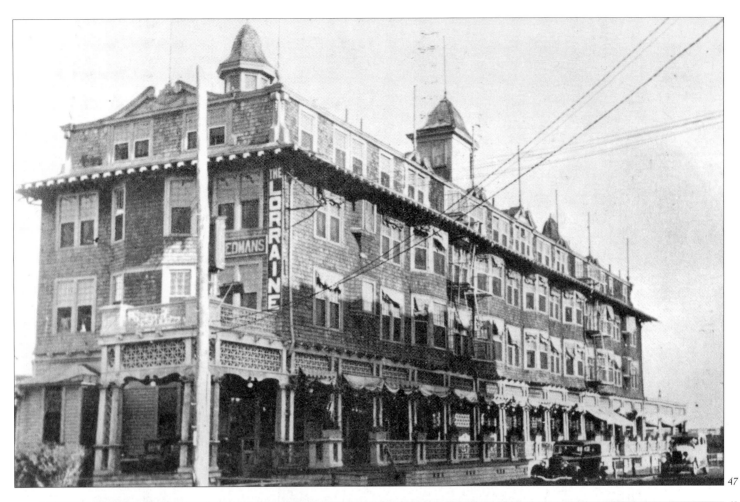

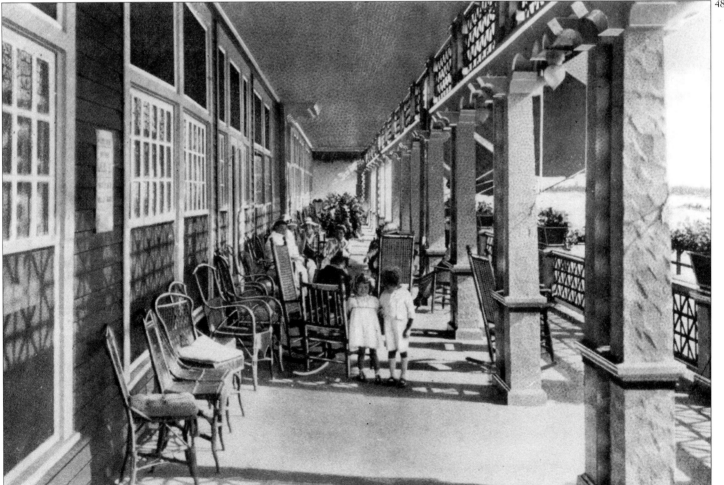

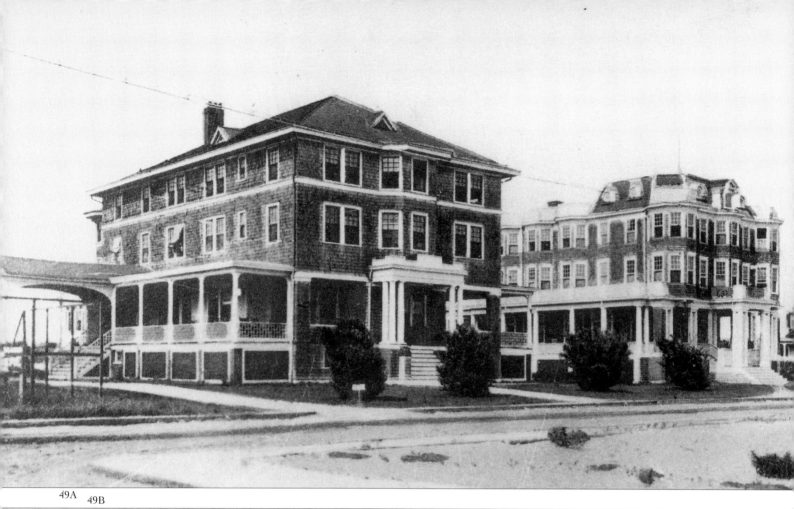

49A 49B

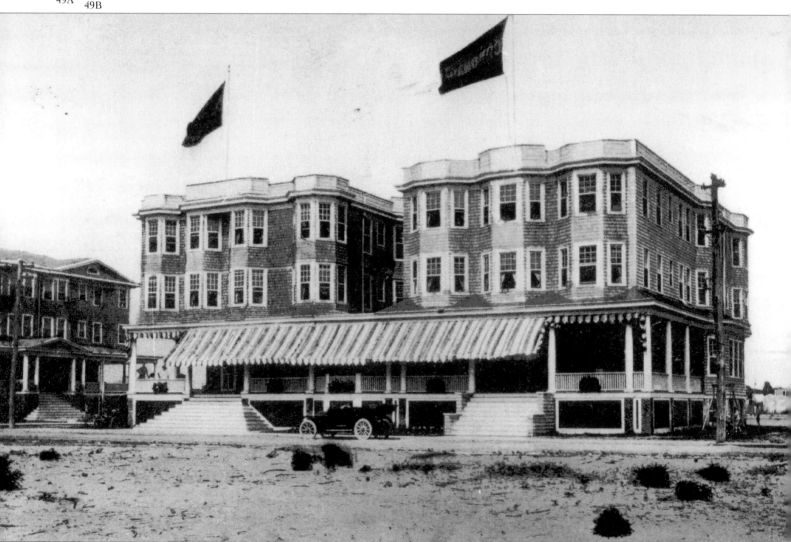

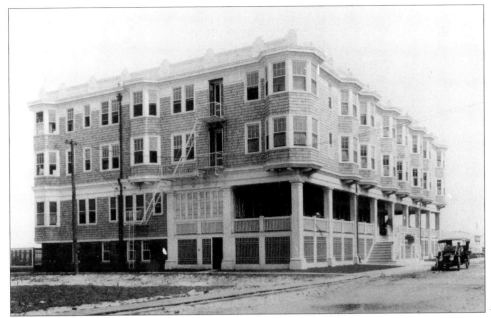

49C

49D

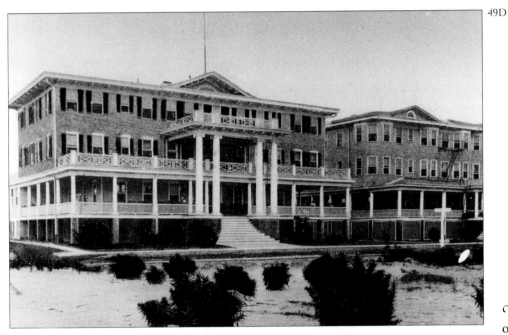

49A-E. During the first half of the 20th century, there were hundreds of hotels and rooming houses near the beach in Edgemere. Among the best-known medium-size establishments were the Belvedere and the Frontenac *(49A)*, the Coronado *(49B)*, the Shelbourne *(49C)*, the Strand and the Breakers *(49D)*, and the New Linderman *(49E)*. The latter was owned by the Linderman family, which had extensive hotel interests in Edgemere until the 1940s. And on oceanfront streets like Grand View Avenue (B.35th Street) were dozens of "cottages" designed primarily to accommodate summer boarders. *(Robert Stonehill)*

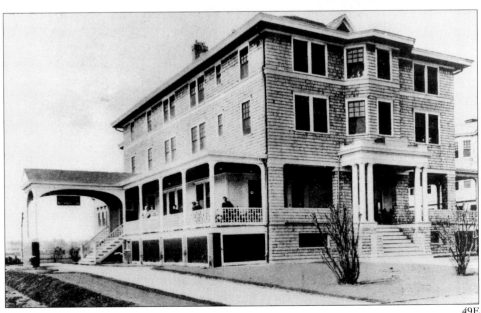

49E

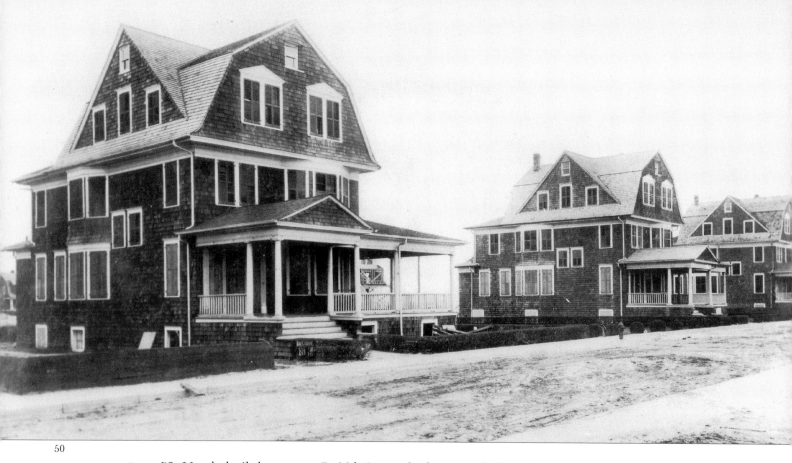

50

50. Newly built houses on B.44th Street, looking north from the ocean beach, in October 1916. The Rockaway hallmarks, open porches and plentiful windows, are much in evidence. Most of the building lots in Edgemere were generous—80 or 100 by 100 feet—allowing room for large homes and wide lawns or landscaped areas. *(Queens Borough Public Library)*

51. Another way to take the sea air at Rockaway was to camp right on the beach, either in a tarpaper shack or a tent colony. By the early 1920s, as the beach eroded and the dwellings proliferated, there wasn't much open sand left in this section of Edgemere. Bathing suits reflected an enduring Victorian modesty.

51

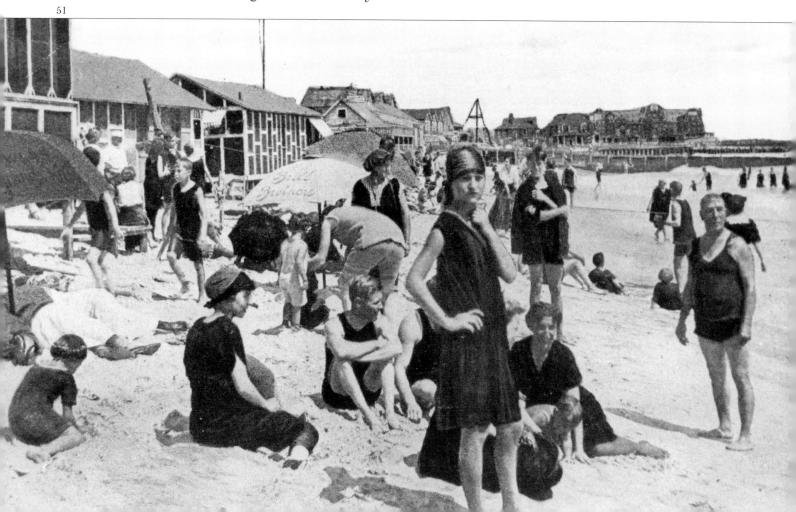

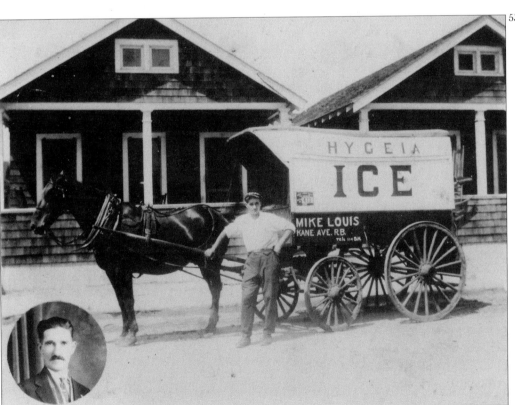

∽ **52.** Summer bungalows were an attractive option for summer visitors who preferred to do their own housekeeping indoors. Many small dwellings like those in this row along B.40th Street were built between 1912 and 1919.

∽ **53.** Iceboxes remained in many bungalows and tents in Rockaway through World War II. This 1921 photograph shows Mate Lucev, a Czech immigrant who ran his ice business under the name Mike Louis, making the rounds in Edgemere. When the horse died in 1927, Mate and his partner Sam Ortulan bought a truck and continued delivering ice until 1951. *(Emil Lucev)*

EDGEMERE ∽ 35

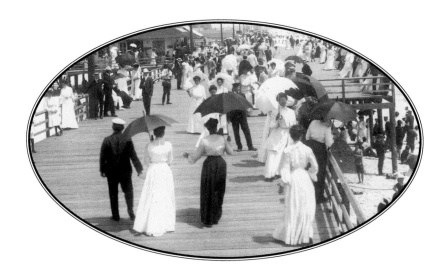

Arverne

The earliest commercial penetration of the area now known as Arverne occurred when the Far Rockaway Branch Railroad, a subsidiary of the South Side Rail Road, built a line down the peninsula in the spring of 1872. This railroad had arrived in Far Rockaway in July 1869 and seemed destined to keep its terminal there, until it became clear that the rival Long Island Railroad intended to lay track to Rockaway Beach. On July 4, 1872, South Side trains began running all the way to Seaside House at B.103rd Street. Although there were no stops in the sand dunes en route, the isolation of this part of the peninsula had been broken forever.

The first arrivals in the Arverne were fishermen, who often built primitive shacks for themselves. In 1875 William Scheer put up the first house, on what is now B.73rd Street. Others came along, including a successful New York attorney, Remington Vernam, who enjoyed hiking through the pristine sands and breathing the clear ocean air. Vernam was also stirred by the prospects for real estate development in Rockaway. He learned that William H. Amerman owned a sizable tract of land running from the beach to the bay, which had originally been bought by his father during the New York cholera epidemic of 1837. In addition, the Cornell heirs still held on to their ancient claim, and so no one could secure a clear title to the land without settling accounts with them. Vernam persisted, aided by his wife Florence, and after several years was able to acquire the land that now makes up the section they named Arverne. According to legend it was Mrs. Vernam who sug-

gested this name when she observed her husband's signature, "R. Vern," with the last letters, "am," trailing off in illegibility. Florence Vernam also had a vision for how she wanted the village to develop. On a trip to the Netherlands she had become enchanted with the canals of Amsterdam, and plans were drawn up for a waterway similar to the Amstel Canal. A right of way for the canal was cleared, but cost estimates were high, and eventually remnants of the canal were filled in and Amstel Boulevard (which is now part of Beach Channel Drive) was laid out in its place.

In 1884, with four other investors, Vernam incorporated the Ocean Front Improvement Company, with capital stock of $500,000. Among the problems Vernam and his partners had to solve was the lack of access to their property. Early on, they pushed through completion of Rockaway Beach Boulevard in 1886. At the same time their work gangs leveled sand dunes, filled in low-lying areas, and marked out the first streets. Vernam then took on the Long Island Railroad, which had absorbed the old South Side Railroad in 1881. The existing tracks ran close to the oceanfront and thus cut through what would otherwise be prime beach resort property. In March 1887 the railroad agreed to build a new roadbed closer to Jamaica Bay, between B.55th and B.107th Streets. By the next spring 1.6 miles of the new route were completed, just in time for Vernam's grand opening of his new vacation village. His development company erected a station at B.66th Street and labeled it Arverne-by-the-Sea.

Essential to Vernam's plans was the construction of

a large hotel, which was completed in time to open on July 1, 1888. That summer fifty building lots were sold for an average of $600 each. Gaston Avenue (B.66th Street) and Larkin Avenue were the first main streets, and it was around their intersection that some fine homes were built. Impressed with the potential of Rockaway, in 1889 the Straiton family, who gave their name to what is now B.60th Street, incorporated another real estate venture, the Arverne Improvement Company. All during the 1890s lively building activity continued in Arverne, particularly in the western sections. In September 1895 a proposition to incorporate the village was unanimously approved by the property owners, and the name Arverne-by-the-Sea was officially adopted. Boundaries for the community, which held 1,800 residents, were designated as Edgemere on the east and B.75th Street on the west. A small local government was put in place, but this vestige of small-town life was soon swept away. In 1898 the consolidation of New York City saw the entire Rockaway peninsula detached from the town of Hempstead to become part of the Fifth Ward of the new borough of Queens.

The years from 1898 to 1916 saw Arverne at the peak of its prosperity and reputation. Its promoters pointed out the area's proximity to the heart of New York City, with frequent and rapid train service. Numerous resort hotels were built, including the Colonial (B.64th Street), Bilbo's Hotel (B.62nd), Avery's Inn (B.67th), Hotel Majestic (B.69th), the Atlantic (B.75th), and the Shanley and the Nautilus, both on B.59th Street. The oceanfront boardwalk ran for two miles, terminating at B.59th Street, and buildings were permitted on only a small section of it. There were a number of restaurants and recreational facilities. The first theater was built in 1904, on the new 150-foot pier opposite B.67th Street.

Despite a good start the Vernams' hotel did not share in the general success of the community. Financial difficulties came early on, and in March 1896 a foreclosure suit led to the appointment of a receiver for the hotel and the twelve building lots on which it stood. Subsequent hearings revealed not only that the mortgages exceeded the value of the hotel but also that the property's income did not cover payment of interest and fixed charges. In January 1899 Remington Vernam filed for bankruptcy, reporting liabilities of $728,040. The approximately 5,000 building lots the Vernams still owned were used to cover his debts. In 1903 a New York investor, Ignatz Rosenfeld, bought the hotel and spent thousands of dollars to improve it. His expressed desire was to create in

Rockaway a strong rival to Atlantic City, complete with boardwalk and (nongambling) casino. He got off to a fairly good start, but in 1911 was forced to follow Vernam into bankruptcy. The hotel came closest to realizing the ambitions of its first two owners after Henry Prince bought the property in 1915 and renamed it for himself. The Prince attracted celebrities such as Lillian Russell, Sophie Tucker, Belle Baker, the Dolly Sisters, and Mae West. Isadora Duncan and her famous dancers performed on the beach in front of Bilbo's in 1915. Overall business was good for the next two decades, but in 1935 the big old hotel burned to the ground.

Meanwhile, Remington Vernam had not gone quietly from the Rockaway scene. In 1904, with fresh financing, he began reclamation of the large tract of land in Arverne between the railroad tracks and Jamaica Bay. He named his new town Vernam Park. As was customary in Rockaway there were disputes over title to the land, especially around B.51st Street. Conflicting claims put forward by the Vernams and the Norton heirs came to a head in 1905, when armed guards on both sides destroyed buildings and fences on the property. Court injunctions were issued, but both sides resisted a final settlement. Then in July 1907, the sixty-five-year-old Vernam died unexpectedly. His son Clarence was more disposed to come to an agreement, but four years passed before the Nortons were paid $53,000 for their interests and development could proceed unimpeded. Meantime a Brooklyn businessman named Louis J. Somerville had taken over Vernam Park, changing its name to Somerville Park. His company proceeded to grade and pave streets, install sidewalks, and build other amenities. Before long a community of small to medium-sized homes began to establish itself in the area. In 1920 the Somerville company decided to put up for sale all the property it still held. They subdivided the tract of land between Amstel Boulevard and Banfield Street into 324 building lots and auctioned them off in July 1920. Over the years city amenities were installed, and today the community of one- and two-family homes continues to be known as Somerville.

The Vernam name continued to be important in the life of Arverne. In October 1916 Clarence Vernam sold the last sizable open tract of land in Arverne— 359 acres on the bay side—to a syndicate of investors who incorporated as the New York City Waterfront Company. They subdivided the property, some of which was filled in with sand dredged from Jamaica Bay, into over 6,000 lots. Beginning in 1917, with streets laid out and sewers installed, the area became

the site of a number of moderate-cost bungalows for the middle class.

In the western section of Arverne there were also problems over title to the land. Between B.53rd and B.59th Streets was a large tract that in the 1880s had been given by Judge Donohue of Rockaway to the Rev. John C. Drumgoole, founder of the Mission of the Immaculate Virgin, an orphanage on Staten Island. Father Drumgoole later added to these holdings, so that the Mission's property extended from ocean to bay. Disputes over title to this land reached the courts more than once, and each time the decision came down in favor of the Mission. Finally, in July 1899 the Working Boys' Summer Home was dedicated, occupying a large plot on what is today B.56th Street. The home provided a two-week summer vacation for about fifty boys at a time. This program was discontinued during World War I, and in the postwar real estate boom the land was converted into tracts of beach bungalows.

The battles over real estate in Arverne also involved the Long Island Railroad. Because of a dispute with Vernam over ownership and use of the station that he had built on Gaston Avenue (B.66th Street), beginning in 1892 the railroad refused to have its trains stop there. Instead, the LIRR built its own station six blocks to the east, at Straiton Avenue (B.60th Street). The courts finally rendered a decision that required trains to stop at both locations. An attempt in 1908 to bypass the Gaston Avenue station led to another court injunction. That same year a new brick station opened

at the site, with an island platform accommodating both trolley cars and railroad trains.

Fire played a major role in shaping Arverne as it did in other communities on the Rockaway peninsula. Among the hotels burned to the ground was Bilbo's, on March 27, 1916. One of the most spectacular blazes occurred on June 15, 1922, when roughly 150 structures were destroyed, including ten hotels, an orphanage, and a Coast Guard station. Over 3,000 persons became homeless overnight. Yet, Arverne was soon rebuilt, reaching another peak in its history in the years just after World War II. A number of smaller apartment houses were built for the growing permanent community—the largest, next to Far Rockaway's—in the postwar period. Two six-story structures were particularly prominent. One, on B.68th Street, was of Art Deco design, and the other, on B.66th Street, was more utilitarian in appearance. Arverne's small stores and its many houses of worship gave an important sense of cohesiveness to the community. One of the most interesting buildings, Derech Emunoh, which followed the design of the famous Touro Synagogue in Newport, Rhode Island, was at its height a spiritual home to over 2,000 worshippers.

Along with a large part of Rockaway, especially the eastern sections, Arverne began to decline in the 1950s. By the 1970s most of the buildings in Arverne between Rockaway Beach Boulevard and the boardwalk had been leveled. Amazingly, Derech Emunoh still stands, symbolizing the spirit of a vibrant Jewish community that continues to exist in memory.

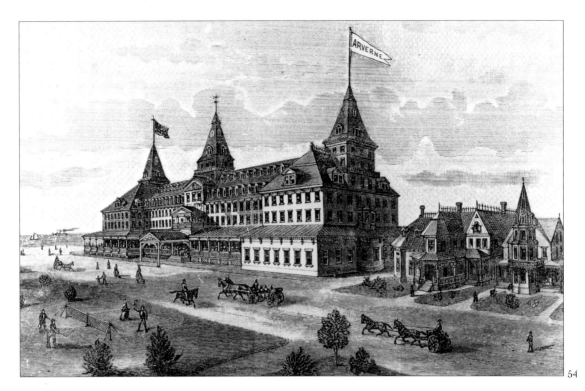

54. In 1888 Remington Vernam published a booklet promoting his brand-new vacation development, Arverne-by-the-Sea. He featured the Arverne Hotel in a somewhat idealized engraving, a big, impressive place to which he wanted to attract guests. The booklet also promoted the purchase of the building lots Vernam and his partners were offering for sale in the new development. *(Emil Lucev)*

55. Arverne became a successful seaside resort, as seen in this 1907 view of Remington Street (B.69th Street), with the Arverne Hotel in the right background. At the left, on the corner of Rockaway Beach Boulevard, is the Majestic Hotel. Arches have been erected in the middle of the street for the coming Baby Parade, a popular event at many resorts in this era. *(Robert Stonehill)*

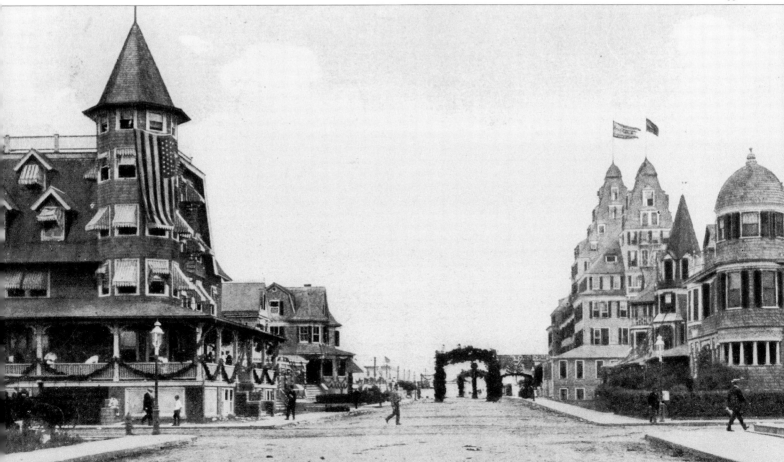

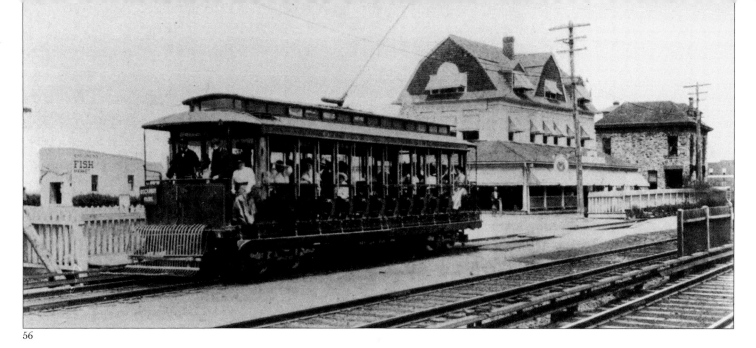

56

56. Transportation was in place for the new development from its earliest stages. In addition to Long Island Railroad trains, trolley cars ran from Far Rockaway through Arverne to Hammels and on to Neponsit. On nice days the open cars offered a pleasant ride. There were six open trolleys on the line, and they remained in service until 1928. However, improvements made in 1910 converted them into something closer to conventional closed trolleys. *(Vincent F. Seyfried)*

57. Vernam built a railroad station at B.66th Street in Arverne that defied convention in its distinct configuration. As it looked in 1908, the building was set diagonally to the track, with a square first floor and two dormers attached to a tower that was topped by two more dormers. *(Vincent F. Seyfried)*

57

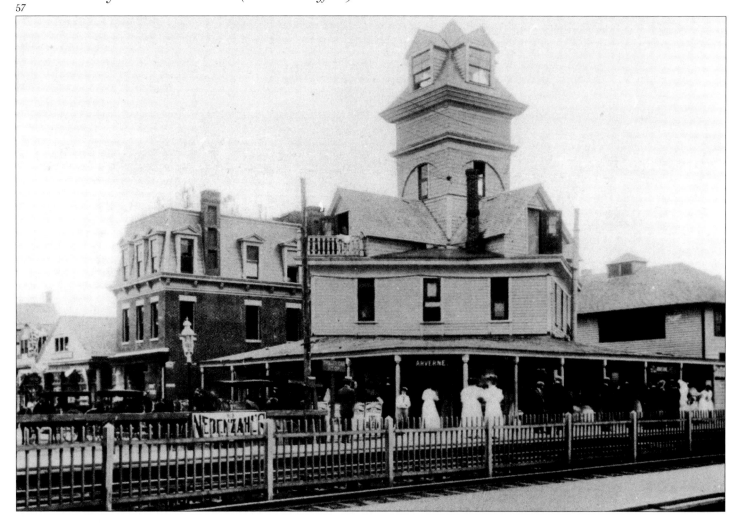

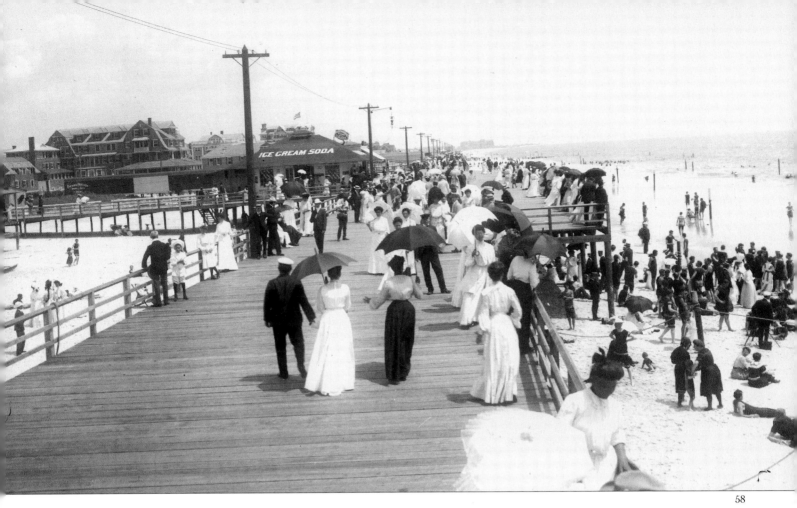

58. This 1900 photo of the boardwalk looking east from B.69th Street offers a good look at turn-of-the-century summer fashions. As usual for the time, only a few people were in bathing suits, and fewer still were in the water. The hotel at the left is the Avery, and the shadowy bulk in the distance is the Edgemere Hotel. *(Weber)*

59. Among the first hotels built in Arverne was the oceanfront Germania, opened in the 1890s by the proprietor, Herman Mertens. For many prosperous German-American families, a vacation stay at this hotel was an important part of their lives. In 1904 the Germania burned down, as did the nearby Columbia and Waldorf hotels. *(Robert Stonehill)*

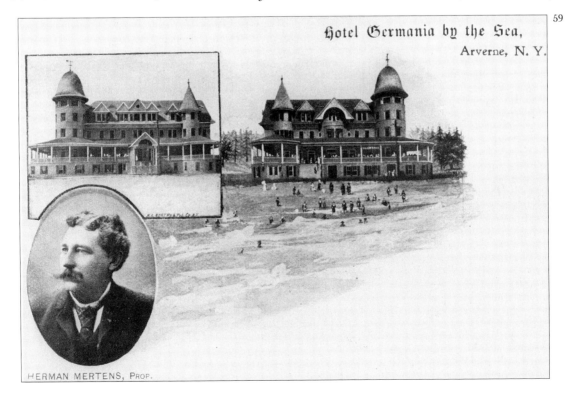

Hotel Germania by the Sea,
Arverne, N. Y.

HERMAN MERTENS, Prop.

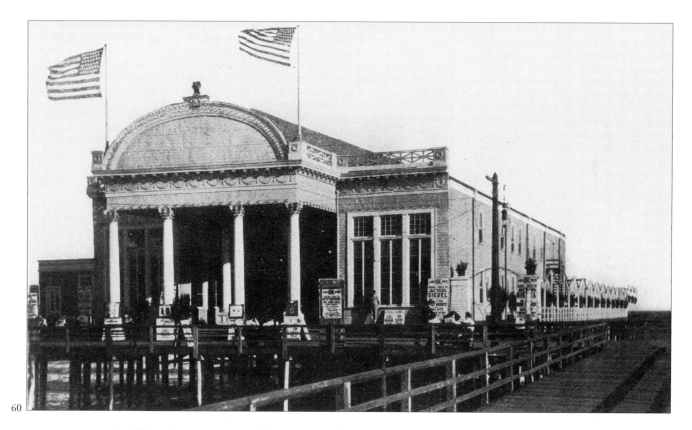

60

~ **60.** The Arverne Pier Theatre was built at the foot of Vernam Avenue (B.67th Street) in 1904. The pier itself was about 150 feet long, with room for an indoor theater and an outdoor cafe. The entertainment included vaudeville acts as well as short silent films. This photo was taken in 1911, three years before the entire structure was washed away by a storm.

~ **61.** On the north side of the boardwalk at B.67th Street was the Arverne Pier Danse movie palace. The architecture was turn-of-the-century ornate, with classical pilasters and arches. *(Robert Stonehill)*

61

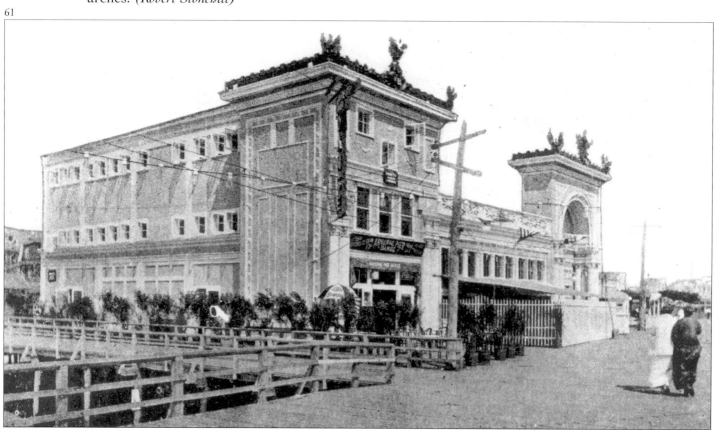

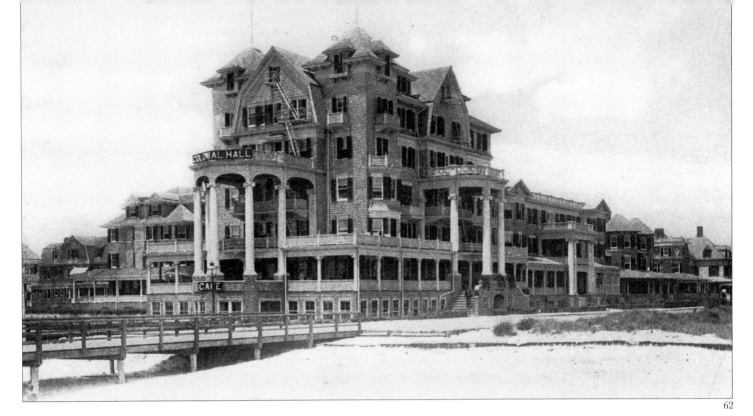

ↄ **62.** One of the grandest hotels in Rockaway was Colonial Hall, on the ocean at B.64th Street. The 30-foot-high pillars added to the imposing look of the exterior in this 1905 photograph. A fire in 1922 damaged part of the building, and in April 1929 the entire building burned to the ground.

ↄ **63.** Colonial Hall is in the left background of this beach and boardwalk postcard view, looking east from B.69th Street around 1906. At the time this section of the boardwalk extended only from B.74th Street to B.62nd Street.

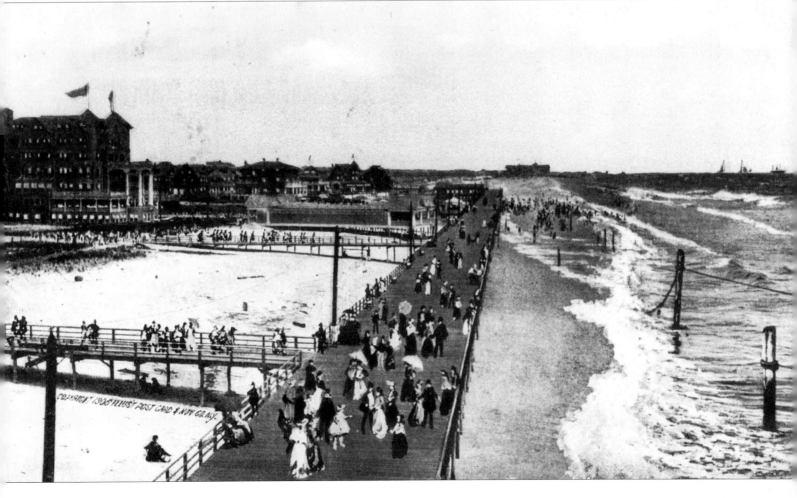

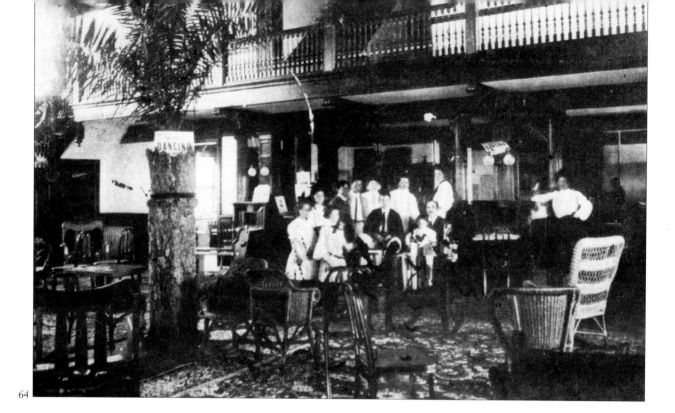

64

64. This rare 1905 photograph of a typical interior of a Rockaway hotel shows the Colonial Hall staff gathered in one of the many public rooms. Wicker chairs, wooden benches, ornate rugs, and potted palms dominated the decor of this and most other resort hotels. *(Robert Stonehill)*

65. Another landmark hotel in Arverne was the Majestic, built around 1908 at the corner of Rockaway Beach Boulevard and B.69th Street. A wrap-around porch and colorful awnings did much to protect the guests from the hot summer sun. A rathskeller was in the hotel's basement. *(Collection of Vincent F. Seyfried)*

65

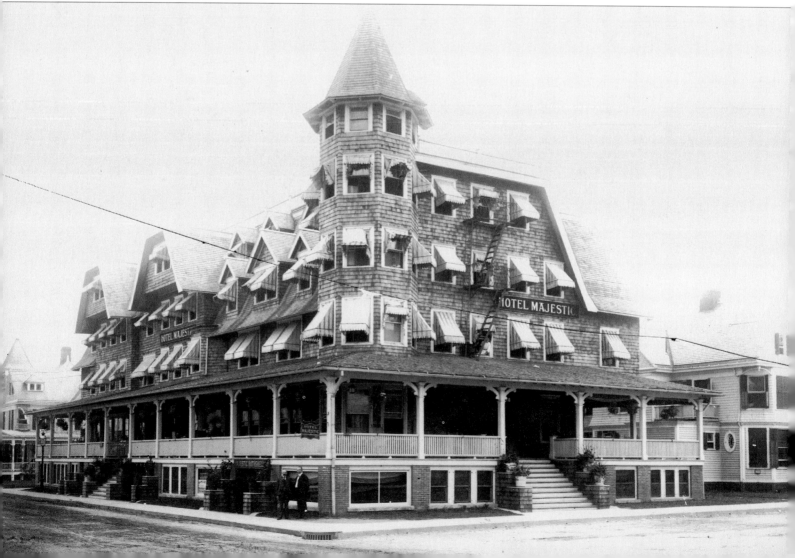

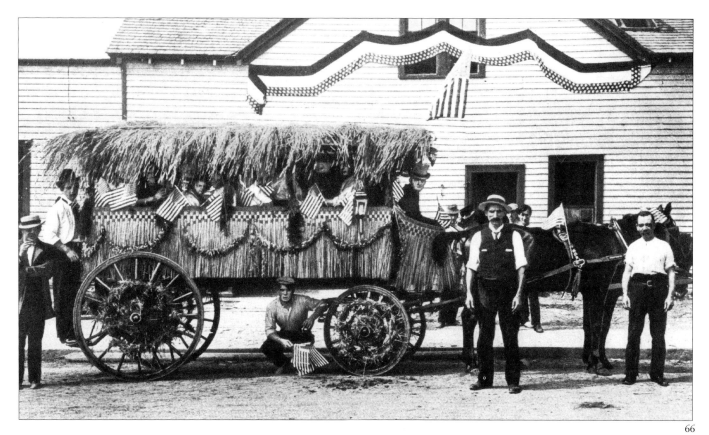

66. A Fourth of July excursion on a horse-drawn carriage was one of the diversions offered by hotel managers to their guests. Other amusements included dances, picnics, and other events considered old fashioned by today's standards. *(Vincent F. Seyfried)*

67. Typical of smaller hotels was the Piermont, on Larkin Place. In this 1910 photograph the columned entrance overwhelms the modest hotel. The porch is well furnished with rocking chairs. *(Charles Huttenen)*

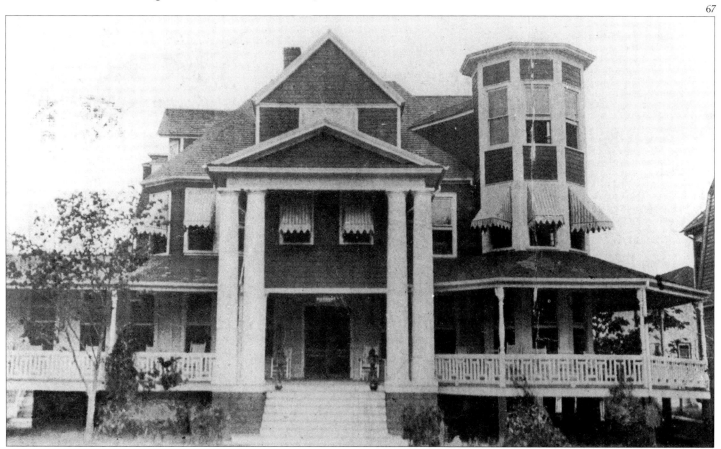

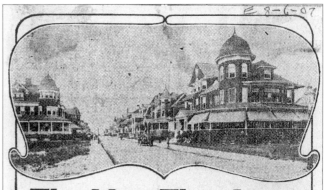

68, 69. After Remington Vernam died in 1907, his family sold off much of his property. A tract of reclaimed land between Jamaica Bay and the railroad, from B.67th Street west to what is now known as Vernam Basin, was bought by a developer from Brooklyn, Edward L. Somerville. He finished the land-fill, laid out streets, and began a campaign to sell lots. Advertisements like this one *(68)* in New York newspapers promised a seaside paradise to harried city dwellers. The upper-middle-class houses in the picture were on B.60th Street, not on Somerville's land, but his small lots sold nevertheless. Within just a few years houses like those pictured on Amstel Boulevard and B.66th Street *(69)* were built and occupied. *(Ad: Vincent F. Seyfried. Photo: Robert Stonehill.)*

70. Arverne was a prosperous, busy place around the turn of the century. Large boardinghouses and smaller private homes dominated the peninsula as far as the eye could see. Few chimneys are in view, indicating that most of these properties were not built for occupancy in cold weather.

71. A typical street extending back from the beach in the heart of Arverne. Cupolas, turrets, bay and dormer windows, and towers of different shapes were among the architectural elements favored by the resort's architects.

The Man That Lives In An Apartment

Thousands of people living in New York and Brooklyn are dissatisfied with the high rents and noise of the apartment. They would move if they could only find the place that appealed to them. If you happen to be among these thousands, you couldn't do better than to inspect the lots we are offering at

ARVERNE
BY THE SEA

One of the most superb residential propositions in or around Greater New York. Located on the line of the Long Island Railroad electric service, where the Belmont tunnel will bring it within thirty minutes of the heart of New York. Still water and surf bathing; boating and fishing. Cool in summer; warmer than the city in the winter. Macadamized streets, stone sidewalks, electric lights, gas, every up-to-date convenience. Schools, churches. Ample fire protection. Inspection welcomed. Illustrated booklet sent to you upon request.

SOMERVILLE REALTY CO.

192 Montague Street. BROOKLYN.

EDWARD L. SOMERVILLE, Pres.

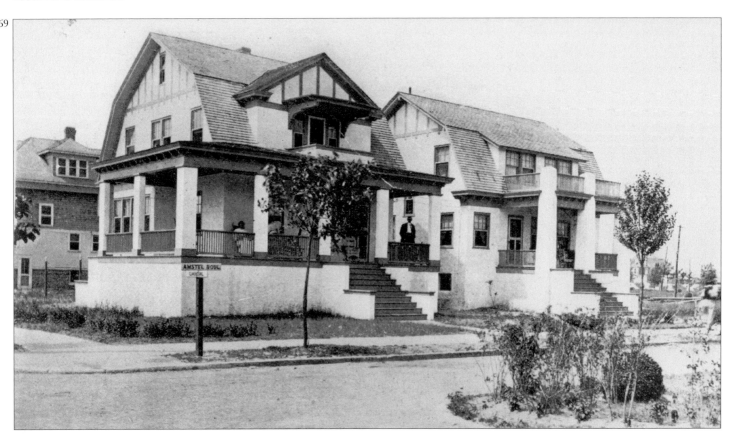

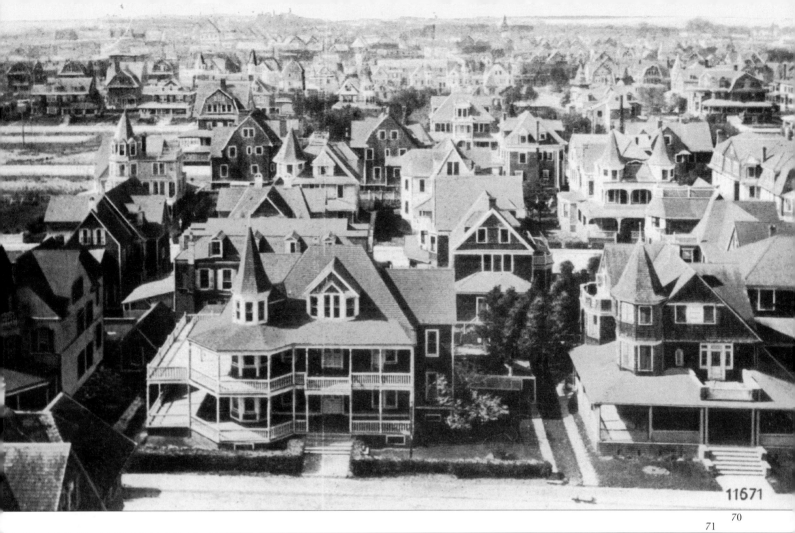

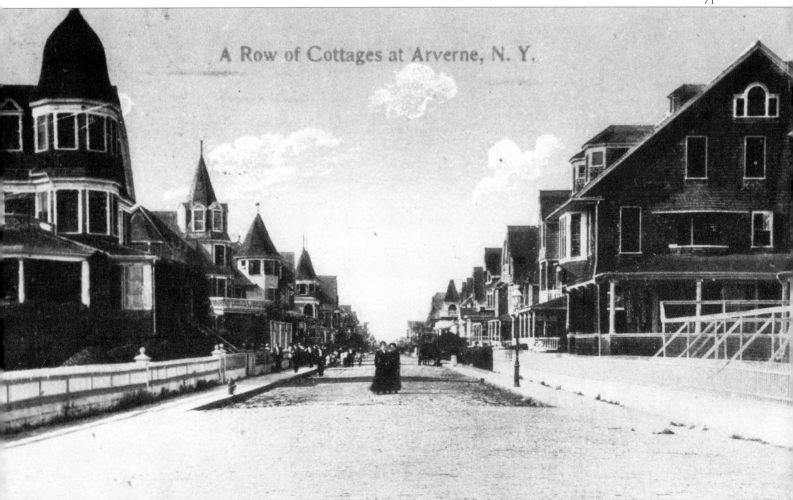

A Row of Cottages at Arverne, N. Y.

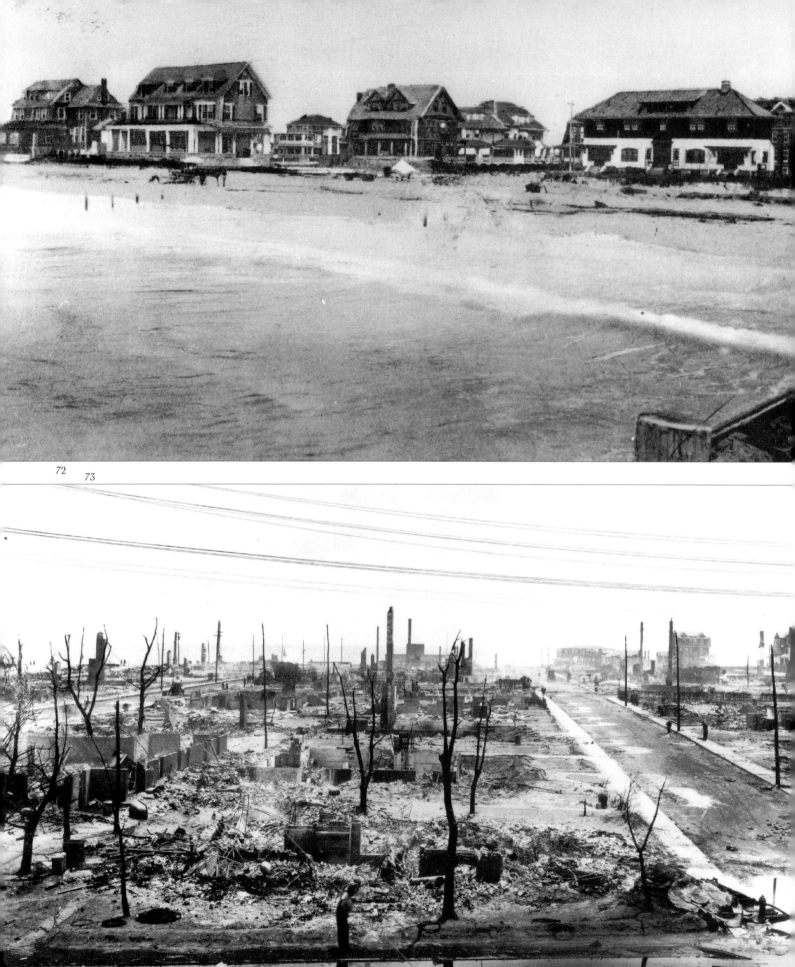

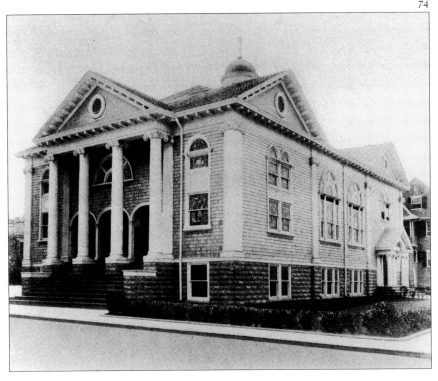

74

72. The beach from B.63rd to B.61st Street presented a peaceful scene in this 1914 photo. The oceanfront is dominated by large cottages with ample windows to catch the sea breezes. *(Robert Stonehill)*

73. The great fire of June 15, 1922, devastated a large part of Arverne. Only remnants of buildings remain on B.61st Street, at right, typical of many streets in the neighborhood. *(Queens Borough Public Library)*

74. One of the few buildings still standing in Arverne is Temple Derech Emunoh, built in 1905 on the corner of B.67th Street and Larkin Avenue. In its heyday the temple, whose name translates as Road to Faith, could seat a congregation of over 600. *(Vincent F. Seyfried)*

75. Vacationers gather on a hot summer's day at B.71st Street. The boardwalk here was built more like a pier, with its high, stilt-like pilings. Less than a hundred yards inland is a tent colony, right next to the Carlton-Summerfield Baths. (Summerfield and Carlton were the names of B.70th and B.71st Streets, respectively, before 1916.)

75

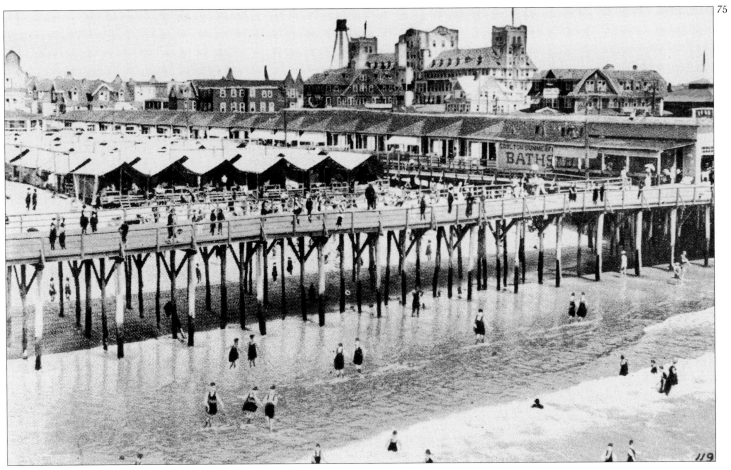

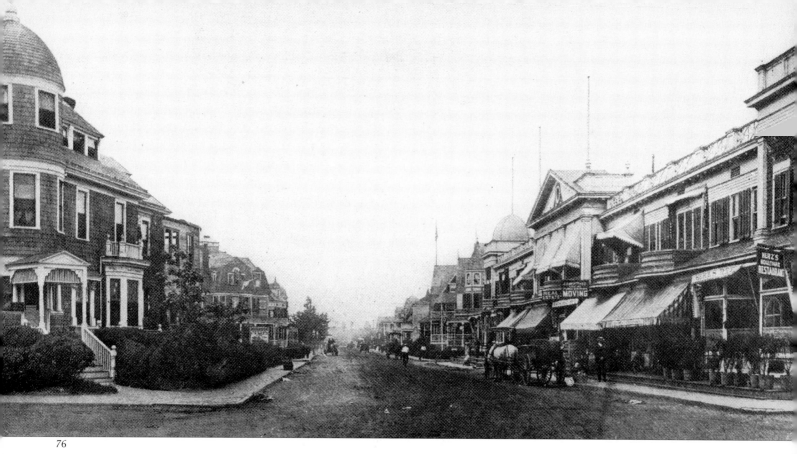

76

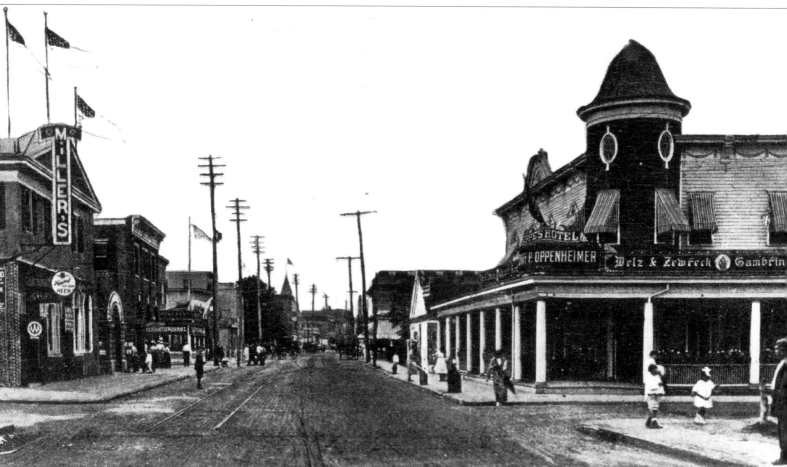

77

76, 77. Two postcard views of Rockaway Beach Boulevard on the eve of World War I. Looking west from B.69th Street *(75)*, there are still houses large and small across the street from restaurants and other public facilities. Farther west, looking toward B.75th Street *(76)*, the boulevard is given over to commerce. Oppe's Hotel, with its German flavor, and Miller's Hotel and Casino dominated the corner. *(Robert Stonehill)*

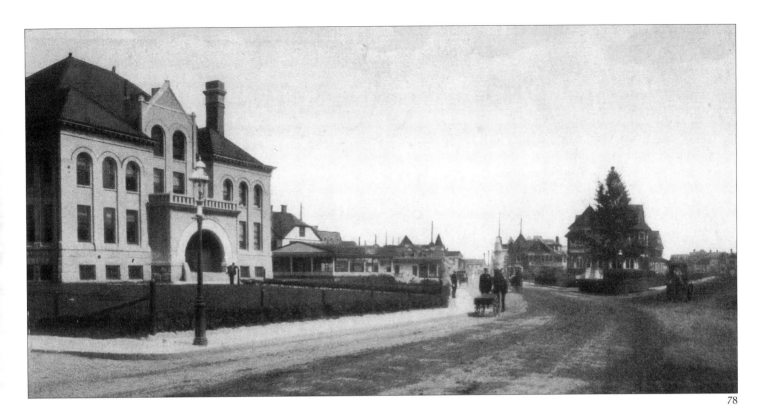

〜 **78.** Looking east in this turn-of-the-century view from B.68th Street, where a fork in the road divides Larkin Avenue, at right, and Rockaway Beach Boulevard. at left. The large building in the foreground was P.S. 42; after World War II the building housed the Far Rockaway High School Annex. It remains today as the Addabo Health Center.

〜 **79.** The Shore Front Parkway, built in the mid-1930s under the administration of New York City Parks Commissioner Robert Moses, ran from B.73rd Street, as seen in the photograph, to B.108th Street. Called "the road to nowhere" by local residents, the wide highway soon became a barrier between the beachfront and most of the residents.

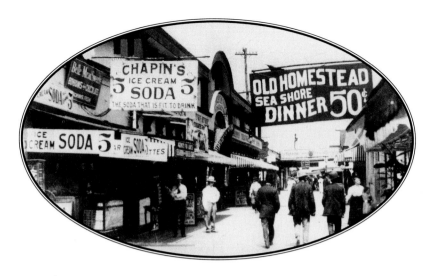

Rockaway Beach

Until the second half of the 19th century most of the Rockaway peninsula, especially the western section, lay fallow, an uninhabited land of sandhills, dunes, and marsh grass. The U.S. government did intrude on the far-western beach with the outbreak of the War of 1812. As part of the chain of forts intended to protect New York harbor from the British and any other invaders. a blockhouse named Fort Decatur was built on the oceanside. After the war the fort was dismantled.

Some forty years passed before investors began to take note of the area as a likely site for real estate development and other commercial ventures. In 1853, a hotelkeeper from Jamaica named James S. Remsen joined with a partner to buy up tracts of Rockaway land running from Jamaica Bay to the ocean. Their parcel was around present-day B.103rd Street, which became known as Seaside. At first they put up a modest fishing shack on the bay. Other investors followed. Garet V.W. Eldert opened a restaurant and hotel near B.85th Street, while another hotelman from Jamaica, Michael Holland, in 1857 purchased sixty-five acres east of the Remsen plot. In 1868 Louis Hammel of Susquehanna, Pennsylvania, bought some land and built a hotel. Meeting with some success, he bought additional land.

These early entrepreneurs soon realized that the area, now called Rockaway Beach, could never be fully developed as a resort until access to it was greatly improved. Their opportunity came in the person of Dr. Richard H. Thompson, then health officer of New York City. Thompson was also an investor and in 1863 accepted an offer of part of Remsen's land in exchange for the construction of a railroad running from East New York to Canarsie, connecting with a ferry to Seaside. Thompson died before the route's completion, but other influential investors, including the Speaker of the New York State Assembly, followed through and completed the Brooklyn and Rockaway Railroad in the fall of 1865. Beginning the next summer day-trippers from the city came to Rockaway in ever-increasing numbers.

Remsen went from shack owner to hotel impresario, building a hotel designed for extended stays, a relatively rare phenomenon in those days. To accommodate the ferries from Canarsie he built three piers adjacent to his hotel. In those years the bay side attracted the majority of visitors. The bay's then-pristine waters and scenic beauty had a special attraction to residents of the crowded city. But as interest in the oceanside increased, the local businessmen had wooden planks laid out across the sands so that their customers could enjoy the ocean breezes. Over the years these plank walks became Rockaway Beach's first streets: Wainwright Avenue (B.104th), Remsen-Seaside Avenues (B.103rd), Holland Avenue (B.92nd), and Hammels Avenue (B.85th).

The post-Civil-War period saw a major increase in railroad construction throughout the U.S. Tracks began to criss-cross Long Island, and in 1869 the South Side Railroad built a line to Far Rockaway. Trains reached the water's edge at B.30th Street, where the railroad company built a pavilion, including a restaurant and bathhouse. The profitability of the

South Side Pavilion encouraged the company to expand its operations farther down the peninsula, to the Rockaway Beach area. On July 4, 1872, the Seaside Station opened at B.103rd Street. Trains then began stopping at Eldert's Grove (B.84th Street) and at B.92nd Street. In 1875 the line was extended to Neptune House (B.107th Street). Interestingly, the tracks ran close to the ocean shore because at this time land on the bay side was not only more expensive, it was also more populated. It would be several more decades before ocean bathing became popular with the masses.

The year 1875 also marked the arrival of one of the most important developers of Rockaway Beach, William Wainwright. A journalist and politican as well as a restauranteur and developer, he came to the area looking for investment opportunities. First he bought out the interest of Remsen's partner in Seaside House, and within a few years he began to expand operations. A man of considerable imagination and drive, Wainwright was perhaps the first businessman to see the Rockaways as a combined seaside resort and popular amusement center. To facilitate this development he added piers on the bay and extended free landing rights to various steamboat companies. In all he created five landings, from B.85th to B.107th Street. Throughout the summer, but especially on Sundays and holidays, boats left Manhattan piers in the morning crowded with people eager for an outing, then returned in the evening after a day at the beach.

In 1885 Wainwright constructed bathhouses on the ocean side—places to change into bathing attire as well as shower, sunbathe, and swim. In addition he began providing places of amusement with the carnival atmosphere of Coney Island. Almost singlehandedly he transformed Seaside Avenue into a passage of shops, ice cream parlors, cheap museums, magic shows, and booths with games of chance, fortunetellers, and other attractions that provided amusement for the crowds and profit for the investors. It was this aspect of Rockaway that would remain the area's popular image long after this era ended.

Wainwright had been a state assemblyman before coming to Rockaway, and he used his political connections to recruit investors to build a railroad from the mainland over Jamaica Bay to Rockaway. Work began in 1879, and Wainwright induced two property owners, Holland and Hammel, to donate land for stations on the condition that they would forever bear the name of these donors. Construction difficulties abounded. The most troublesome task was completing the five miles of wooden trestle built over the bay.

Finally, on August 26, 1880, the railroad opened. Only a few weeks were left in the season, but huge crowds got caught up in the excitement of "going to the sea"by train.

The railroad's backers had in mind other ideas beyond simple transportation. They had formed the Rockaway Improvement Company and proposed to lay out a 700-acre seaside park on which would be erected hotels, pavilions, bathing facilities, a racecourse, and a theater. Crowning the entire enterprise would be a mammoth hotel resort, planned as the largest in the world. The main building was designed to stretch over five city blocks—1,184 feet—with height varying from four to seven stories. Construction work began in the fall of 1879. In the exuberant spirit of the time, everything about the hotel was planned on a colossal scale, including the dining rooms, kitchens, piazzas, and guest rooms. Plans for the resort called for 3,000 bathhouses at the beach and an iron pier 1,200 feet long, where passengers could debark from steamboats.

About 500 workers were brought to Rockaway for the project, many of them living in various boardinghouses in the area. But before long there were signs of trouble. Wages began to fall into arrears, and the disgruntled workers theatened to strike. In addition, landlords complained that they had not been paid rent. Finally, in August 1880, even as the railroad opened, the overextended Improvement Company slipped into receivership. The receivers tried to hold the project together, and even managed to open one wing of the hotel for the summer of 1881. And for the first time the big building got a name—Hotel Imperial. Problems continued, and for the next several years the newspapers were filled with accounts of battles over liens and foreclosures. The hotel fell into disuse, and thousands of curiosity-seekers came to Rockaway to gaze at the unused behemoth. Finally, in 1889, the building was demolished for the lumber and whatever else could be salvaged from the wreckage. Myth has it that this lumber was used in the construction of the hotels subsequently opened in the area. Even though "the biggest hotel in the world" never really opened, it became an important part of Rockaway folklore.

Within a few years of the opening of the railroad, the real heart of Rockaway Beach became the Hammels-Holland-Seaside area, roughly between present-day B.84th and B.107th Streets. This one-mile stretch of beach was the prime destination of the throngs of visitors from the city.

From its early beginnings in 1870 until about 1920, this section housed hotels, boardinghouses, saloons,

rental-cottage colonies, stores, amusement arcades, restaurants, food stands, bathhouses, and all kinds of rides, from Ferris wheels to roller coasters—anything that would meet the people's need for amusement. While Coney Island with its many transit connections attracted the masses and Far Rockaway continued to appeal to the upper classes, Rockaway Beach catered to the growing middle class of the New York City area. Much of the crowd was young—parents with children in tow, teen-agers testing their freedom, and young unmarried people, either in same-sex groups or couples. The beach itself was probably the main attraction. Thousands changed into rented bathing suits in cramped bathhouses and then splashed in the surf, free for a few hours from the confining clothes of the day. All in all, Rockaway became a place where people could give vent to the need for relatively uninhibited play.

Many visitors to Rockaway Beach gravitated to their favorite spots year after year. The Williamsburgh House was one among a number of hotels and boardinghouses that catered to people from particular New York neighborhoods. Country of origin was also an important factor in these days of mass immigration. The German presence was strong in the 19th century. Datz', Schuber's, and Schuster's were among the notable German-style hotels, and Schildt's Carousel was imported from the Black Forest to be the first ever in Rockaway. Seaside came to have a distinctly Gaelic flavor, sometimes being called Irishtown or the Irish Riviera. A year-round stable Irish population became an important part of Rockaway after World War I, and remains a strong community today. There is a popular annual festival and parade, centered on the Irish hotels and bars on Rockaway Beach Boulevard.

The Iron Pier, 1,300 feet long and 32 feet wide, was another major attraction in Rockaway Beach. Built in 1879 by the Havemeyers, a family of German origins that had made a fortune from their Brooklyn sugar refineries, it was the largest pier in the U.S. at the time. The structure was badly damaged in 1892 by a fire that also caused considerable damage to the entire Seaside area. Many of the attractions were rebuilt, but the pier failed to regain its former status. In later years the old pier suffered from inadequate maintenance and was gradually washed away by successive storms. The structure was finally demolished in the 1920s, when a new boardwalk was built by New York City.

In May 1900 George C. Tilyou, who had opened Coney Island's Steeplechase Park in 1897, bought up the Ward Estate, between B.97th and B.101st Streets, and the next year opened a new Steeplechase on the large site. He filled his new amusement center with rides and equipment he had purchased after their use at the Pan American Exposition in Buffalo. Tilyou also knew the value of public transportation to his site and convinced the Long Island Railroad to establish a new station on their line at B.98th Street. This became key to his success, especially because in 1898 the Brooklyn Rapid Transit Company had arranged to run its steam-powered elevated trains from central Brooklyn to Rockaway via the Long Island Railroad right of way during the summer. The fare was ten cents—twice the subway fare but still affordable to the masses—and the line remained well used until it was discontinued during World War I. Tilyou died in 1914, but his amusements lived on, and in 1928 the famed, durable Rockaway Playland was opened on his property.

The opening of Rockaway Beach Boulevard from Far Rockaway in 1886 had proven to be a boon to business west of Arverne. The road was built sixty feet wide—a good size at the time but inadequate to handle the ever-increasing beach traffic. In 1904 the establishment of a trolley line on the Boulevard, running from B.75th to B.116th Street, gave the area a decidedly urban appearance. In April 1904 a rail connection was set up at B.84th Street so that the trolleys could cross over to the railroad tracks and run all the way to the Far Rockaway station. The trolleys were replaced by buses in 1928.

Public institutions necessary to the growth of a community developed slowly in Rockaway Beach. The Roman Catholic Church of St. Rose of Lima opened in 1886 and moved into larger facilities on B.84th Street, its present location, in 1907. St. Camillus Chapel on B.100th Street opened the next year. The Jewish population of the area organized a congregation in 1896, meeting informally at first, then in Temple Israel on B.84th Street beginning in June 1900. Five years later Derech Emunoh came to B.67th Street in nearby Arverne. The Congregational church that opened in February 1911 later moved to B.94th Street and Rockaway Beach Boulevard. Rockaway Beach Hospital opened on B.85th Street in 1907, paid for by public donations. It continued operating until 1959. Peninsula Hospital Center, on B.51st Street in Edgemere, is now the major medical center for the area. Facilities to care for those in need have always been important to the Rockaways. As early as the 1880s there existed a Sanitarium for Hebrew Children on the ocean at B.111th Street. For many years St.

Malachy's Home for Orphans operated a summer home on the same street.

Politically, Rockaway Beach set itself up as an incorporated village on July 1, 1897, just six months before the whole peninsula became part of the Borough of Queens, City of New York. Ever since, there have been debates about the advantages and disadvantages of this affiliation.

Politics or no, building continued apace until World War I, then accelerated in the 1920s. This was especially noticeable on the bay side, where new buildable land was created by filling in swampy meadows and building up tidal flats with sand pumped from the bottom of Jamaica Bay. The old, established sections of Hammels, Holland, and Seaside saw a decline in their summer trade. Most of the large-scale amusement facilities went out of business, although Rockaway Playland continued to thrive into the 1960s. A few large hotels survived for a time, but ultimately the area was left with very few public accommodations. Development was largely in stores and offices with apartments above the street level, along with a sprinkling of affordable two-family homes on the outer edges of the community. Rockaway as the "playground of New York" was much diminished, especially after World War II.

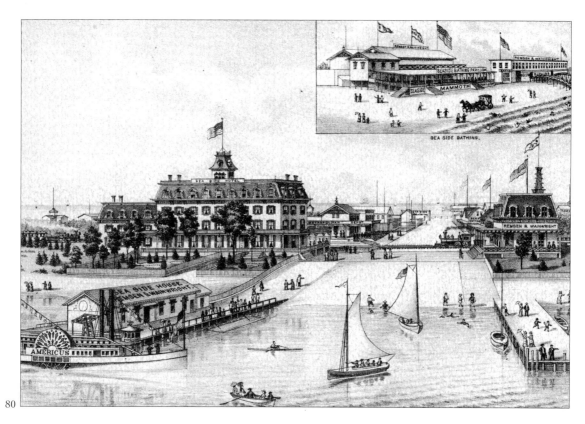

SEA SIDE BATHING.

80. An artist's view (1883) of the steamboat landing at Seaside Avenue (B.103rd Street) and Jamaica Bay. The boats ran regularly from Manhattan, dropping off passengers in the morning and returning them to the city in the evening. The excursionists spent the day bathing, fishing, and boating on Jamaica Bay—which was then unpolluted—or they walked across the peninsula to enjoy the Atlantic Ocean beaches and other amusements. As the billboards indicate, William S. Wainwright was already one of Rockaway's business leaders. The railroad stopped at the Seaside station, maintaining a regular schedule from both Brooklyn and Manhattan. Boats and trains offered the best method of traveling to Rockaway; a journey in a horse-drawn carriage over poor roads took a good part of the day. (Hayward Cirker)

81. Two large paddle-wheel steamboats discharge their passengers at B.103rd Street, in the summer of 1903. A little over twenty years later this landing was buried under about six feet of landfill when Beach Channel Drive was built to relieve motor vehicle traffic congestion in Rockaway. The *General Slocum*, at left, came to a terrible end when she burned to the waterline and sank on June 15, 1904, off North Brother Island in the East River. Just over one thousand people, mostly German immigrant families on an excursion sponsored by St. Mark's Lutheran Church, died in the disaster. (Weber)

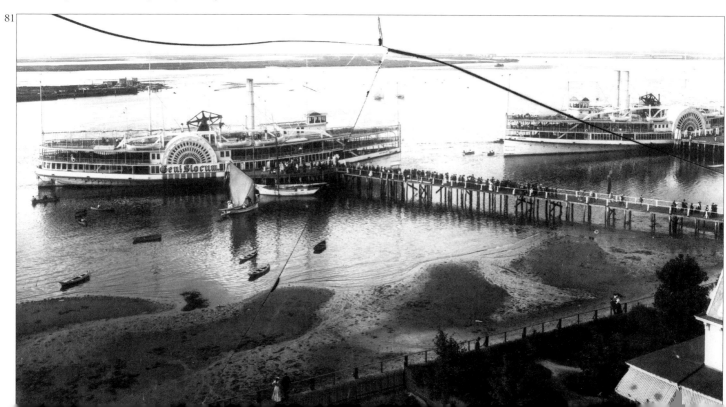

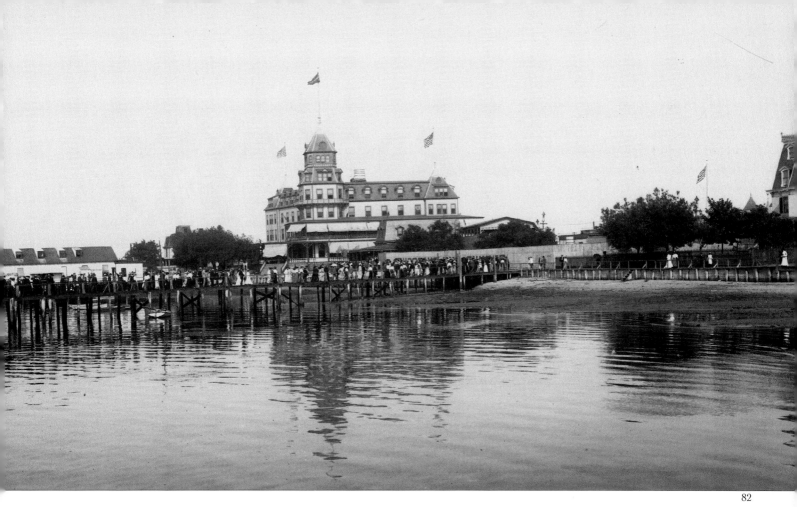

∽ **82, 83.** At the turn of the century a long line of day-trippers walks along the pier at B.103rd Street *(82)* toward the bathhouses and other attractions of Rockaway. In the background is Seaside House, shown in a closeup of the hotel from a 1912 advertisement *(83)*. Seaside House, first opened in 1856, was rebuilt and remodeled many times before it was finally torn down in 1941. The building in the photo was put up by the Sea Beach Hotel Company in 1893, after the old structure burned down. *(Photo: Weber. Ad card: Robert Stonehill)*

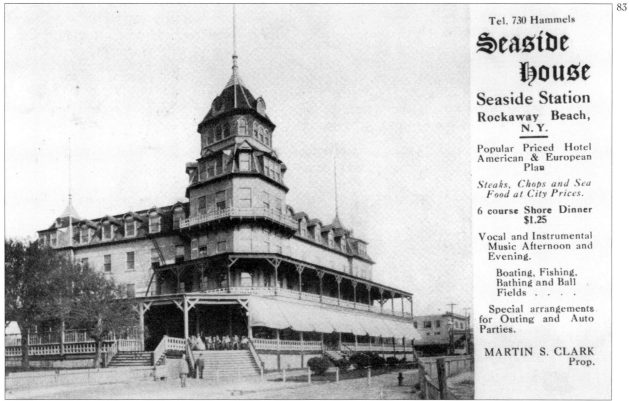

84. The crowds were drawn to the "Finest Beach on the Atlantic Coast" by advertisements like this one in the *Brooklyn Eagle*, July 3, 1904. *(Vincent F. Seyfried Collection)*

85. Photo of Rockaway Beach taken in 1899, looking east from the Shoot the Chutes tower, eighty feet above B.104th Street. In the right background are the towers and flags of Steeplechase Baths, facing the ocean. The tracks of the Long Island Railroad pass alongside the large, flat roof of the new Seaside station. In the distance is the brick bulk of P.S. 44. Most of the other buildings of any size are hotels. *(Queens Borough Public Library; Weber photo)*

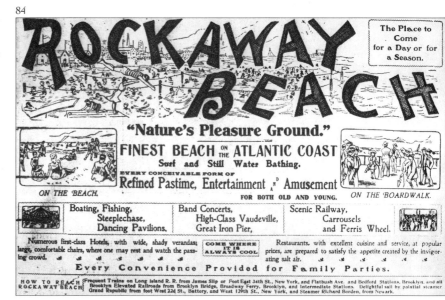

84

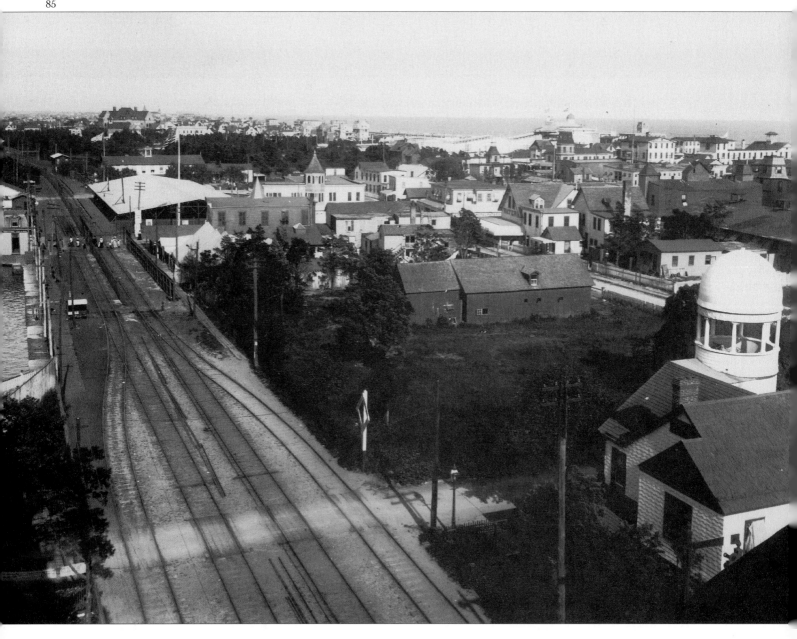

85

86

86, 87. The first school in Rockaway Beach *(86)* was opened at the northwest corner of Rockaway Beach Boulevard and B.94th Street in 1881. The town's first schoolmistress was Julia Holland, wife of developer Michael Holland. She had been hired by the Union Free School District of the Town of Hempstead in 1878, then taught pupils in her home for her first three years. One of the first New York City schools built in the borough of Queens *(87)* after the 1898 consolidation was P.S. 44. Located across the Boulevard from the first schoolhouse, it opened in 1901 with 551 pupils. The old building was used a magistrate's court and a police station before it was torn down to make way for a new building for the 100th police precinct. *(First school: Queens Borough Public Library; Courtesy Rockaway Chamber of Commerce. P.S. 44: postcard view)*

87

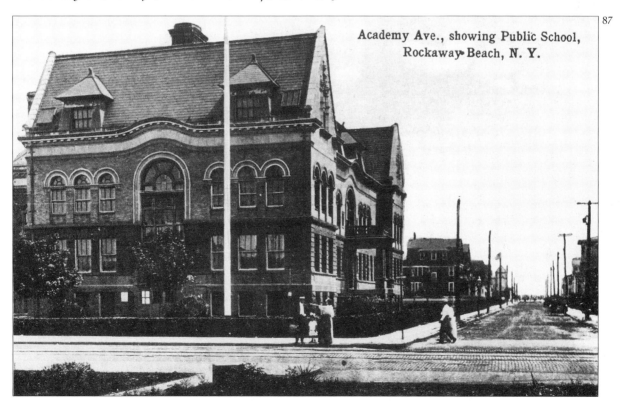

Academy Ave., showing Public School, Rockaway Beach, N. Y.

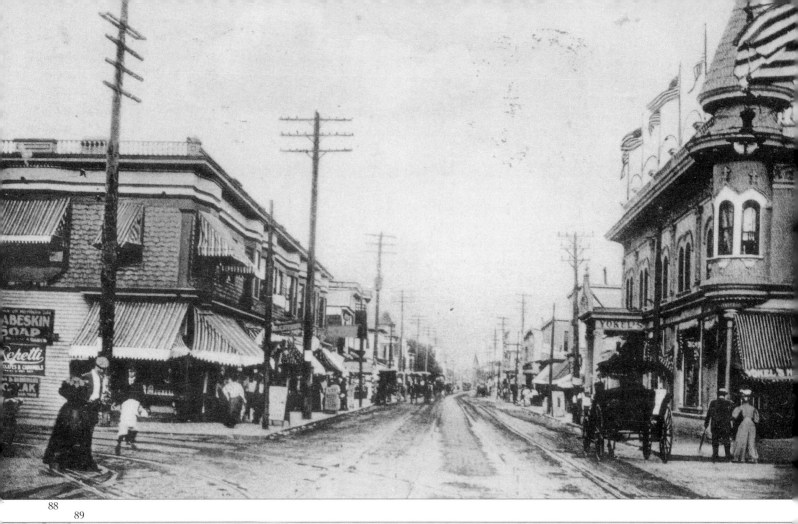

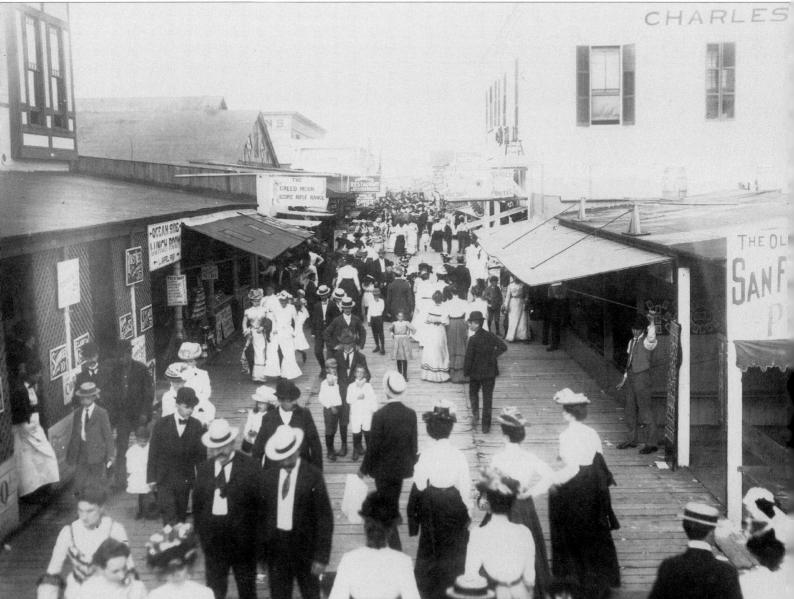

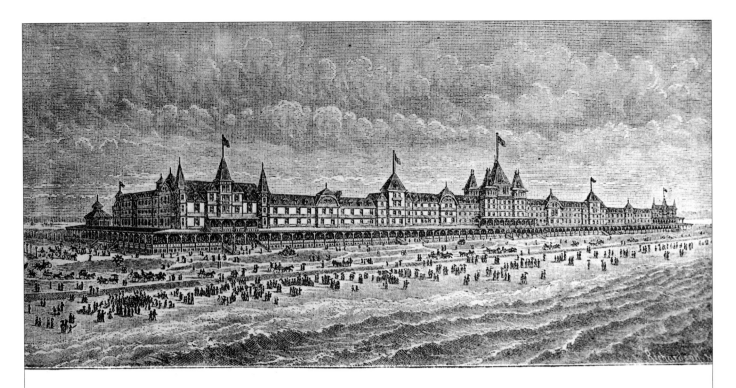

ROCKAWAY BEACH HOTEL

88. Rockaway Beach Boulevard, looking east from B.84th Street around 1908. The ocean is one block to the right. This is the heart of the business district, with two- and three-story frame buildings, mostly stores, offices, restaurants, and hostelries. At the right is Yokel's, one of the many hotels in the area. *(Robert Stonehill)*

89. Along the Bowery, old Ocean Avenue, now the Boardwalk, in 1900. This is the old-time Rockaway that lingered in the memories of those who escaped their small city dwellings to catch some of the resort's fresh air and excitement—the beach, the shows, the barkers, the food stands, bathhouses, and of course all the people. Some of these buildings were destroyed in a fire that swept through the area on May 13, 1911. *(Queens Borough Public Library; Weber photo)*

90. Investors in the Rockaway Improvement Company had grandiose plans for their Rockaway Beach Hotel, also known as the Imperial, when they commissioned this drawing for their letterhead in 1879. Construction proceeded on the oceanfront from B.110th to B.116th Street, but the project was undercapitalized and had financial problems from the start. Only a small part of "the biggest hotel in the world"—1,184 feet long and 250 feet wide—was opened to the public in 1881. The derelict building was finally torn down for its lumber in 1889. *(Queens Borough Public Library)*

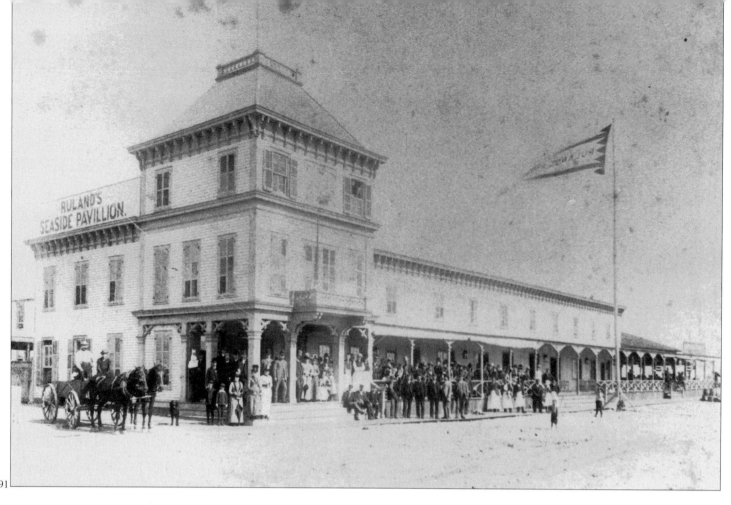

91

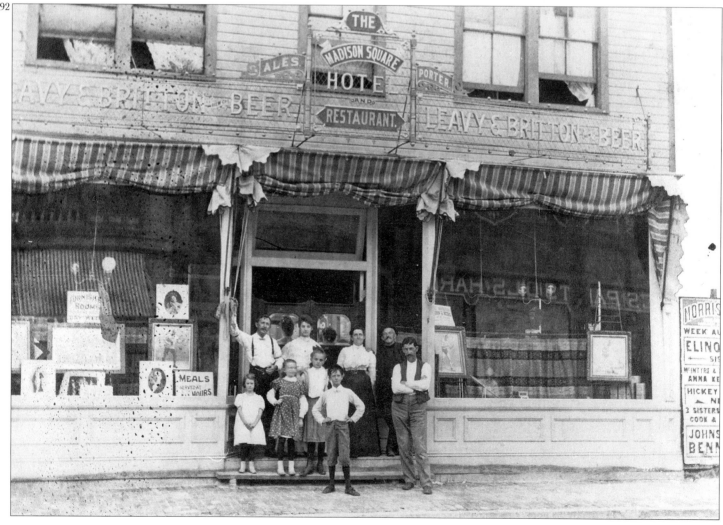

92

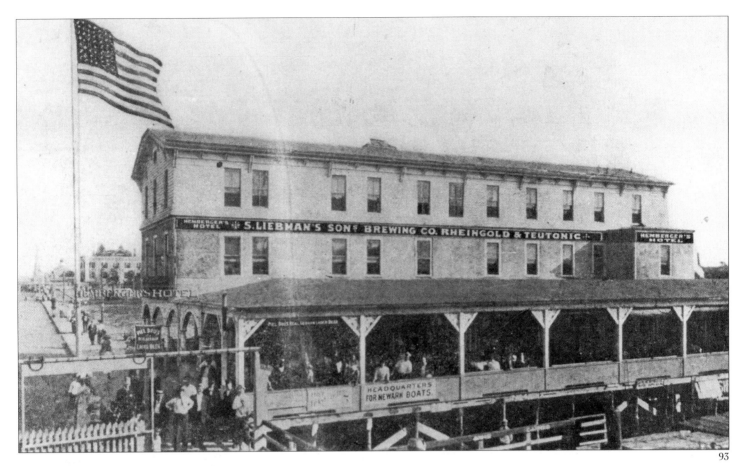

93

~ **91.** Albert Ruland's Seaside Pavilion as it looked in an original photo taken about 1885. The building was moved in April 1877 from its location at about B.27th Street a mile west to a new site, Third Landing (Holland), at B.92nd Street. At this time it was the largest hotel on the peninsula, with about fifty rooms. The building was 200 feet long and 40 feet wide. (*Queens Borough Public Library*)

~ **92.** The Madison Square Hotel and Restaurant was an old-fashioned family establishment where children were part of the family. So was the pugilistic fraternity, judging not only from the pictures in the front windows but also from the name of the establishment—at the time, Madison Square Garden was the premier boxing arena in the U.S. (*Queens Borough Public Library*)

~ **93.** The bay side of the Rockaway peninsula was a popular place to build hotels for the tourist trade. Louis Hemberger's Hotel, on B.98th Street, dates from the 1890s. To accommodate the crowds that came to Rockaway on the steamboats near his property, Hemberger added a second story in 1909 and a third story in 1910. In a custom still practiced today, the hotel sign was dominated, and paid for, by an advertiser, S. Liebman's Sons Brewing Co., of Brooklyn. Their Rheingold brand remained one of the most popular beers in New York City until the 1950s. Note the sign "Headquarters for Newark Boats," indicating that Rockaway was popular with excursionists from New Jersey as well as those who came from New York. (*Robert Stonehill*)

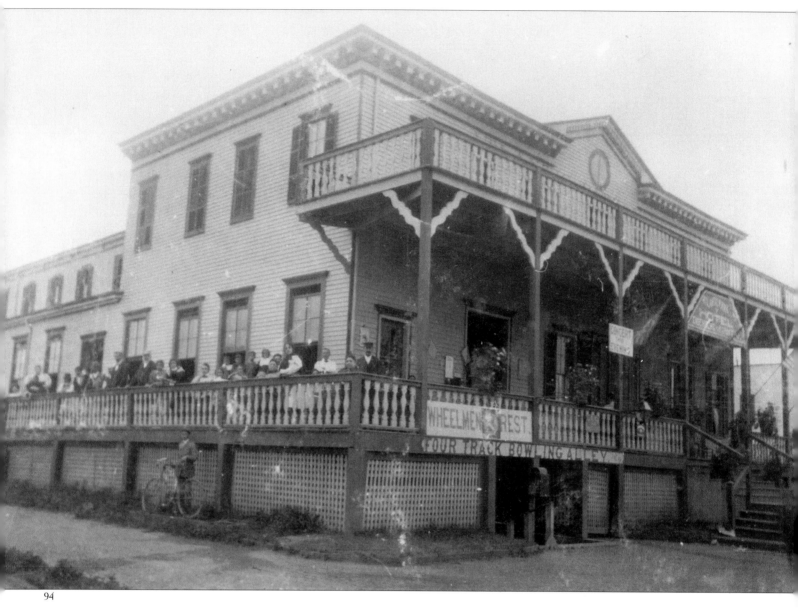

94

~ **94, 95.** The Atlantic Park Hotel at B.75th Street and Rockaway Beach Boulevard *(94)* billed itself as a "wheelmen's rest," to attract bicycle riders to its doors. Cycling became a national fad in the 1890s, the decade when this photo was taken. The Atlantic's bar *(95)* was a popular stop in pre-Prohibition Rockaway. Typical of the time was the elegantly carved black walnut bar, with the back-bar mirror and the overhead kerosene lamp. *(Exterior: Robert Stonehill. Interior: Queens Borough Public Library)*

~ **96.** The staff at the Atlantic Park took time from their work to pose for this photo in 1896. Child labor laws were virtually nonexistent at the time, so cheerful young faces are in evidence among the more careworn adults. *(Queens Borough Public Library)*

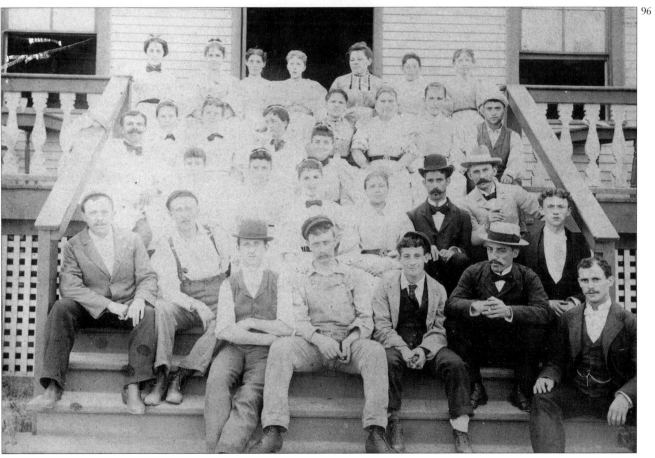

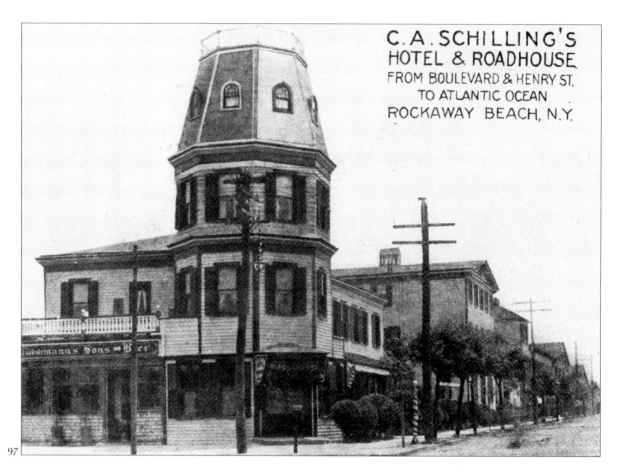

C.A. SCHILLING'S
HOTEL & ROADHOUSE
FROM BOULEVARD & HENRY ST.
TO ATLANTIC OCEAN
ROCKAWAY BEACH, N.Y.

97

∾ **97.** Another favorite stopping place in turn-of-the-century Rockaway was Charles Schilling's Roadhouse at Henry Street (B.102nd Street) and Rockaway Beach Boulevard. The building, remodeled but still recognizable, now houses the Irish Circle, a pub.

∾ **98.** The Bowery around B.102nd Street, in 1910. In high season this area was packed with day-trippers looking for amusement. With fewer people in this photo, probably takene early in the morning, the buildings and their signs are more readily visible. The post prices were low but so were wages; at this time in the U.S. factory workers earned $11 per week, on average. The entrance to Morrison's Theatre is on the left side, center. *(Robert Stonehill)*

∾ **99.** Summer promenaders on the Bowery in 1900, looking west from B.103rd Street. Murray's Pavilion can be seen at the far left, and the northwest edge of Wainwright & Smith is in the right foreground. *(Vincent F. Seyfried Collection)*

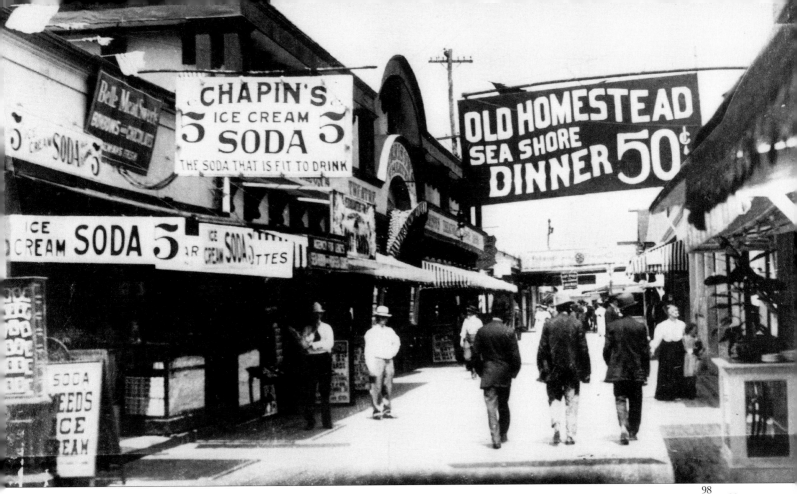

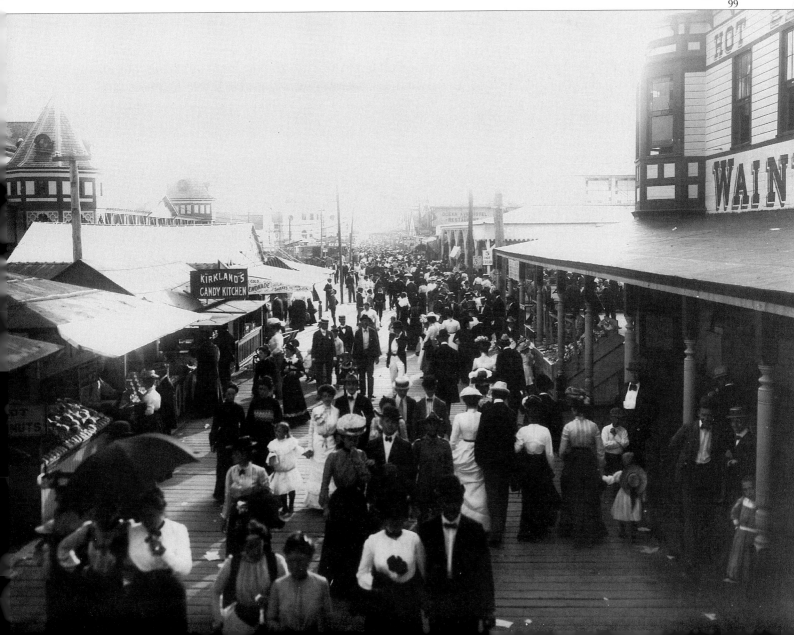

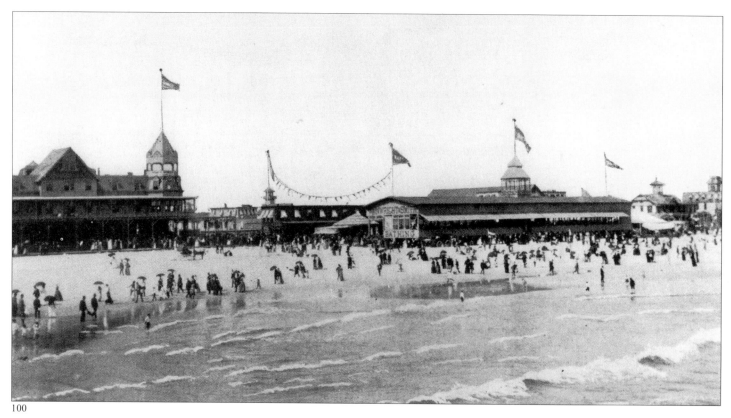

100

～ **100.** Photo taken in 1887 of the oceanfront at B.103rd Street. This is the only known picture of this section before the great fire of September 20, 1892, wiped out almost all these buildings. The long, low building at the right is Wainwright & Smith's original bathing pavilion. *(Emil Lucev)*

～ **101.** The aftermath of the great fire of 1892. Fanned by a stiff breeze from the northeast and fed by the mostly wood construction in the area, the fire raged virtually out of control for days. In the area of devastation, between B.102nd and B.106th Street, the blaze destroyed nineteen hotels, three restaurants, and numerous casinos, concession stands, and amusements. *(Emil Lucev)*

101

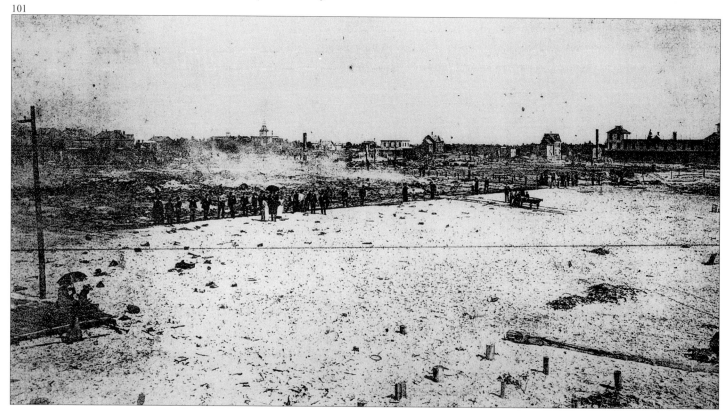

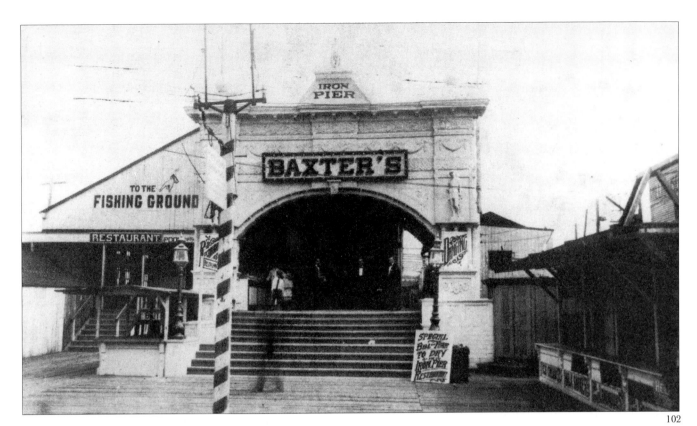

102

~ **102.** The great fire also damaged the Iron Pier at the foot of B.105th Street. The pier was one of the longest in the U.S., about 1,300 feet long and 32 feet wide. Though its owners were quick to rebuild, the pier never recovered its former popularity. The fishing ground advertised at left was at the far end of the pier. At right, a sign advertised "Special Bill of Fare Today" at Baxter's Restaurant. *(Robert Stonehill)*

~ **103.** This map shows Rockaway Beach as it was in 1896. Most of the important places are labeled, with the heaviest concentration of hotels and similar establishments on B.102nd and B.103rd Streets. Rockaway Beach Boulevard, the only east-west through street, is shown close to the railroad tracks. The open sand dunes began at B.121st Street. Like a nautical chart, this map has numbers indicating the depth of the water at mean low tide. *(Queens Borough Public Library)*

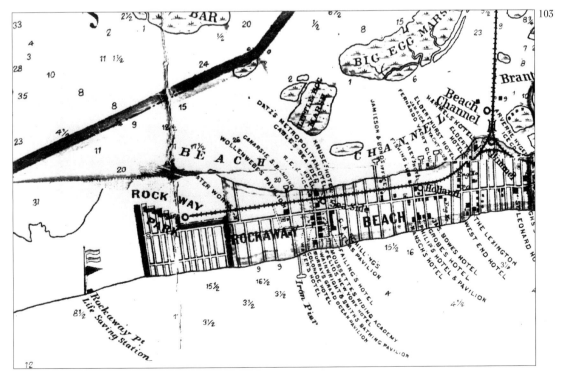

103

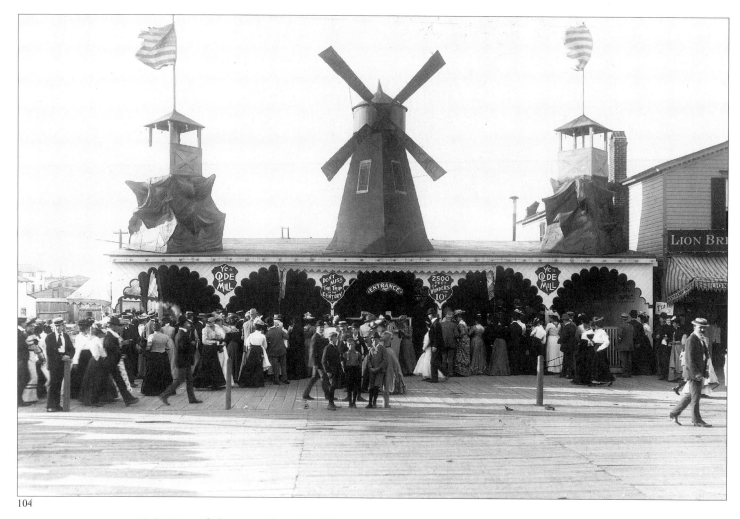

104

~ **104.** One of the great boardwalk attractions at the turn of the century was Ye Olde Mill, just west of B.104th Street. Behind the facade, seen in this 1903 photo, patrons stepped into a small boat and were taken on a fast, lurching ride down a 2,500-feet-long twisting flume that was built to resemble an old-fashioned millrace. *(Weber)*

~ **105, 106.** Two postcard views of Seaside Avenue (B.103rd Street), around 1914. Looking south toward the ocean from Rockaway Beach Boulevard *(105)*, the immigrant presence in this area of Rockaway Beach can be seen in the Deutscher BierGarten, in the right foreground, and in Healy's, an Irish establishment, in the background. Beyond the Curtis sign, at left, is Wainwright & Smith's mammoth beachfront bathing pavilion. Looking north toward Jamaica Bay, in the distance *(106)*, is a closer view of the bathing pavilion and its large sign, at right. In the left foreground is the entrance to the Aunley Carousel. *(First view: Robert Stonehill. Second view: Queens Borough Public Library)*

~ **107.** Interior of Healy's restaurant, 1910. The formal tone of the establishment is set by the staid suits of the men and the extravagant hats of the ladies. The bentwood chairs and white tablecloths are typical of turn-of-the-century restaurant decor. *(Queens Borough Public Library)*

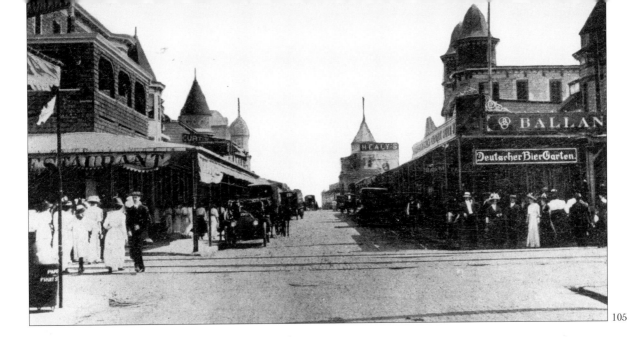

105

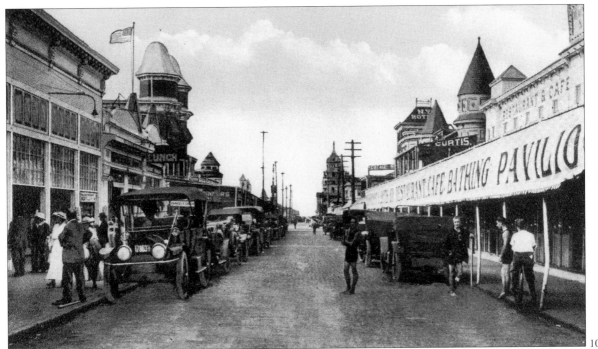

106

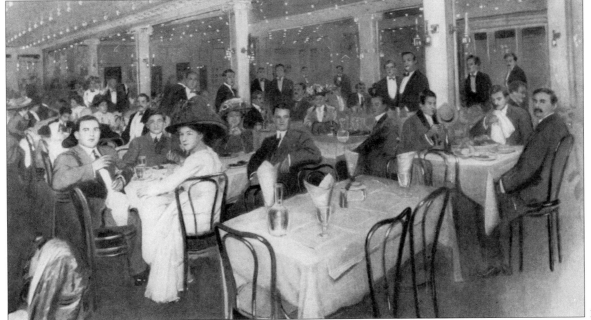

107

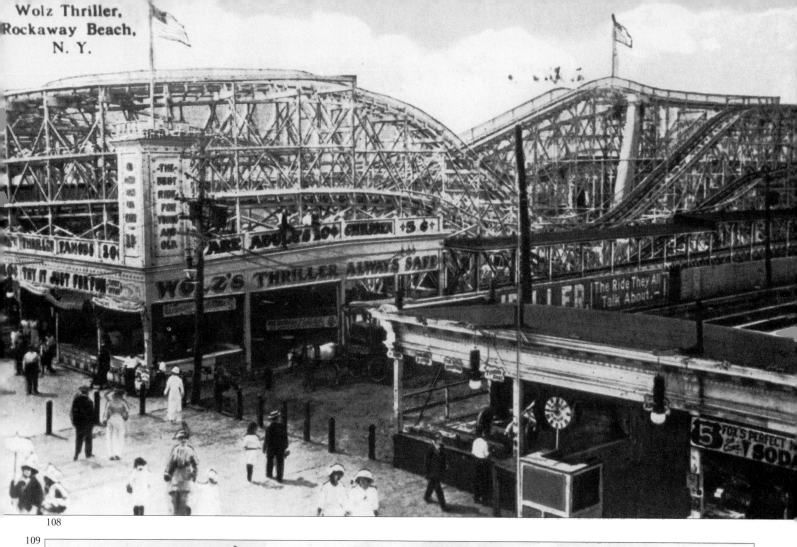

108

109

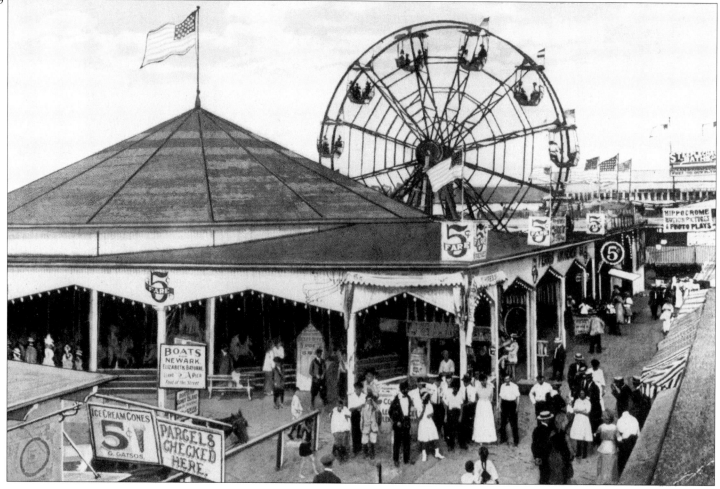

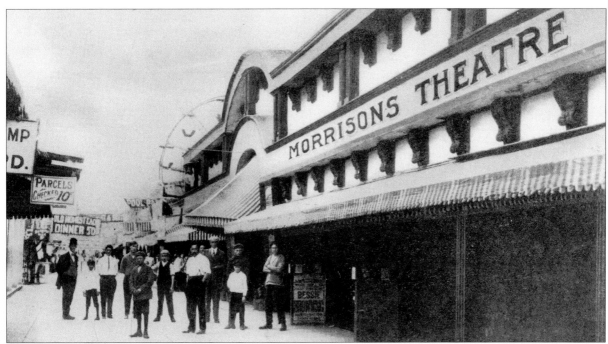

~ **108.** Wolz's Thriller, at the foot of B.104th Street and the boardwalk in 1916. This "Always Safe" ride was one of the longest-lasting amusements at Seaside, finally being torn down in 1937 to make way for a project that many in Rockaway felt was a ruinous boondoggle, Robert Moses' Shore Front Parkway.

~ **109.** Along the boardwalk east of B.101st Street around the turn of the century were two favorite beach amusements, then and now, the carousel and the Ferris wheel. *(Robert Stonehill)*

~ **110.** Morrison's Theatre was on the northwest corner of the boardwalk and B.102nd Street. In its day, the theatre featured such great names as Charlie Chaplin, Mae West, and prizefighter-turned vaudeville performer James J. Corbett. This postcard view dates from 1912.

~ **111.** A 1912 view of the American Music Hall, which was on the corner of the Bowery and B.105th Street and was managed by impresario William Morris. It was part of Deimling's Pavilion, an entertainment center where, as the sign at the left said, "basket parties" were welcome. These convivial groups brought their own food in a picnic basket and generally bought drinks and other refreshments from the house. *(Robert Stonehill)*

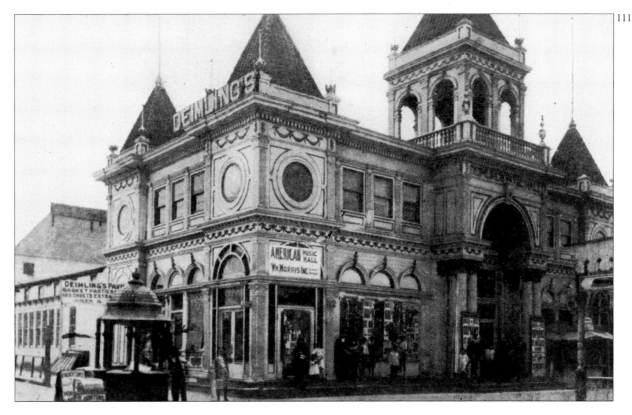

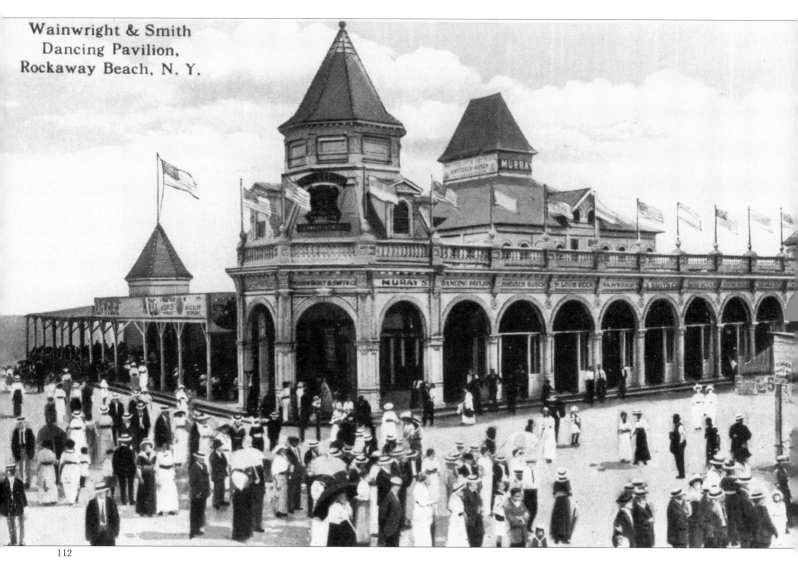

Wainwright & Smith
Dancing Pavilion,
Rockaway Beach, N. Y.

112

∾ **112, 113.** Murray's Dancing Pavilion was part of the Wainwright & Smith complex on the beach. This postcard view *(112)* around the turn of the century shows the ladies in their light-colored, long skirts and the gentlemen in jackets, ties, and straw hats. Inside the pavilion *(113)*, couples gather on the dance floor for the promenade, July 4, 1908. The orchestra is against the wall, in the background. *(Robert Stonehill)*

113

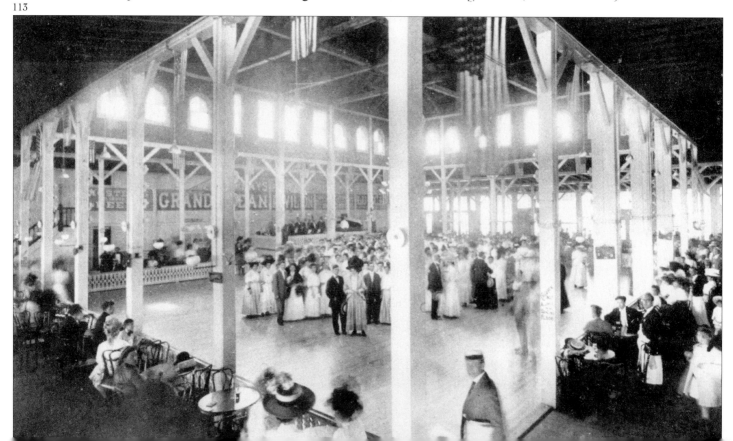

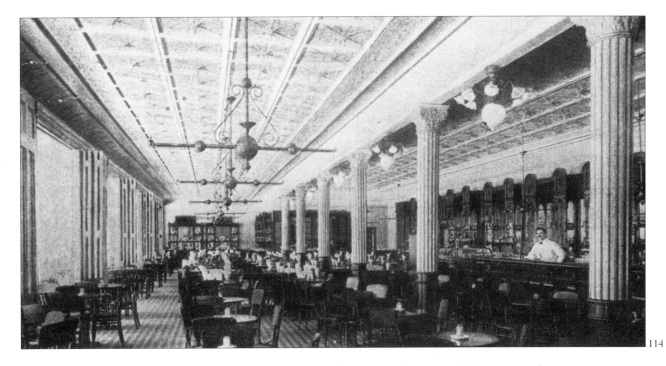

∽ **114.** The vast dining room and bar of Wainwright & Smith's was another great attraction. This was clearly a high-class establishment, with substantial wooden tables and chairs that were a cut above those found in most other Rockaway restaurants. Among other features of this grand room were the tin ceiling, large mirrors behind the bar, and classic columns. A combination of gas-jet chandeliers and electric globes supplied the lighting.

∽ **115.** Wainwright & Smith's Bathing Pavilion was built on pilings that went to the water's edge and beyond, depending on the tide. On this hot summer day in 1904, most of the people on the beach seem to have no intention of joining the bathers frolicking in the surf. Just visible slightly to the left of center is a capped hawker selling bananas and peanuts.

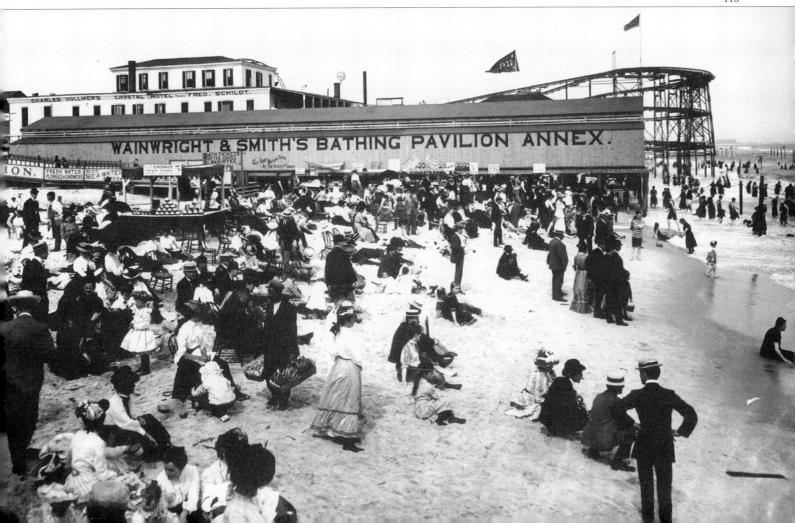

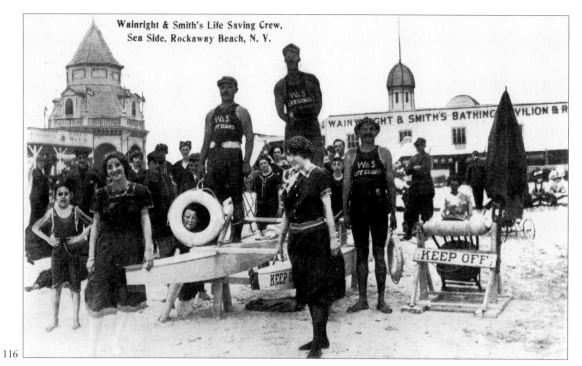

Wainright & Smith's Life Saving Crew,
Sea Side. Rockaway Beach, N. Y.

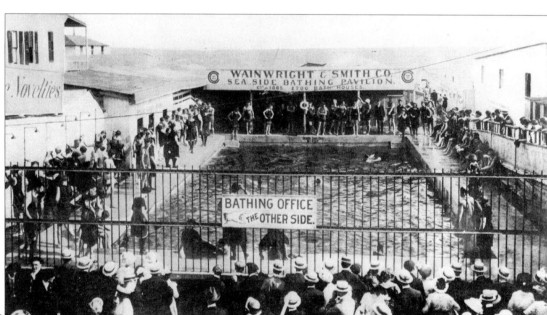

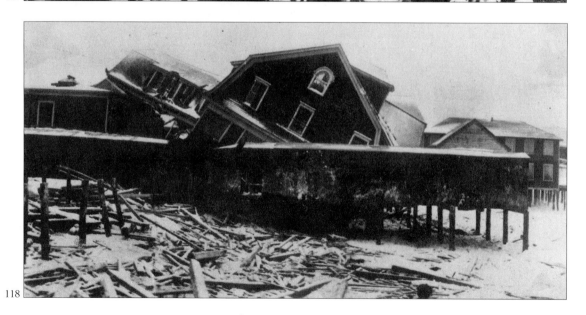

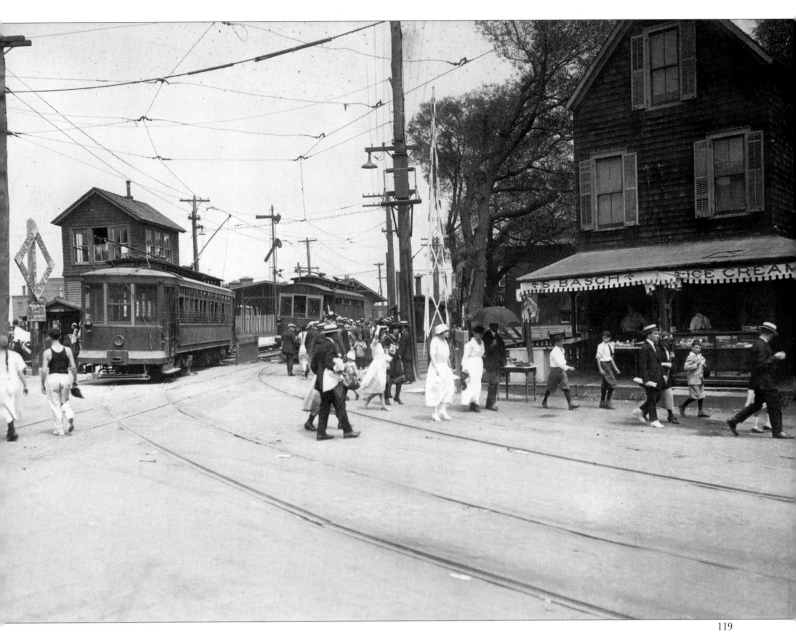

⚓ **116.** Wainwright & Smith's staff of sturdy lifeguards stood ready to rescue anyone caught in the surf. As today, the guards attracted their share of bathing beauties. In fact, lifeguards were rare at the turn of the century, and so were pictures of them. No lifeguard observation towers are in evidence here, but skiffs and life preservers are ready for use. *(Library of Congress)*

⚓ **117.** Not an Olympic-size pool but a good place to cool off for those who chose to suit up. As at the beach, most customers were content to watch from the sidelines. Nevertheless, the open showers at left attracted many patrons, and Wainwright & Smith's "2700 Bath Houses" were steadily occupied on hot summer days. *(Robert Stonehill)*

⚓ **118.** The great storm of February 1920 devastated the Rockaways and toppled many buildings, including the Pasadena Hotel at B.86th Street. High tides and surging seas pounded the beaches for several days and caused major property damage. *(Underwood; from the New York Herald)*

⚓ **119.** Hammels Junction, 1921. The trolleys ran from the Far Rockaway railroad station to this point, where many of the passengers debarked to head for the boardwalk and other attractions. The cars then turned and ran on B.84th Street to Rockaway Beach Boulevard, where they turned again and headed west to the dunes of Neponsit. Most of the men were in their Sunday-best suits and straw skimmers, the ladies in dresses, hats, and high heels. Most of the skirts were still long, but a few were in the latest short fashion. The cars stopped running in 1928. *(Municipal Archives)*

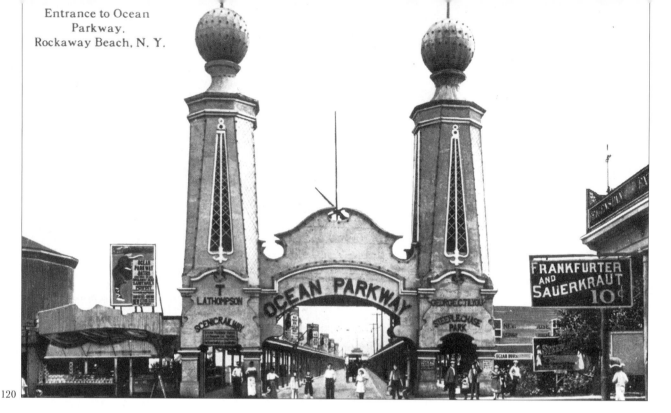

120

120. George C. Tilyou and L.A. Thompson were rivals in Coney Island but became partners in a Rockaway Beach venture, a giant oceanfront amusement complex opened in 1902. At the right is the entrance to Tilyou's Steeplechase Park, at the left is the entrance to Thompson's Scenic Railway. Ocean Parkway was a two-block-long thoroughfare to the boardwalk, with this welcoming gate at Rockaway Beach Boulevard and B.98th Street.

121, 122. The boardwalk end of Ocean Parkway was a busy place during the summer of 1910, the date of this postcard view *(121)*. Note the classical bathing figures that decorated the roof. Inside the amusement center, Thompson's scenic railway *(122)* was one of the main attractions. A bit rickety by today's high-tech standards, the coaster was decorated with a large mural of a Rocky Mountain scene, at left.

123. The beachfront facade of Rockway's Steeplechase amusement complex was about 1,000 feet long. This 1919 photo shows three successive stages in men's bathing attire: the long woolen suit to the knees, with apron; the somewhat shorter one-piece suit without apron; and the latest fashion, a two-piece suit with belt, which gained favor during the 1920s. *(Robert Stonehill)*

121

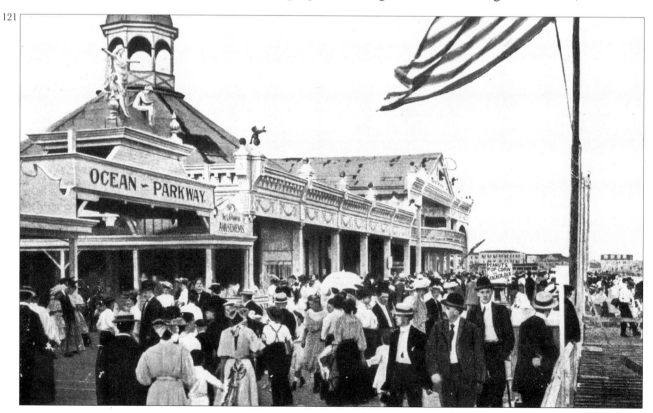

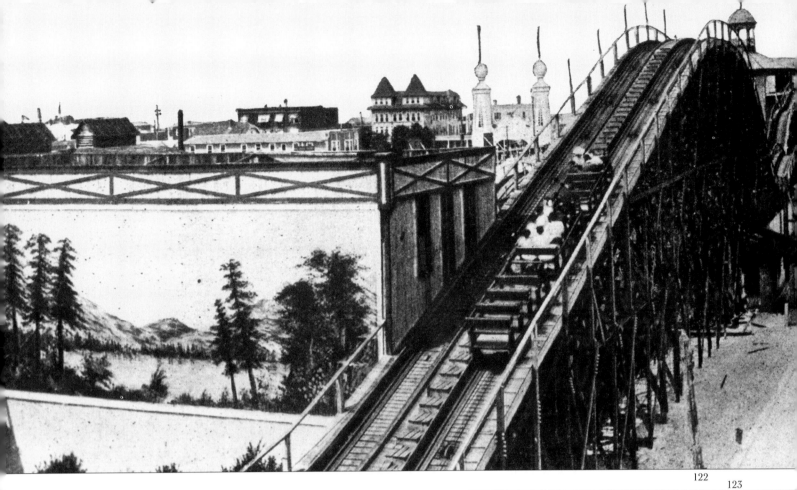

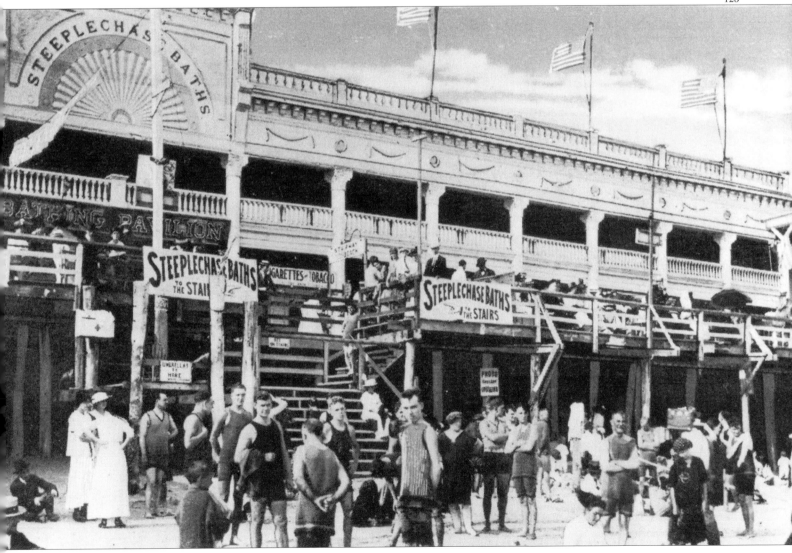

124. The beach had a different look in June 1934, when well-known lifeguard "Taps" Cullen kept a sharp eye on ocean bathers from his umbrella-covered tower. Wearing one of the cut-out suits popular in the 1930s, Cullen was ready to drop down the firehouse-type pole to help any swimmer in trouble. The boardwalk in the background, off B.102nd Street, has many fewer tourist attractions than it did thirty years earlier.

125. For many summers William E. Auer pitched the tents for his Steeplechase Camp on the sand at B.97th Street. The tents were leased by the month or by the season and could accommodate a family. Many had wooden porches in front, with fanciful names to identify one tent from the next. This 1912 photograph shows one side of the camp in the shadow of the scenic railway, "a spectacular ride." *(Robert Stonehill)*

126. Another campground, F. C. Chaffee's tent city off B.108th Street, opened in 1901 and continued in business until 1920. The rents ran from $18 to $64 per month and included city water and gas connections. Many families came back year after year and even planted little flower gardens in front of their open-air vacation homes. *(Charles Huttenen)*

127. Browne's Court, on the boardwalk at B.95th Street, offered eight rows of cottages for rent, each with two or three bedrooms, small sitting room, kitchen, and bath. The cottages offered more protection from the elements than the tents, but were stuffy and overheated in the summer sun. And there was always the danger of fire. This postcard view dates from around 1915.

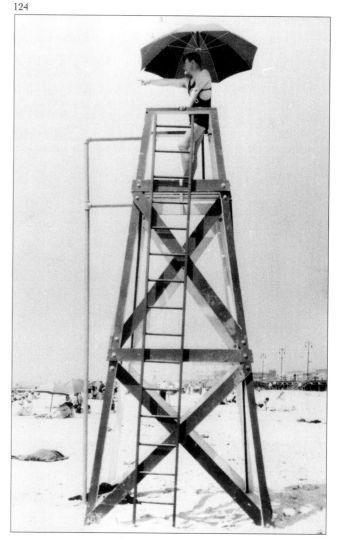

125

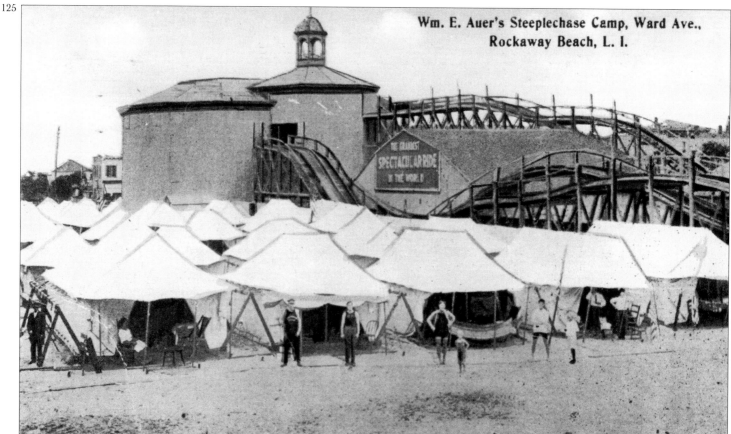

Wm. E. Auer's Steeplechase Camp, Ward Ave., Rockaway Beach, L. I.

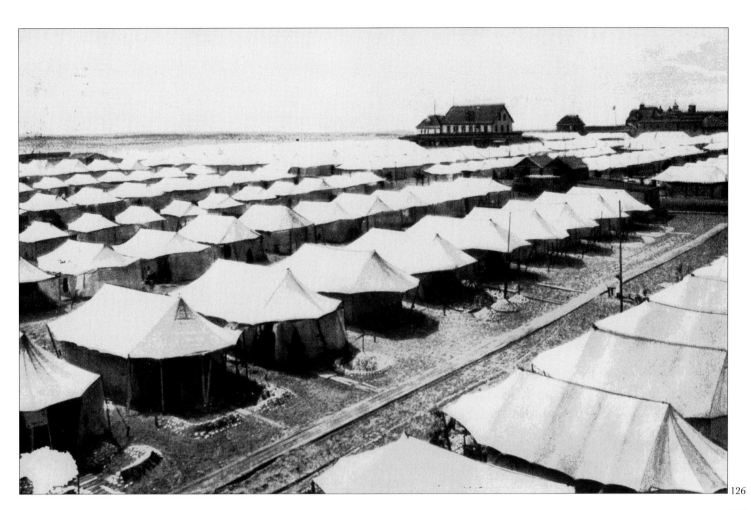

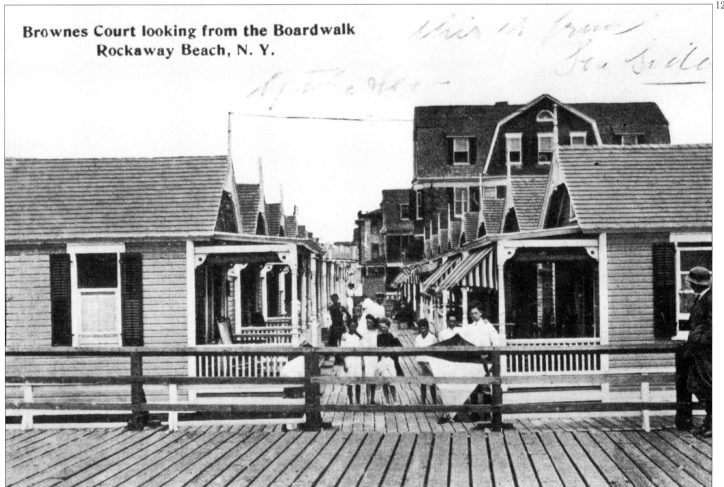

Brownes Court looking from the Boardwalk
Rockaway Beach, N. Y.

128

128. Louise Court, part of the Hollywood Cottages development on Rockaway Beach Boulevard and B.101st Street, had twenty-eight rental units. The trees, shrubs, and other greenery gave the place a cool suburban look. Judging from the length of the skirts, this photo was taken during the 1920s. The cottages are among the few still standing on the Rockaway peninsula. *(Robert Stonehill)*

129. This row of summer homes was built out into Jamaica Bay from Java Street, Hammels, around 1912. This postcard view shows the west side of the houses, with the common walkway giving access to each house.

130. The Holland Avenue pier was the property of a private association of about thirty clubs and individual homeowners who shared the cost of maintaining the structure. Among the establishments on the pier were two boat clubs, Amity and Woodruff, the Jefferson Yacht Club, and the Bayview Hotel. The area was filled in during 1923, and the boardwalk is now B.92nd Street.

131. Nearby the Holland Pier was the Jamaica Bay Yacht Club, built in the middle of a long pier stretching out into Jamaica Bay from B.90th Street. The club was founded in 1892 and had a membership of about 250. This 1915 photo was taken from the north end of the pier, toward the shore.

129

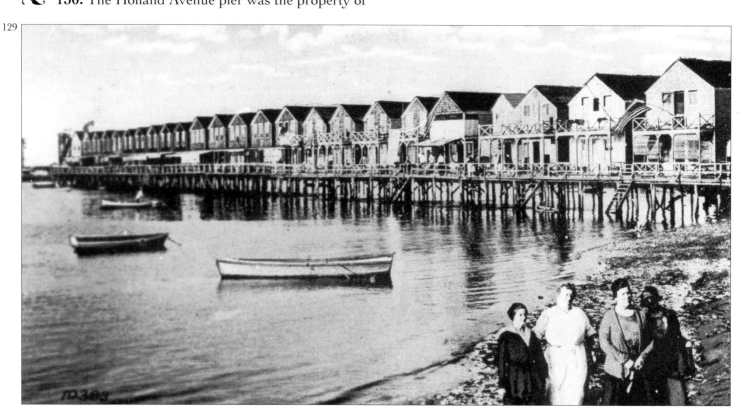

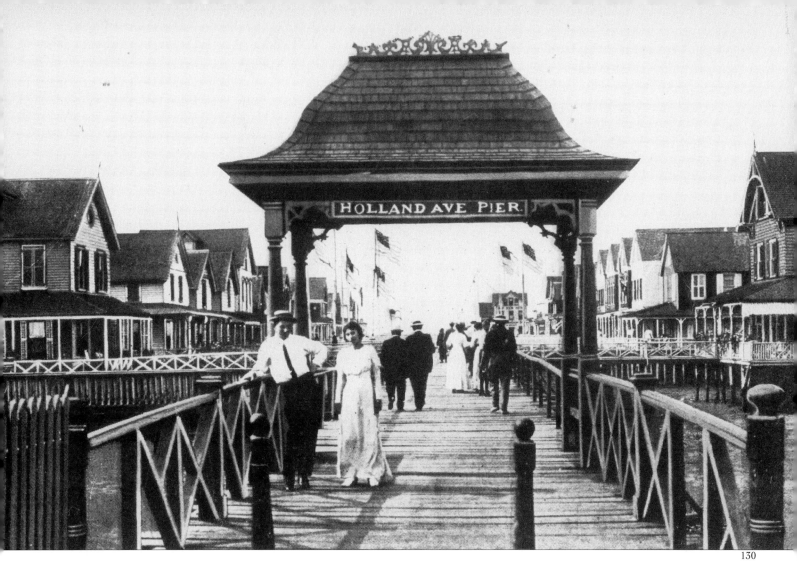

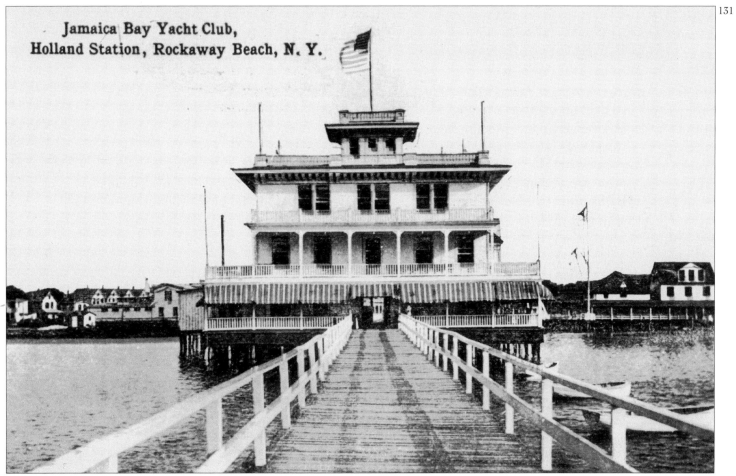

Jamaica Bay Yacht Club,
Holland Station, Rockaway Beach, N. Y.

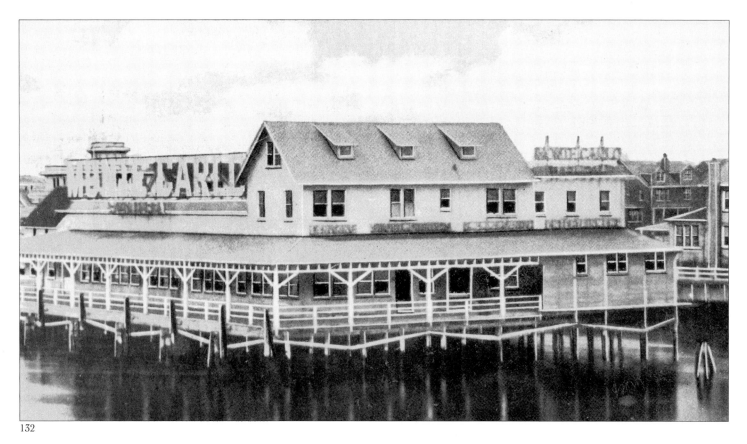

132

~ **132.** The Monte Carlo, a nightclub built for the prosperous 1920s, was opened in 1930 on the bay at B.92nd Street. As the Depression deepened, the club was sold and renamed the Moulin Rouge by the new owners. The first juke box in the Rockaways was installed in the club. *(Robert Stonehill)*

~ **133, 134.** The oceanside boardwalk at Holland *(133)* in 1918 was a pleasant place for a stroll or to "take the waters" at Dunn's Lucerne Baths or the Holland Baths. Just two blocks east, at B.91st Street, this section of the boardwalk came to an end at the Oriental Hotel *(134)*, seen in this 1912 postcard view. *(Robert Stonehill)*

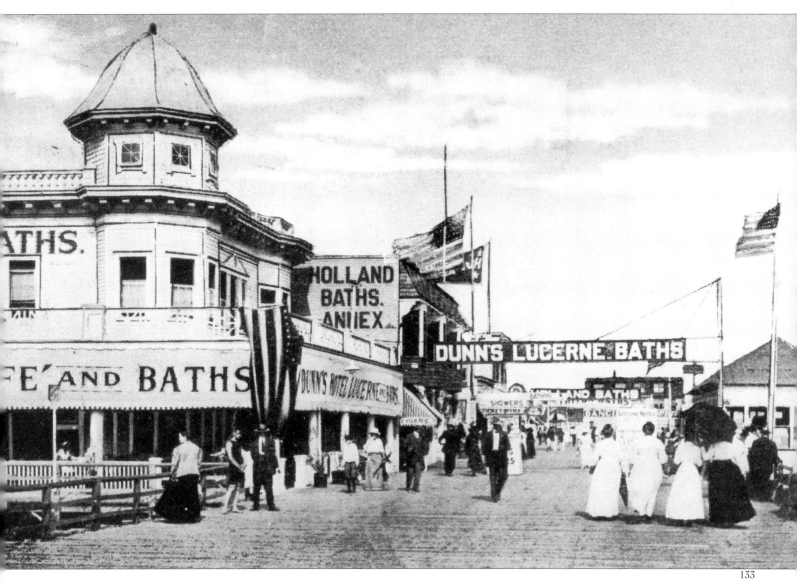

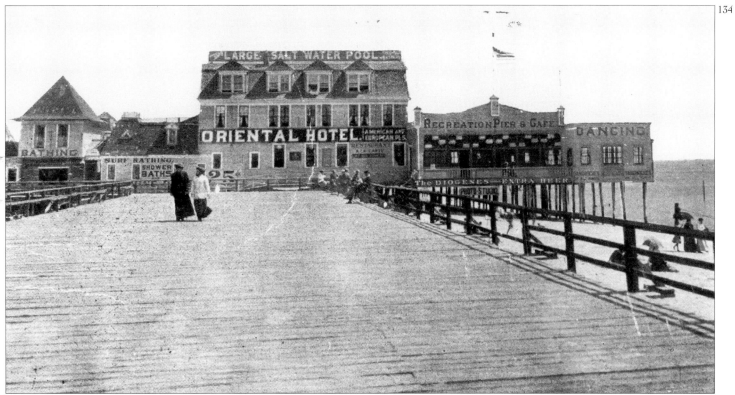

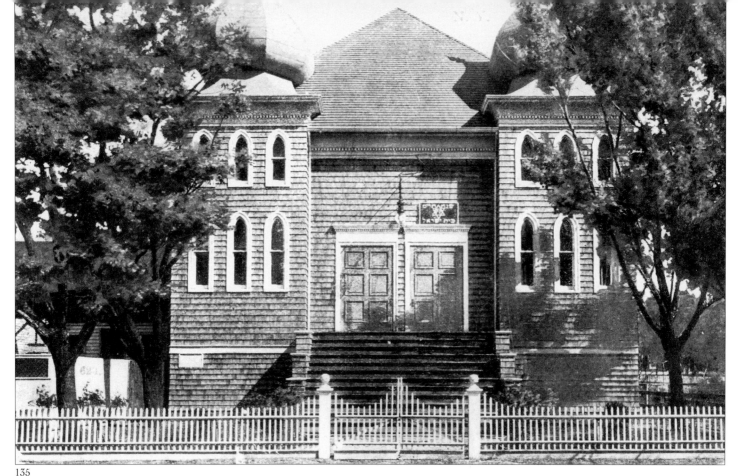

135

136

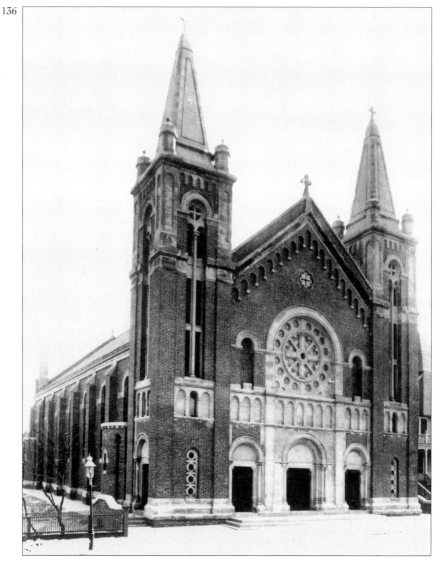

〜 **135-137.** Away from the boardwalk and other tourist areas, religious institutions played an important part in the life of Rockaway Beach. Temple Israel *(135)* was built in the shingle style in 1900, on B.84th Street just south of the Boulevard. Expanded to include a school and social center in 1905, the building burned to the ground in 1920. Also on B. 84th Street was St. Rose of Lima R.C. Church *(136)*, built in 1907 to accommodate about 1,000 people. The parish had been organized in 1886 in a small wooden church. The First Congregational Church *(137)* was founded in 1881 and, after worshipping in several smaller buildings, moved to this site on B.94th Street in 1899.

〜 **138.** Midway between Temple Israel and St. Rose of Lima on B.84th Street was Magnolia Cottage. The windmill was a unique structure in the Rockaways, but the "cottage" itself was typical of the dozens of boardinghouses that opened in the Rockaways around the turn of the century. The Victorian look was enhanced by the scalloped shingles, decorative half-timbered detail in the roof triangles, steepled tower, and of course the wrap-around porch. The site is now occupied by the St. Rose of Lima parochial school. *(Charles Huttenen)*

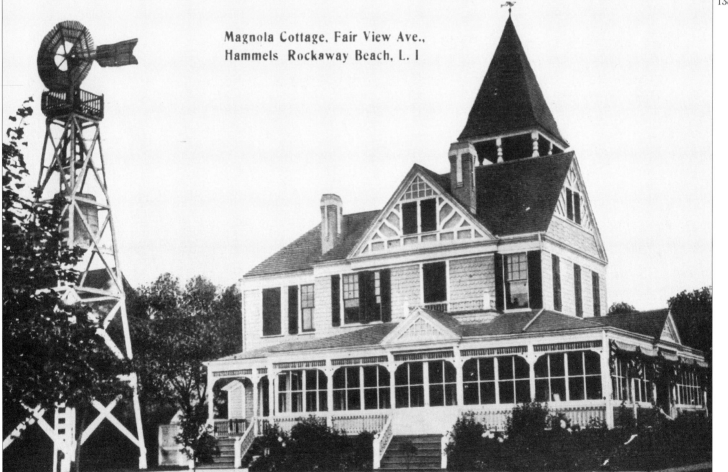

Magnola Cottage, Fair View Ave.,
Hammels Rockaway Beach, L. I

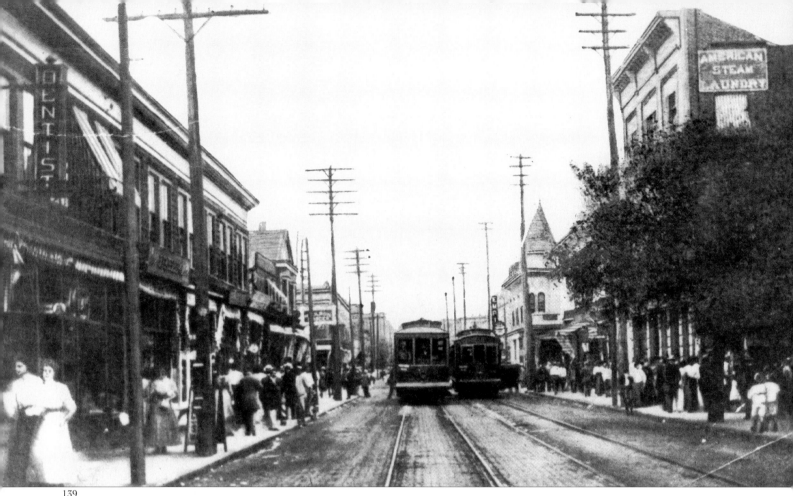

139

140

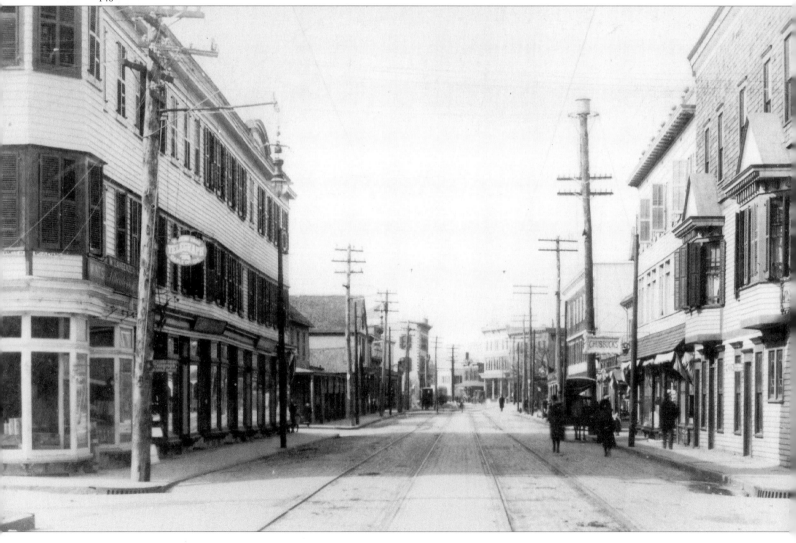

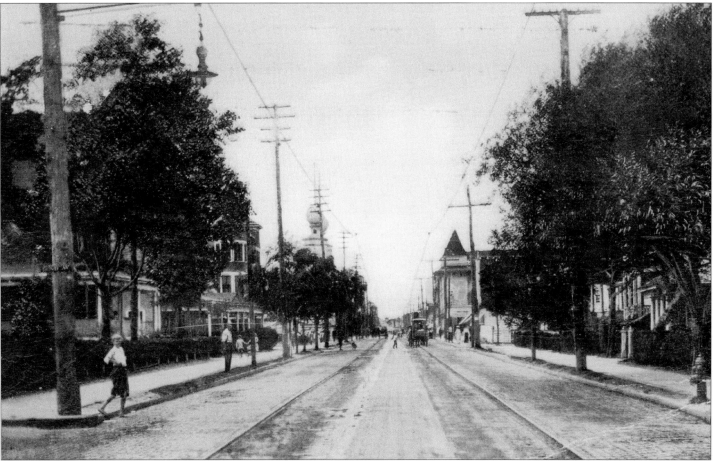

141

139. Looking east along Rockaway Beach Boulevard from B.85th Street, about 1908. The thoroughfare was only about fifty feet wide, leaving little room for vehicles to pass even in an era when automobiles were rare. Most people took the trolley car or walked. The Boulevard's handsome red brick paving was barely able to hold up under the vehicular traffic that increased year after year.

140. Looking west along Rockaway Beach Boulevard from B.85th Street, in the off-season around 1905. Small stores of all kinds lined the street. At the right front is Mary Pachinger's Saloon, a favorite watering-hole. The telegraph and cable office at the left was a busy place in the days when telephones were relatively rare. *(Robert Stonehill)*

141. With its private homes nestled beneath shade trees, Rockaway Beach Boulevard at B.96th Street in 1912 looked more like the main street of a small town than of a busy beach resort. Two blocks down, on the left, are the towers marking the Boulevard entrance to Steeplechase Park.

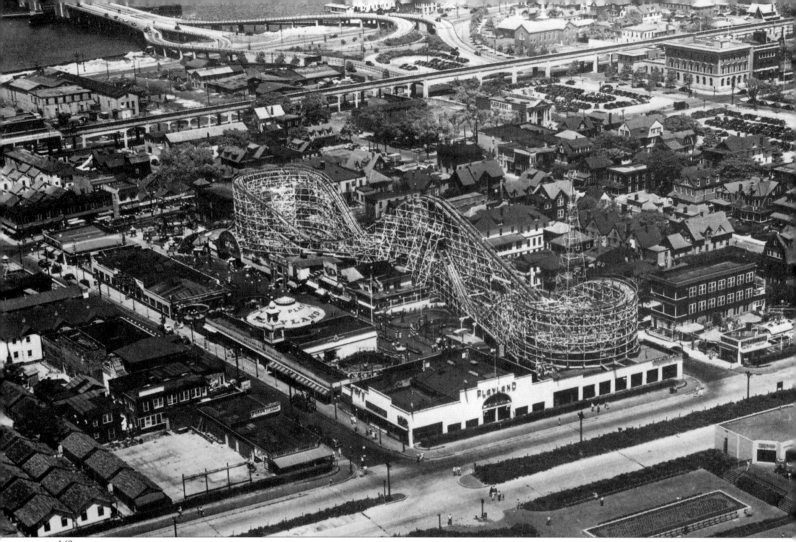

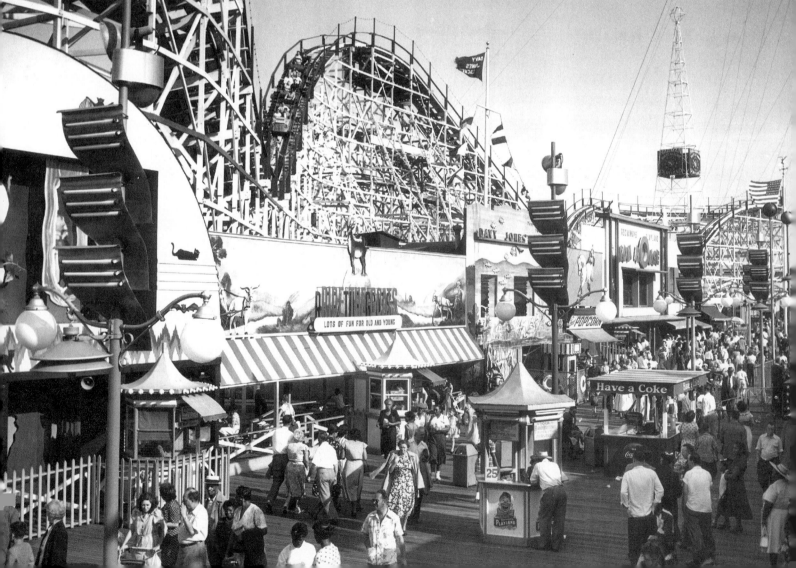

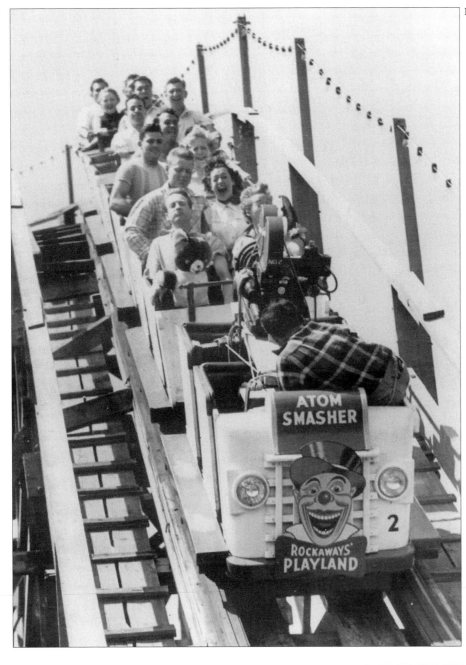

145

142. This view of Rockaways' Playland in 1945 also shows a good cross section of the heart of Rockaway Beach. At the top of the photo is the traffic interchange where Cross Bay Boulevard enters the peninsula. The viaduct nearby, running from left to right, was built by the Long Island Railroad in the early 1940s and became part of the New York City subway system in 1956. The three-story building in the upper right-hand corner, which looks like it belongs in Manhattan, is a New York City police station house. In the lower left-hand corner is a tightly packed old bungalow colony, and in the foreground is Shore Front Parkway, the highway that Robert Moses planned to connect the Rockaways with Atlantic Beach and points east. (*Queens Borough Public Library; courtesy Rockaway Chamber of Commerce*)

143. Crowds were still enjoying the scene on the midway inside Playland, August 3, 1956. The complex was the last surviving amusement park in Rockaway. Increasing expenses and slowly dwindling patronage finally forced the park to close in 1987. The rides and buildings were destroyed or sold for salvage, and the large site was still vacant at the turn of the new century. (*Queens Borough Public Library; courtesy Rockaway Chamber of Commerce*)

144. Keeping up with the times in the Nuclear Age, Playland renamed its roller coaster the Atom Smasher in the 1950s. The movie camera in the front seat was not usually part of the ride, but the expressions on the faces of the riders were much the same as they had been in earlier decades at Playland, ranging from delight to terror to resignation. (*Emil Lucev*)

145. One of the last Long Island Railroad trains out of the Rockaways enters the Hammels station in October 1955. The New York City subway trains began running on these tracks in June 1956. (*Vincent F. Seyfried*)

Rockaway Park and the Western Section

The land to the west of Rockaway Beach was the last to be developed, and most of the construction in the area took place in the 20th century. In fact most of the land itself did not exist until the late 19th century, according to early maps of the area. A U.S. Government Survey of 1812 shows the Rockaway peninsula ending at about the present location of B.137th Street. Most of the western section was formed naturally, as wind, storms, and regular tides washed sand from east to west. Much of the beach land that was eroded away from the Hamptons and Fire Island and, indeed, eastern Rockaway came to rest at the western end of peninsula. This natural process has been interrupted in the 20th century by dredgers keeping the Rockaway Inlet channel open between the peninsula and Manhattan Beach, Brooklyn.

ROCKAWAY PARK

One of the narrowest sections of the Rockway peninsula, Rockaway Park is bounded by B.110th Street on the east and B.126th Street on the west. The human presence in this area was sparse until tracks of the New York, Woodhaven and Rockaway Railroad were laid in 1880. In March 1890 the president of the Long Island Railroad, Austin Corbin, purchased a large parcel of land connected with the mammoth Imperial Hotel project. This land comprised most of what has come to be known as Rockaway Park. The LIRR's real estate subsidiary, the Long Island Land Improvement Company, took possession and set about to create a seaside colony of cottages and villas. Washington Avenue—essentially an extension of Rockaway Beach Boulevard—was laid out with a mall down the center from B.116th to B.129th Street. The Rockaway Improvement Company, another LIRR subsidiary, was in charge of developing the tract. Early on the company bought the western third of the old Imperial and remodeled it into the new Rockaway Park Hotel. The company also began improving the land, dividing it into building lots (a total of about 11,000), and constructing homes and hotels and putting in conduits for gas, electricity, and water.

Development began in earnest after 1900, when a boardwalk was built and twenty-three acres of bay flats were filled in. A new brick schoolhouse, P.S. 43, was built in that year, complementing P.S. 44 in Rockaway Beach and P.S. 42 in Arverne. By 1902 Rockaway Park had grown to a community of about 100 cottages, and by World War I it was attracting large crowds of summer visitors.

B.116th Street became the hub of the community, with its stores, restaurants, banks, and the Park Theatre, rivaling even Far Rockaway's Central Avenue. The Rockaway Chamber of Commerce has its office on this bustling thoroughfare of commerce.

Despite its early appeal as a summer resort, Rockaway Park, especially in its western parts, is essentially a year-round residential community. This is true today more than it ever was.

BELLE HARBOR

What with the effects of shifting sands and shifty real estate operators, along with a lack of natural landmarks, the property of western Rockaway was subject to endless litigation that seemed a throwback to the early days of Far Rockaway. Finally, in 1900, a New York state court ordered that a large block of land just west of Rockaway Park be sold at auction. Edward P. Hatch, son of one of the men who had been involved in the litigation, bought all of what is now Belle Harbor and Neponsit. Within two years he flipped the property, selling it to a corporation named the West Rockaway Land Company. The company then sold off the far western section and began developing the rest of the tract, from what is now B.129th Street to B.141st Street, as a community of substantial year-round homes. The president of the company was Frederick J. Lancaster, the man who had developed Edgemere. With his penchant for classy-sounding names, he named his new place Belle Harbor.

Beginning in 1903 the company had work crews in the sand, leveling the dunes, laying out the streets, installing water, gas, electric, and now telephone lines. Most streets were seventy feet wide, paved with macadam and flanked by sidewalks. Trees suitable to the oceanfront climate were planted. The development office was in the heart of Rockaway Park, on B.116th Street opposite the Long Island Railroad station. Salesmen sold lots in blocks of three, with four required for all corner locations. All sales carried restrictions on the cost and style of architecture of all homes to be constructed. Believing in the development's potential for price appreciation, the company declined to sell its oceanfront property.

Access to Belle Harbor presented some problems at first, until the land company made arrangements with the Ocean Electric Railroad, another subsidiary of the LIRR, to extend its trolley line into the community along Newport Avenue as far as B.138th Street. Completed in 1909, the single-track line ran down the center of the tract, so that no resident had to walk more than two blocks to reach public transportation. A second track was laid four years later.

The Belle Harbor Yacht Club was organized in 1903, and the Roman Catholic Church of St. Francis de Sales was established in 1906; two years later the parish church was built. Lots sold steadily if slowly over the years, until finally, in 1915, with World War I threatening to destabilize business in the United States, the land company elected to close out all of its unsold land. To facilitate a quick sale they eased restrictions in the development. Lots thirty feet in width gave way to smaller, twenty-foot parcels, with asking prices dropped accordingly to bring in more potential buyers. In all, 679 lots were put up for sale, including many on the bay. Two absolute auctions were held, on July 31 and August 2, 1915. By the close of business, virtually all the vacant, unsold land in Belle Harbour, including the company's waterfront properties, was in the hands of individual owners.

During the booming 1920s and even into the 1930s, hundreds of houses were built all over Belle Harbor, so that by World War II the area was almost completely developed. No boardwalk was ever extended into the community, emphasizing the residents' desire to remain remote from the outside world. And so it remains today, an area of affluence and quiet, set apart from the rest of New York City.

NEPONSIT

The name Neponsit, like the name Rockaway, has been attributed to more than one source. The company that developed the land stated that the name was Indian for "place between the waters." But it has also been claimed that Neponsit was the name of one of the Indian sachems who sold Rockaway to the English settlers in 1685. From its beginning in 1909 the Neponsit Realty Company was bent on creating an exclusive community for affluent homebuyers. A large workforce soon turned sand dunes into streets and laid a model sanitary sewer system. Rockaway Beach Boulevard was extended through the community, 100 feet from curb to curb with a landscaped mall in the center. The entrance to the community was marked by a massive ornamental gateway.

Neponsit Realty Company organized a subsidiary to construct homes according to the designs of an in-house architectural firm. The same plans could be used only four times within the bounds of the development. The architects strove to create an aura of solidity and permanence, while using light colors on the exterior to suggest a vacation resort. Most of the houses had walls of stucco laid over hollow tile bricks. The roofs were of tile to reduce the risk of fire spreading from lot to lot. By the spring of 1911 twenty-five houses ranging in size from five to nine rooms had been built. These first houses were on the south side of

Newport Avenue, between B.143rd and B.149th Streets. In 1914 the community expanded toward the bayside.

Neponsit's remote location posed something of a transportation problem until the developers agreed to pay half of Ocean Electric Company's costs of extending its trolley line from B.138th Street to B.147th Street. The cars began running on July 5, 1912, and four years later the line was extended to B.149th Street. In 1913 the developers made arrangements for the steamship *Cymbia* to make regular trips between the Neponsit Beach Club and Lower Manhattan, presumably for commuters to the financial district. The trip was scheduled to take about seventy minutes.

The Neponsit Realty Company made additional efforts beyond transportation to lure homebuyers to the community. In 1912 it constructed a yacht club two-and-one-half stories high with an ornate pillared entrance and spacious front and side porches. Behind the clubhouse was a bulkhead where residents could tie up their boats all year long. The company also sponsored such community events as motorboat races and lawn tennis tournaments. Of course, access to the ocean remained a prime feature of the development. The beach was kept free of bathhouses and other facilities that might attract the general public. The ocean-front building lots were 100 feet back from the high water line. This space allowed less room for storm damage amd erosion than in other areas, but at this western end of the peninsula accretion, not depletion, was the norm.

On August 16, 1919, the Neponsit Realty Company conducted a final auction of unsold lots in order to liquidate its affairs and retire from business. By this time the central section of the development had been pretty well built up, especially on the south side. Building continued through the booming 1920s. During the 1940s and '50s Neponsit attracted a number of judges and politicians, including two mayors, William O'Dwyer and Abraham Beame. Celebrities such as Judy Garland and comedian Sam Levenson were also in the area. The Marine Parkway Bridge from Flatbush Avenue, Brooklyn, and the new Shore (Belt) Parkway was opened in 1937, at which point the most remote part of Rockaway became perhaps the most accessible.

JACOB RIIS PARK AND BREEZY POINT

Shortly before the First World War the City of New York purchased a section of Neponsit for $1,250,000—worth about $40 million in 2000. Because the bulk of this property was to be used for a public park, the site was named after Jacob Riis, the Danish-American writer whose muckraking books like *How the Other Half Lives* exposed the squalid living conditions of New York's poor. In addition to the park New York City built a large hospital at the site's eastern end, mainly for tubercular patients who were thought to benefit from the curative features of sea air.

For various reasons the park remained unfinished for many years. This section of Rockaway was easily accessible only by automobile, and comparatively few New Yorkers owned cars. The construction of the Marine Parkway Bridge, which carried cars as well as shuttle buses from the end of the IRT subway line, gave new impetus to the development of Riis Park.

Perhaps the most important event in the park's history occurred in May 1919, when the first successful transatlantic flight was launched at the property's northeast corner. Despite the great importance of this flight, which was much celebrated at the time, the episode remains largely forgotten today.

Riis Park is east of the bridge. The area to the west includes Roxbury, Rockaway Point, and Breezy Point. This area boasts one of the most spectacular vistas in the New York area, encompassing the Atlantic Ocean, Jamaica Bay, as well as the distant skyscrapers of Manhattan. An early owner of this property was Collis P. Huntington, president of the Central Pacific Railroad and one of the American "robber barons." At first a Coast Guard and Life Saving Station was the only building in the area. Shortly after 1900 a tent city was created, and in the 1920s some bungalows were built as summer rentals.

From the start Breezy Point attracted an Irish-American population. Gradually, permanent structures were built, mainly one- and two-family frame homes insulated for winters. This small community, fiercely independent, has vigorously fought off all attempts to develop the area with high-rise apartment buildings. Despite the geographic reality, residents have tended not to think of themselves as being in the Rockaways. Perhaps to emphasize this separateness theirs have always been gated communities, a very early example of this phenomenon in New York City. With the government's acquisition of land for part of the Gateway National Recreation Area, an influx of outsiders may yet occur. Nevertheless, at this writing Breezy Point continues to retain its original character.

Rockaway Park

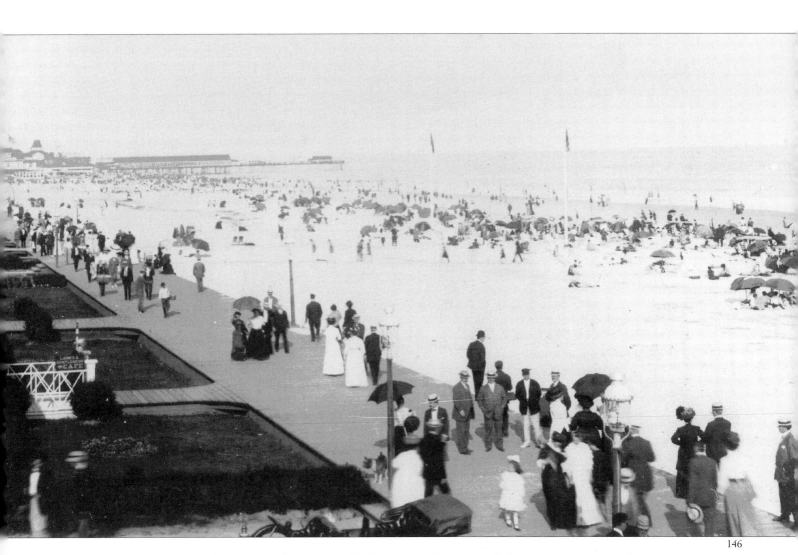

146

~ **146.** Rockaway Park at B.116th Street at the turn of the century was a clean, refreshing seaside resort that attracted bathers, boardwalk strollers, and other vacationists. At the time the boardwalk was just that—boards nailed together on a wooden foundation resting directly on the sand. Experience soon proved that going to the expense of raising the walk above the highest storm tides would eliminate the necessity of rebuilding the walk every few years. *(Robert Stonehill)*

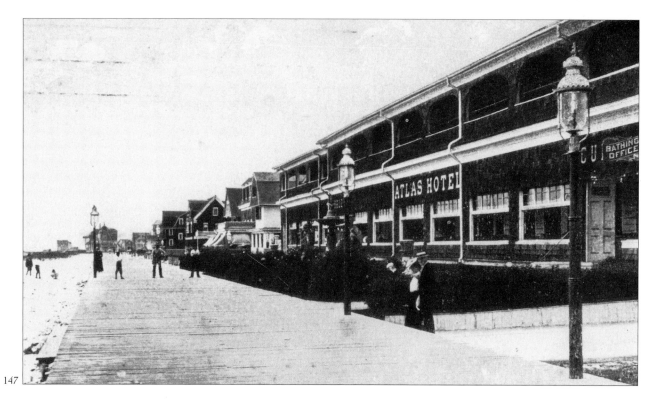

147

147. Gaslights once illuminated the boardwalk in front of Curley's Atlas Hotel and Baths, making for romantic strolls on balmy summer evenings. John J. Curley first came to Rockaway in 1876 and opened his first oceanfront Atlas Hotel at B.102nd Street. It proved to be a popular place, especially among New York's Irish population, and Curley was able to open this larger, more modern establishment at B.116th Street around 1900.

148. Curley's remained one of Rockaway's most successful businesses until well after World War II. The hotel's symbol was the famous pose struck by Atlas as he held a celestial globe on his shoulders. His statue can be seen dimly on the roof at the right, in this photograph taken in August 1933. Beach and boardwalk attire was typical of the time. *(Robert Stonehill)*

148

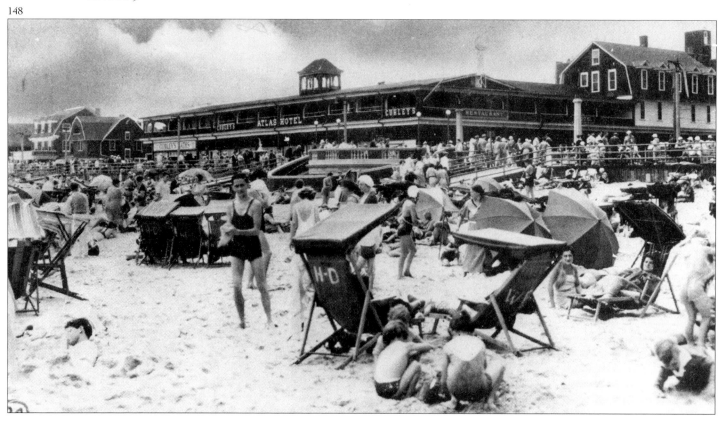

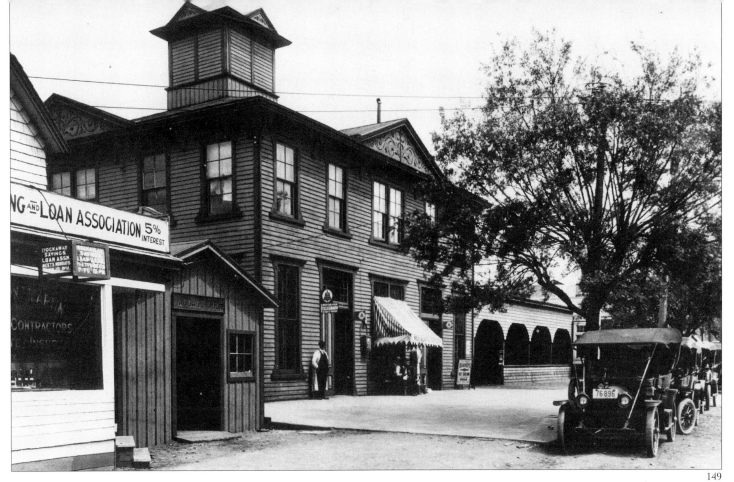

149, 150. The original railroad station on B.116th Street *(149)* was built for the New York, Woodhaven & Rockaway Railroad in 1882. The second floor held the offices of the superintendent, dispatcher, and telegrapher and a private suite for the president. The evocative photograph of the waiting room and ticket office on the ground floor *(150)* was taken in June 1916. This scene was replicated in thousands of towns across the United States. The potbelly stove, iron and wood benches, and kerosene lamps were probably there from the beginning. The ceiling-hung electric bulb, phone booths, and newsstand belong to the 20th century. A new brick station was built in 1917. *(Exterior: Vincent F. Seyfried Collection. Interior: Presbrey photo)*

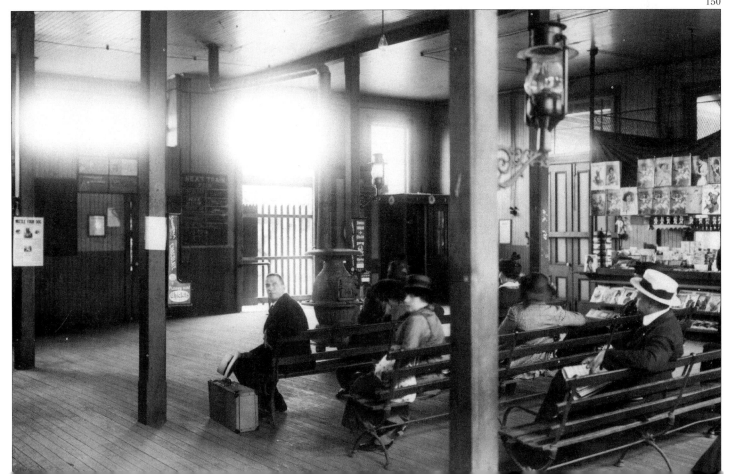

151

~ **151.** This view of the Rockaway Park station platforms and rail yards—empty now but often crowded, especially on weekends and holidays—was taken in 1916 from the station window. The Long Island Railroad was enormously important to the growth of Rockaway in the resort's early days, as were trolleys like those laid up on tracks at the right. In the foreground are the tracks of a turnaround loop used by the Brooklyn Rapid Transit cars, which ran all the way to the Williamsburgh Bridge. *(Presbrey photo)*

~ **152.** Early in the 20th century small gas stations appeared on America's main streets. This vintage photograph was taken on the commercial strip of B.116th Street, between Rockaway Beach Boulevard and Newport Avenue, around 1920. The curbside pump, the tire-filled display window, the uniformed attendant, the straw-hatted customer, and the capped truck driver were typical of the times. *(Vincent F. Seyfried Collection)*

152

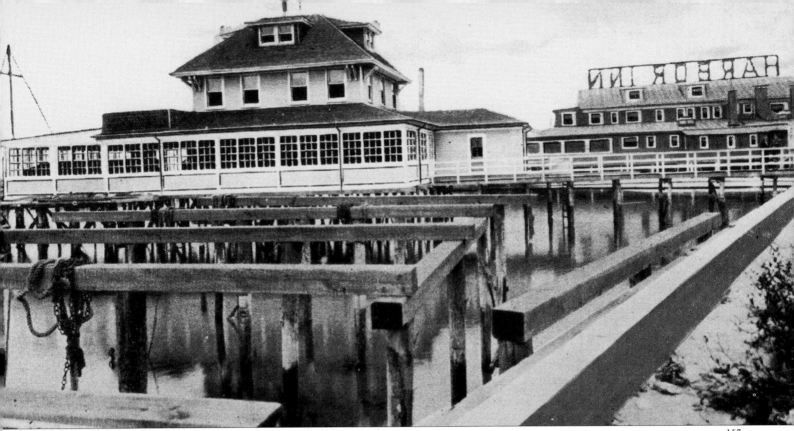

153. Jamaica Bay was the site of many yacht clubs and other facilities not suited to exposure to the ocean. The Rockaway Park Yacht Club and Harbor Inn was at the foot of B.117th Street, off Beach Channel Drive. The club was founded in 1915 with ninety-six members and remained in operation through the 1920s.

154. At roughly the midpoint of Rockaway Park, on Rockaway Beach Boulevard between B.120th and B.121st Streets, is Washington Circle. Around 1900 the surrounding neighborhood was built up with substantial year-round houses.

154

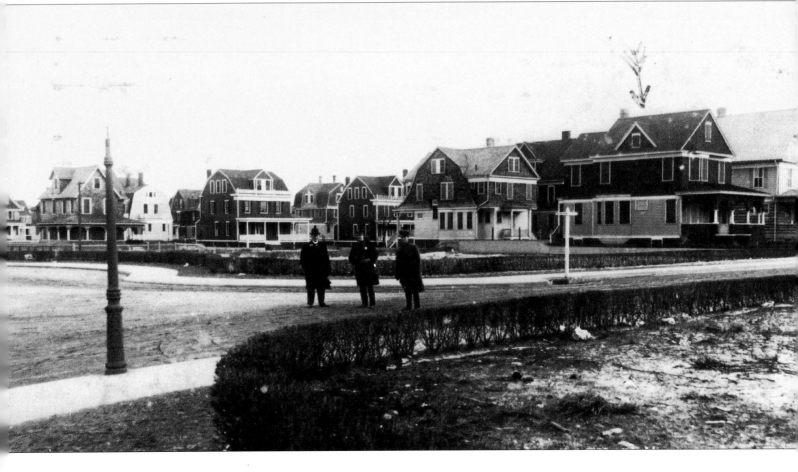

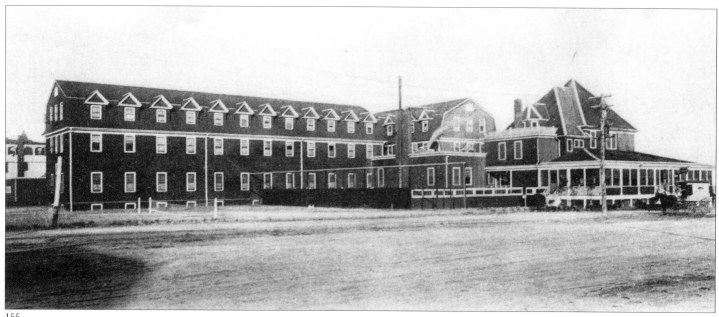

155

156

155. The largest hotel in Rockaway Park was the Park Inn, on the boardwalk at B.116th Street. This photograph was taken in 1905.

156. Typical of Rockaway Park's smaller hotels and boarding houses was the St. Anthony (formerly Mattern House), on B.113th Street. As pictured in 1916, the building was far from luxurious, but it served a practical and worthy purpose: providing a vacation at the beach for people of modest income.

157. The old-fashioned gas lamp at the right and the electric utility poles in the background suggest a time of transition between two different eras. This postcard view of B.119th Street, looking south toward the beach, dates from about 1918.

158. The commercial center of Rockaway Park, B.116th Street, in 1944. The marquee of the Park Theatre advertises a film starring Jimmy Durante and the Harry James Orchestra, "2 Girls and a Sailor." After a decline that began in the 1960s, the street began to show signs of a revival in the 1990s.

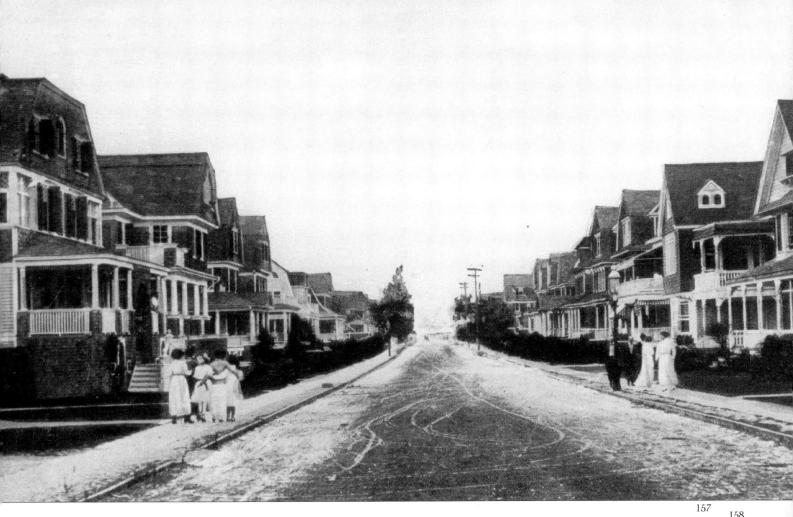

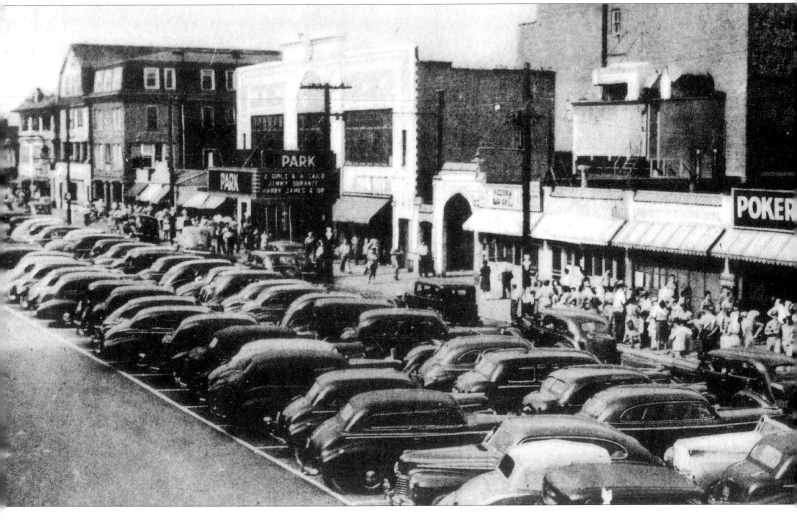

Belle Harbor

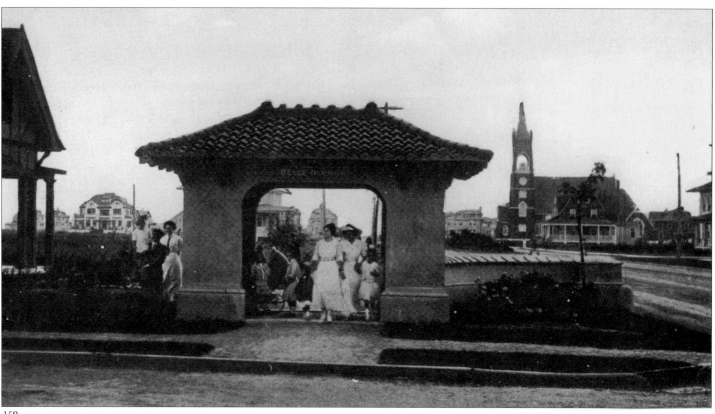

159

↬ **159, 160.** The official entrance to the West Rockaway Land Company's development in Belle Harbor was on Rockaway Beach Boulevard and B.127th Street. In this postcard view of the area *(159)* about 1915, the most prominent landmark is the Roman Catholic Church of St. Francis de Sales. The California Spanish style, with its tiled roofs and stucco walls, was popular at the time. In the second view of entrance *(160)*, about fifteen years later, the trees have grown to provide ample shade for the many houses now lining the Belle Harbor streets. Several years after this photo was taken, the gateways were torn down. *(Robert Stonehill)*

↬ **161.** Typical of the many real estate subdivisions on the Rockaway peninsula early in the 20th century, Belle Harbor was touted in advertisements and promotional brochures as a good investment. Significantly, the copy in this 1912 advertisement described the development not as just a summer resort but as an "ideal spot for an all-the-year-round home." Unlike many claims of developers, this one turned out to be accurate. In the 1990s some Belle Harbor homes sold for over $1 million. *(Vincent F. Seyfried*

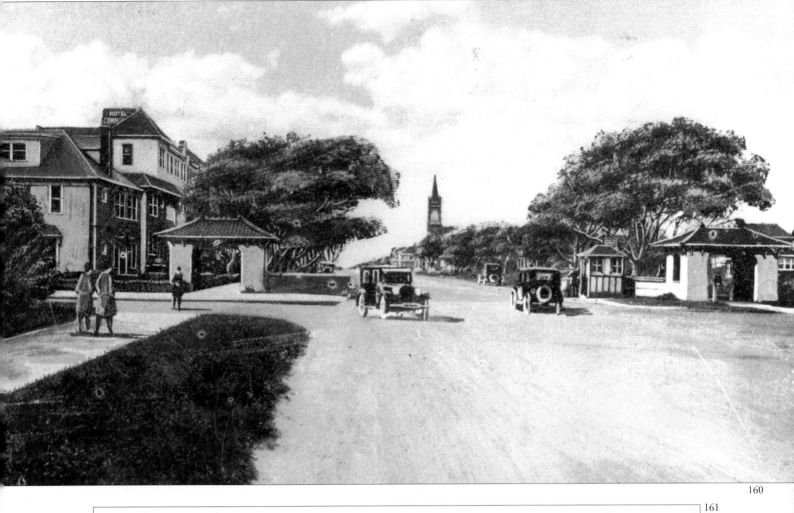

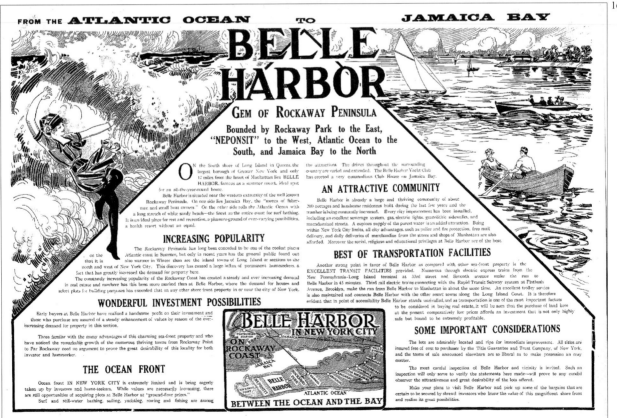

162. An important transportation link in the early 20th century was provided by the trolley car. The Ocean Electric Railroad ran cars from Far Rockaway west to Neponsit. Here passengers on Newport Avenue, Belle Harbor, boarded at the rear door, where the conductor collected the five-cent fare from each. The billboard at the right advertised an "absolute auction sale" of 700 Belle Harbor building lots. *(Vincent F. Seyfried Collection)*

163. New houses line this built-up section of Newport Avenue in 1915. Paved streets, wide sidewalks, and all public utilities are in place. *(Vincent F. Seyfried Collection)*

164. Hotels were relatively rare in Belle Harbor because the developers' aim was to keep the community primarily residential. The Belle Harbor, seen here in a view from August 1911, was a small, family-style residential inn that accommodated a limited number of summer guests. What would otherwise have been an ordinary roof line was enlivened by sets of bracket supports divided by arched dormers. *(Robert Stonehill)*

165. The stucco and tile Hotel Commodore was built in 1927, one of a few small, elegant establishments among the private homes of Belle Harbor. The hotel, at the corner of Rockaway Beach Boulevard and B.127th Street, was torn down in the 1970s. *(Robert Stonehill)*

166. The Belle Harbor Yacht Club on Jamaica Bay between B.126th and B.127th Streets was founded in 1905. Membership numbered 200 by 1908 and 500 by 1920. This promotional souvenir showed not only the long pier that provided dock space for members' boats but also views of the rooms inside the large clubhouse. The building and its pier were demolished during the construction of Beach Channel Drive in the 1930s. *(Robert Stonehill)*

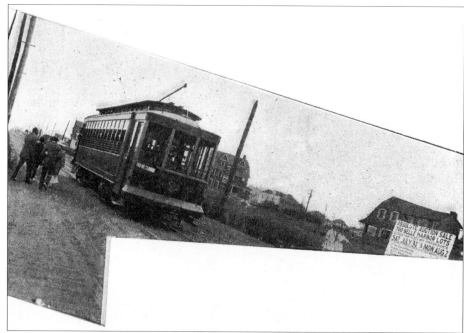

162

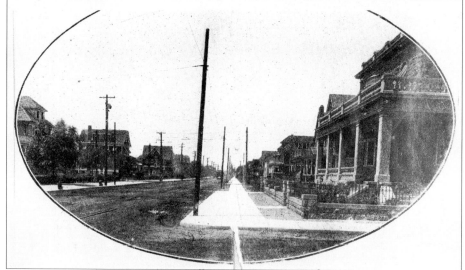

163

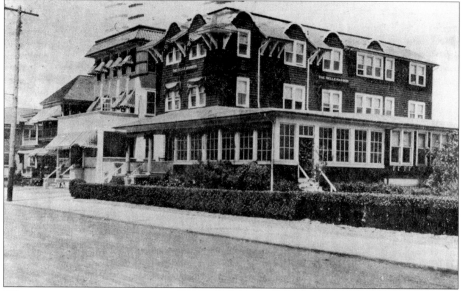

164

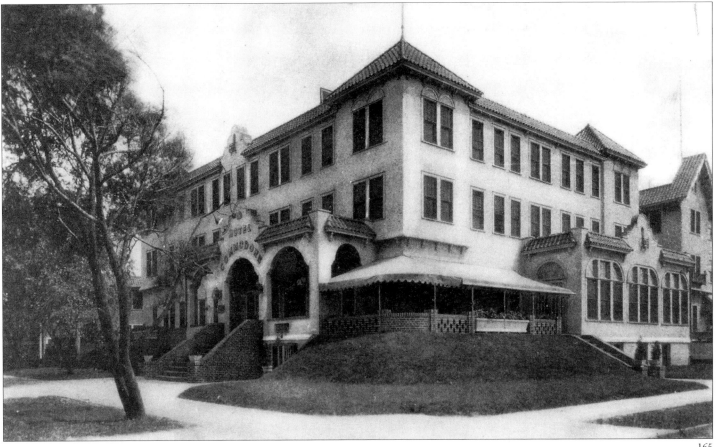

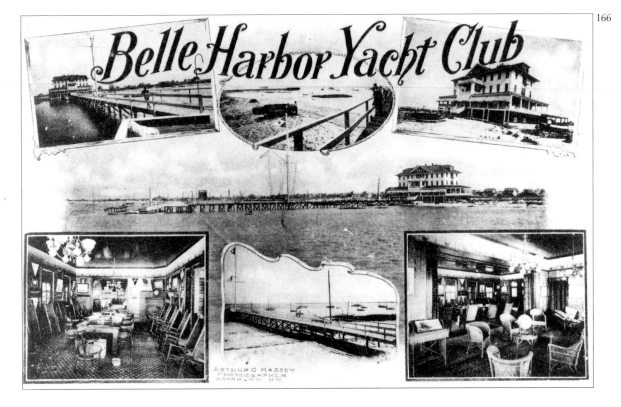

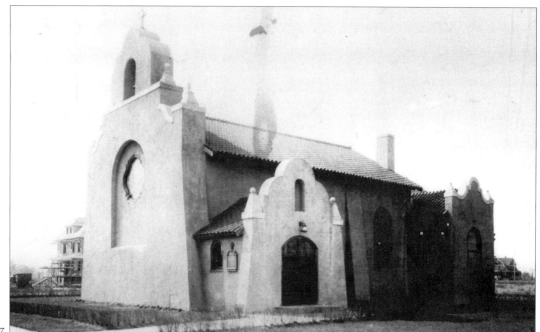

167

167. St. Andrew's Protestant Episcopal Church, seen in this early postcard view, was established in 1906 as a mission. In fact, the building bears more than a passing resemblance to the Spanish missions built in California during the 18th century. The land for the church, on Rockaway Beach Boulevard and B.125th Street, was donated by the West Rockaway Land Company. An adult home now occupies this site.

168. Another religious institution established in 1906 was the Roman Catholic Church of St. Francis de Sales. This building was opened on July 21, 1907, and a school and convent were added to the complex six years later. The large wooden structure burned to the ground in 1935, and was replaced two years later by a church with brick walls.

169. Most of the homes built in Belle Harbor between 1906 and 1917 were large, rambling structures with spacious porches and many windows. These "cottages" on Rockaway Beach Boulevard at B.131st Street are typical of the domestic architecture of the period.

170. By the 1930s Belle Harbor was an established year-round residential community. This view, looking north on B.127th Street from the beach, dates from 1935. The house styles are as varied in design, height, and landscaping as the tastes of their owners.

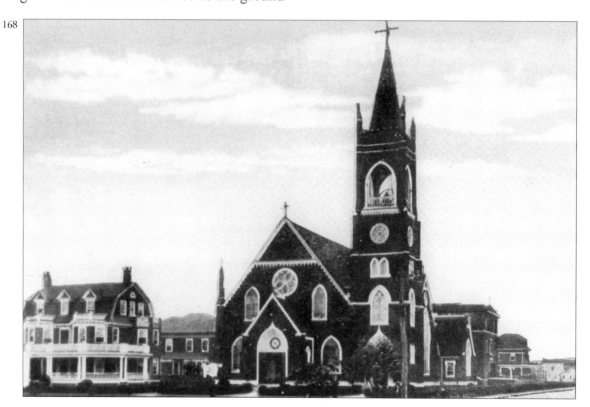

168

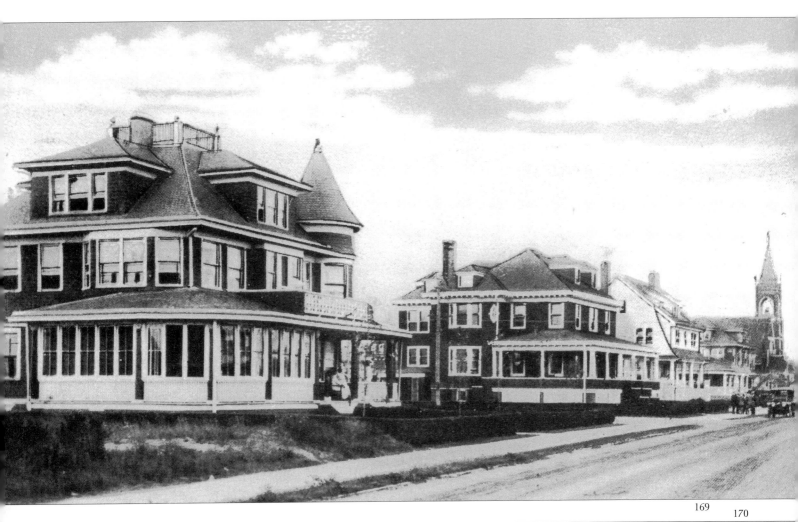

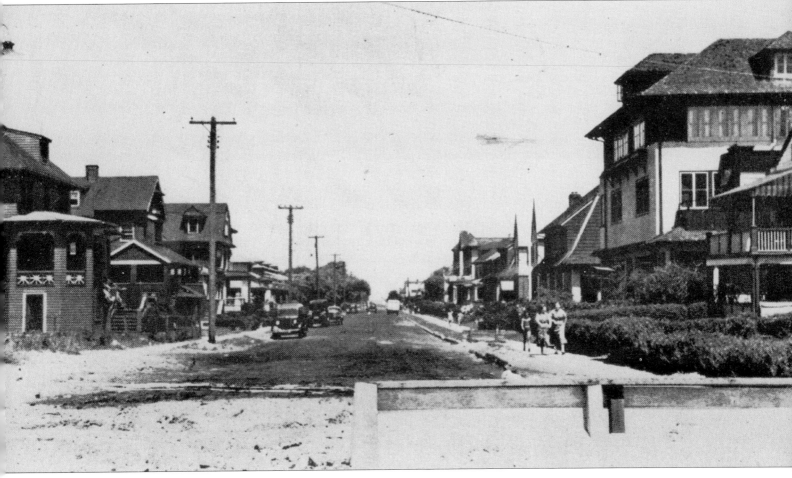

Neponsit

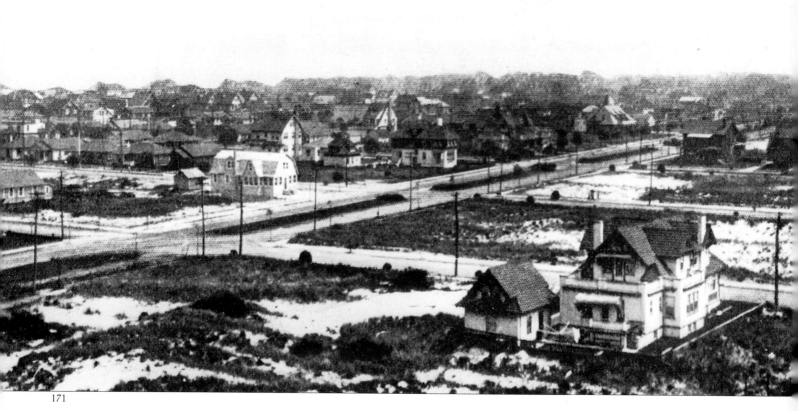

171

~ **171.** Bird's-eye view of Neponsit looking east from the roof of the Neponsit Hospital around 1920. Plenty of open land is still available for building. The wide thoroughfare with center malls is Rockaway Beach Boulevard. *(Robert Stonehill)*

~ **172.** In 1919 there were only two houses on this block of B.145th Street, looking north from Rockaway Beach Boulevard. By the time this photo was taken, in 1927, most of the lots had been filled with substantial, year-round homes.

~ **173.** Small bungalows were the preferred style of building on this block of B.147th Street near the ocean beach. This photo was taken in the late 1920s. *(Robert Stonehill)*

172

173

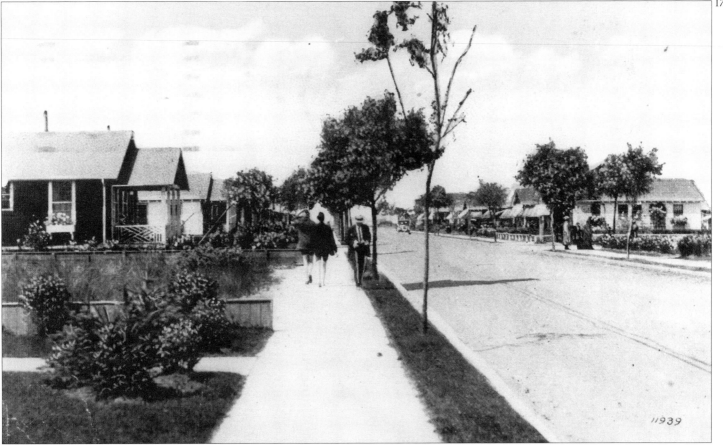

11939

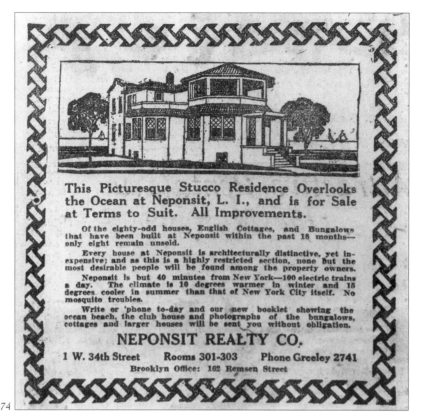

This Picturesque Stucco Residence Overlooks the Ocean at Neponsit, L. I., and is for Sale at Terms to Suit. All Improvements.

Of the eighty-odd houses, English Cottages, and Bungalows that have been built at Neponsit within the past 18 months—only eight remain unsold.

Every house at Neponsit is architecturally distinctive, yet inexpensive; and as this is a highly restricted section, none but the most desirable people will be found among the property owners.

Neponsit is but 40 minutes from New York—100 electric trains a day. The climate is 10 degrees warmer in winter and 15 degrees cooler in summer than that of New York City itself. No mosquito troubles.

Write or 'phone to-day and our new booklet showing the ocean beach, the club house and photographs of the bungalows, cottages and larger houses will be sent you without obligation.

NEPONSIT REALTY CO.

1 W. 34th Street Rooms 301-303 Phone Greeley 2741

Brooklyn Office: 162 Remsen Street

174

175

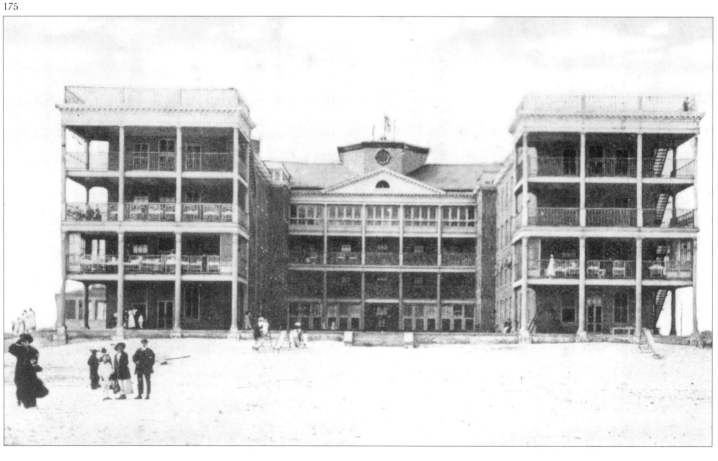

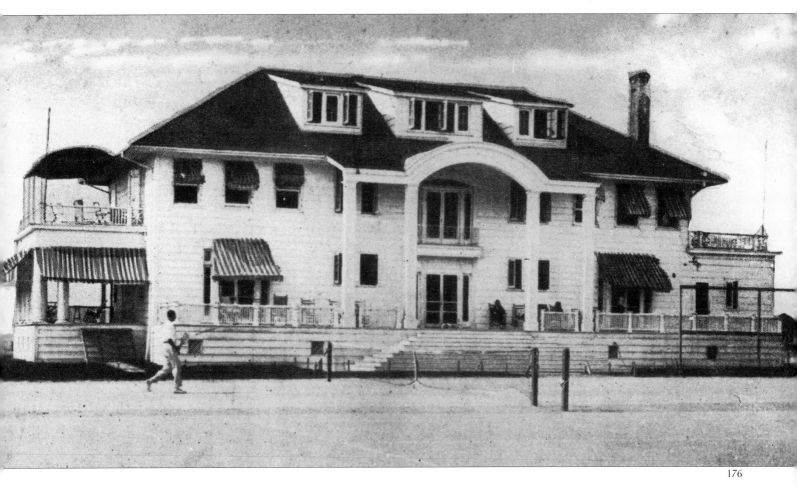

 174. The Neponsit Realty Company built a number of houses on its property in the years before World War I, selling many of them through ads like this one, which dates from January 1913. Seeking the year-round market, the company stated that the Rockaway climate was "10 degrees warmer in winter, and 15 degrees cooler in summer than that of New York City itself."

 175. The Rockaway climate was a major reason why the Neponsit Tuberculosis Hospital was built on the oceanfront in 1918. Like the mountains, the beach offered patients clean, cold air for their ravaged lungs. Note the large open balconies and the many beds in view.

 176. As an incentive for prospective buyers of building lots in Neponsit, the developers built and equipped the Neponsit Club, a recreation center for residents of the new community. A pier 400 feet long extended into Jamaica Bay from the clubhouse, which was at the foot of B.147th Street.

Jacob Riis Park and Breezy Point

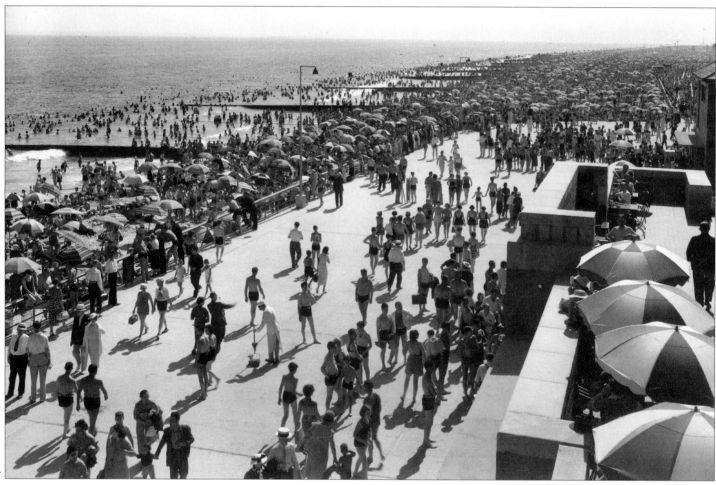

177

∾ **177.** Riis Park on a summer day in 1937 was as crowded as any beach in the New York metropolitan area. Interestingly, this was the first summer that men were permitted to go topless at this public beach. Close scrutiny of this photo taken from the bathhouse roof reveals that not only were some men still covered up, but others promenading on the plaza below wore jacket, tie, and hat for their outing at the shore. *(New York City Department of Parks)*

∾ **178.** Aerial view of the Rockaway Naval Air Station on December 27, 1918, with the barracks and other buildings of Fort Tilden in the foreground. At left, on the Jamaica Bay shore, are seaplane hangars with launching ramps extending into the water; in the center background is a giant hangar for dirigibles. This facility was the headquarters for the naval aviation task force

that was assigned to plan and execute the first transatlantic flight to Europe. Three seaplanes took off from Rockaway just months after this photograph was taken; one of the aircraft reached the objective—Lisbon, Portugal—nine years before Lindbergh made his solo flight to Paris. *(National Archives)*

∾ **179.** The Marine Parkway Bridge, connecting the southern end of Flatbush Avenue, Brooklyn, with Jacob Riis Park and the rest of the Rockaway peninsula, was opened to traffic on July 3, 1937. The bridge was renamed the Marine Parkway-Gil Hodges Memorial Bridge in honor of the late Brooklyn Dodgers catcher and New York Mets manager, whose Brooklyn home was not far from the crossing. *(New York Metropolitan Transportation Authority)*

112

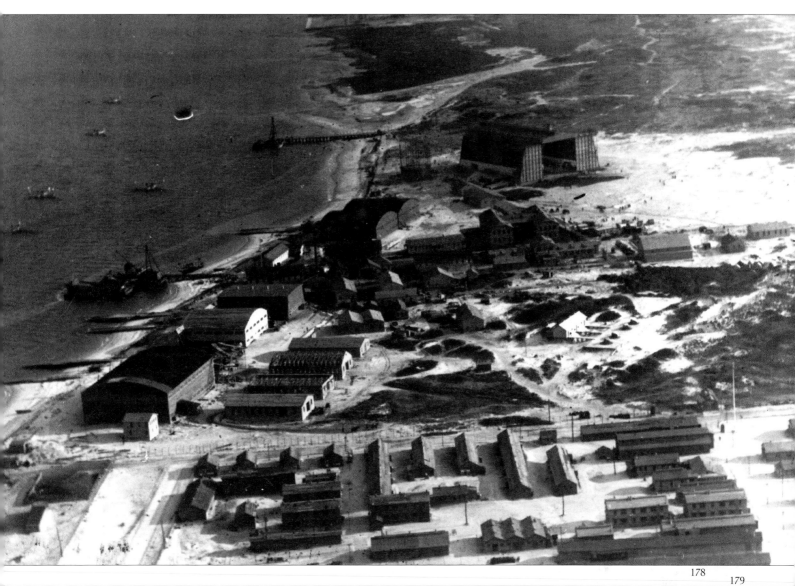

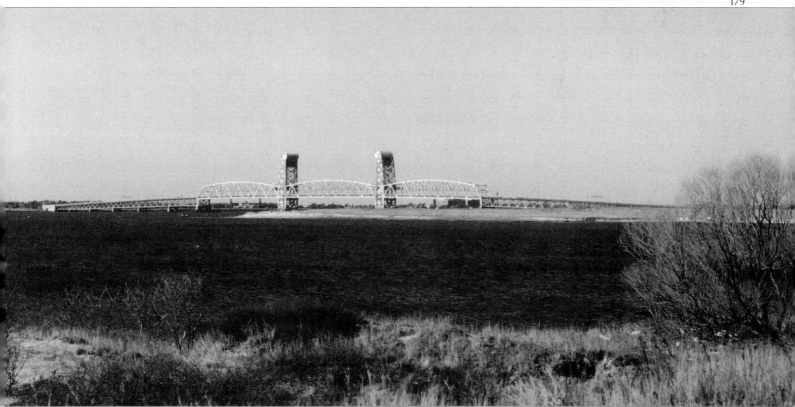

JACOB RIIS PARK AND BREEZY POINT ∾ 113

Index

Hotels, inns, and similar establishments are listed alphabetically
under the specific rather than the generic name.